D1240253

BODY POWER
POWER PLAY

MICHAEL JOSEPH 718 596 7436

BODY POWER

Ansichten zum Sport in der zeitgenössischen Kunst

POWER PLAY

Views on Sports in Contemporary Art

Herausgegeben von Andrea Jahn

HATJE CANTZ **WÜRTTEMBERGISCHER KUNSTVEREIN STUTTGART**

Grußwort

»Letztlich besteht der Mensch nicht nur aus Körper und Seele, also aus zwei Teilen: Er besteht aus drei Teilen, Körper, Geist und Charakter, die Charakterformung geschieht nicht durch den Geist: Sie geschieht vor allen Dingen mit Hilfe des Körpers.«

<div align="right">Pierre de Coubertin (1863 – 1937)</div>

Im alten Griechenland galt die Einheit von Geist und Körper in einer Person als Erziehungsideal des Menschen. Erst die gelebte Synthese von Sport, Kunst und Kult, das heißt die harmonische körperliche und geistige Ausbildung brachte den Menschen der angestrebten Vollkommenheit näher. Baron Pierre de Coubertin, Begründer der Olympischen Spiele der Neuzeit, griff 1906 diese altgriechische Sichtweise auf und führte parallel und gleichberechtigt zu den sportlichen Wettkämpfen fünf musische Wettbewerbe in den Disziplinen Architektur, Malerei, Bildhauerei, Musik und Literatur ein. Nachdem 50 Jahre lang die künstlerischen Wettbewerbe Teil der Olympischen Spiele gewesen waren, scheiterten sie schließlich an der Schwierigkeit, Kunst vergleichen und bewerten zu wollen. Die offiziellen Kunstwettbewerbe wurden gestrichen, der Wille, kulturelle Veranstaltungen im Rahmen der Olympischen Spiele durchzuführen, blieb: Die Kulturolympiade, das heißt ein vierjähriges Kulturprogramm in der Gastgeberstadt vor den Olympischen Spielen, wurde zur festen Tradition.

Auch bei Olympischen Spielen in Stuttgart 2012 soll dem Kulturprogramm eine wichtige Bedeutung zufallen. Einen ersten Vorgeschmack gibt die internationale Ausstellung »Body Power/Power Play – Ansichten zum Sport in der zeitgenössischen Kunst«, die einen Höhepunkt des Kulturprogramms während der nationalen Bewerbungsphase darstellt.

Sie entstand in Kooperation mit dem Württembergischen Kunstverein Stuttgart, der für Konzeption und Organisation der Ausstellung verantwortlich zeichnet. Initiiert und finanziert wurde sie von der Stuttgart 2012 GmbH.

In diesem Zusammenhang möchte ich allen, die an der Ausstellung mitgewirkt haben, herzlich danken, insbesondere der Kuratorin Andrea Jahn, allen Künstlerinnen und Künstlern, von denen sich einige mit speziell für die Schau entwickelten Arbeiten beteiligt haben. Danken möchte ich auch den Autoren für ihre fundierten Textbeiträge zu diesem Katalog sowie allen, die durch ihre finanzielle Unterstützung zur Verwirklichung dieser Ausstellung beigetragen haben.

Raimund Gründler
Geschäftsführer Stuttgart 2012 GmbH

Foreword

'In the last analysis, each individual human being consists not of two parts, that is to say body and soul, but of three: body, intellect and character. And the forming of character not only depends on the mind but also, and above all, requires help from the body.'

Pierre de Coubertin (1863 – 1937)

In Ancient Greece the unity of mind and body within the individual was regarded as the ideal towards which education should aim. For it was only the experienced synthesis of sport, art and religious belief – that is to say, the harmonization of physical and intellectual training – that could bring humanity closer to the perfection for which it strove. In 1906 Pierre Baron de Coubertin, founder of the Olympic Games of the modern era, first staged a decade earlier, took up this Ancient Greek idea and, alongside the various categories of sport, introduced competitions that he saw as no less important in five artistic disciplines: architecture, painting, sculpture, music and literature.

When the artistic competitions had been part of the Olympic Games for fifty years they were abandoned on account of the perceived difficulty of comparing and evaluating art. There nonetheless persisted a determination to stage cultural events alongside the Olympic Games. The Cultural Olympics, a cultural programme taking place in the host city over the four-year period immediately preceding the start of the Games, is now a well-established tradition.

In Stuttgart, which hopes to host the Olympic Games in 2012, we intend to maintain this tradition. A foretaste of the cultural programme planned for Stuttgart is provided in the international exhibition 'Body Power/Power Play: Views on Sports in Contemporary Art', one of the high points in a series of cultural events timed to coincide with the period in which Stuttgart will present its bid to host the Games.

The exhibition, initiated and funded by Stuttgart 2012 GmbH, came about through our cooperation with the Württembergische Kunstverein, Stuttgart, which assumed responsibility for its conception and organization. I should here like to thank most warmly all those who have taken part in the preparation of this exhibition, in particular its Curator, Andrea Jahn, and all the artists, some of whom are showing works specially devised for this event. I should also like to thank the authors of the catalogue texts for their thoughtful contributions, and all those who have aided the realization of this project through their financial support.

Raimund Gründler
Managing Director, Stuttgart 2012 GmbH

Vorwort

Ausstellungen dienen Zwecken, mal merkbarer, mal einleuchtender, mal überzeugender. Die meisten Ausstellungen dienen mehreren Zwecken, mal allen in gleicher Weise, mal den einen mehr und den anderen weniger, mal einem in besonderer Weise. Jeder Zweck, auch der besondere, ist nicht immer auf Anhieb erkennbar. Damit wird seine jeweilige Bedeutung in keiner Weise in Frage gestellt. Das ist oft gerade in den Fällen der Fall, wenn der besondere Zweck außerhalb der Ausstellung selbst liegt. Das spricht meistens dafür, dass es sich um eine besondere Schau handelt. Dieser Fall ist hier, bei »Body Power/Power Play – Ansichten zum Sport in der zeitgenössischen Kunst« gegeben. Ich spreche von ihr.

Sie ist unverkennbar dem Verhältnis von Kunst und Sport gewidmet. Dieses Verhältnis ist spannungsreich und ambivalent und hat Künstler und Ausstellungsmacher seit den Anfängen der Moderne beschäftigt. Andrea Jahn ist es zu danken, dass sie der Frage wieder einmal nachging und daraus ein Ausstellungskonzept entwickelte. Ihm wurde zugestimmt, und so entstand ein Ausstellungsprojekt über das Phänomen Sport, wie es Künstler aus den unterschiedlichsten Gegenden der Welt jetzt und heute sehen, verstehen und empfinden.

Das allein hätte aber kaum genügt, das Projekt zustande zu bringen. Dass es doch gelang, ist dem Umstand zu danken, dass es zum Bewerbungskonzept Stuttgarts für die Ausrichtung der Olympischen Sommerspiele 2012 gehört, ein Kunstereignis zu veranstalten. Gleichgerichtete Interessen, die auf fast wundersame Weise zusammentrafen, haben also die Ausstellung möglich gemacht.

So wird verständlich, dass mit dieser Schau besondere Erwartungen verbunden sind. Die Vorstellung ist faszinierend, mit den Mitteln der Kunst einen Beitrag dafür leisten zu können, dass es der Stadt Stuttgart gelingt, ihr grandioses Ziel zu erreichen, Austragungsort der Olympiade 2012 zu werden. Diese Ausstellung verdient also die ihr gebührende Aufmerksamkeit.

Hans J. Baumgart
Vorsitzender des Württembergischen Kunstvereins Stuttgart

Foreword

Exhibitions serve purposes, sometimes more perceptible ones, sometimes more evident, sometimes more persuasive. Most exhibitions serve several purposes, sometimes all of them equally, sometimes one more than the others, sometimes one in a particular way. Not every purpose, even the particular one, is necessarily evident from the start. In no way, however, does that put its significance into question. That is often the case precisely when the particular purpose lies outside the exhibition. The latter is usually an indication that we are dealing with a special show. So it is with 'Body Power/Power Play: Views on Sports in Contemporary Art'. I am talking about this show.

It is unmistakably about the relationship between art and sport. This relationship is full of tension and ambivalence, and it has occupied artists and organizers of exhibitions since the beginnings of modernism. Andrea Jahn is to be thanked for pursuing the question once again and for developing an exhibition on the theme. It was approved, and it resulted in an exhibition project on the phenomenon of sport, how artists from many regions of the world see it, understand it, and feel it today.

That alone would, however, hardly have been sufficient to bring the project to fruition. For that we are thankful for the circumstance that it was part of Stuttgart's plan to organize an art event as part of its application for the Summer Olympic Games in 2012. Shared interests that came together in an almost miraculous way – that is what made the exhibition possible.

This explains why this show brings special expectations with it. It is fascinating to think that art may be a means to contribute to Stuttgart's effort to achieve its ambitious goal to be the site of the Olympics in 2012. This exhibition is well worth the attention.

Hans J. Baumgart
Chair, Württembergischer Kunstverein Stuttgart

INHALT

CONTENTS

BODY POWER/ POWER PLAY

ANSICHTEN ZUM SPORT IN DER ZEIT- GENÖSSISCHEN KUNST

Andrea Jahn

»It may be useful to speak of a sporting sublime, an urge to speak of what is lost to speech, when we talk so incessantly about what is already past. These complexities suggest that sport will not be conquered by a single method or analytic approach and that perhaps a palpable decentering of our habits of thinking about sport is necessary before we can understand it.«[1]

I.

Auf der Suche nach Texten zum Verhältnis von Sport und Kunst stellt sich irgendwann die Vermutung ein, dieses Verhältnis hätte sich spätestens in den neunziger Jahren in gegenseitiger Skepsis oder Desinteresse aufgelöst. Lediglich in der Literatur findet sich eine Reihe enthusiastischer, humorvoller, bisweilen spöttischer Romane und Essays, die das Thema aus künstlerischer Sicht betrachten und bearbeiten.[2] Das Schweigen von Kunstwissenschaft und Kunstkritik wiederum steht in keinem Verhältnis zur tatsächlichen künstlerischen Produktion, die sich seit den neunziger Jahren verstärkt mit dem Sport als Medienereignis und Freizeitritual auseinander setzt. Nicht von ungefähr äußert sich diese Auseinandersetzung vor allem in Videoarbeiten und Installationen, die den Körper im Wettkampf, die Inszenierung des Raums als Spielfeld und die mediale Aufbereitung des Sportereignisses sowie die damit verbundenen Mythen inhaltlich wie ästhetisch in den Blick fassen.

Der Komplexität der Thematik entsprechen dabei ebenso komplexe künstlerische Konzepte, die sich, wie die eingangs zitierten Autoren Randy Miller und Toby Martin betonen, aus einer einzigen Beobachtungsperspektive nicht angemessen begreifen lassen. Mit ihrem Titel »Body Power / Power Play« widmet sich diese Ausstellung sowohl der Ausstrahlung und Faszination, die vom Körper in der sportlichen Bewegung ausgeht, als auch der Bedeutung, die dem Körper im Spiel und im Machtkampf um Preise, Medienaufmerksamkeit und Kommerz zukommt. Im Sport ist der Körper Schauplatz und Protagonist einer Inszenierung, eines performativen Kunstwerks. Jedes Rennen, jedes Spiel, jeder Wettkampf ist (in Anlehnung an Joyce Carol Oates' Beobachtungen *Über Boxen*) »ein einzigartiges und bis zum Äußersten verdichtetes Drama ohne Worte«[3] oder auch »eine Geschichte, deren Text in der Aktion entsteht«, als »höchst kunstvoller Dialog«[4] zwischen den Kontrahenten und dem Publikum. Nicht zufällig trifft der fiktionale, inszenierte Charakter jeder sportlichen Aktion und schließlich die Spezialisierung und Konstruktion des Körpers selbst in der aktuellen Kunst auf besondere Aufmerksamkeit.

João Penalvas höchst ästhetisch angelegte Videoarbeit *The Prize Song* konfrontiert uns in bewusst gesetzten Ausschnitten und Nahansichten mit den athletischen Bewegungen eines Kunstturners, deren visuelle und akustische Eindringlichkeit sowohl die brutale wie faszinierende Disziplinierung des Körpers zum Ausdruck bringt. Der Turner ist Körper und nichts anderes, er wird vom Bild fragmentiert und scheint gefangen in der endlosen Wiederholung des Loops. Die Ästhetik des Körpers spielt die entscheidende Rolle – nicht seine Idealisierung, die letztlich auf das Bild eines ganzen Körpers angewiesen wäre, sondern die visuelle Annäherung an bewegte Körperlichkeit, die mit ihrer Wucht und Verletzlichkeit unter die Haut geht.

Auch Tamara Grcic arbeitet in ihrer mehrteiligen Videoinstallation *Turf* der spektakulären Inszenierung von Sportbildern entgegen. Die aufgeladene Atmosphäre eines Pferderennens konzentriert sich hier im Ausschnitt vorbeiziehender Pferdekörper, an deren Oberfläche die Kamera ganz nah heranrückt, um in den Bewegungen der Muskeln die ganze Dynamik, Anspannung und Erschöpfung zu erfassen, die ein Rennen ausmacht. Körperlichkeit und Bewegung stehen somit im Zentrum der künstlerischen Aufmerksamkeit, nicht Leistung, Ergebnis und Unterhaltung.

II.

Der Blick auf den Körper bildet jedoch nur eine Perspektive der Ausstellung. Ein weiterer Aspekt, den sie zum Ausdruck bringt, zeigt sich in der künstlerischen Auseinandersetzung mit dem Sport als einem Phänomen, das unser Leben und unseren Alltag in einem Maß bestimmt wie kein anderes. Dabei spielt die Kommerzialisierung des Sports, vom Fitnesstraining bis zum Hochleistungssport, eine zentrale Rolle. Der Jugendkult fordert seinen Tribut bis ins hohe Alter, Sportlichkeit wird zur Voraussetzung und zum Ausdruck privater und beruflicher Leistungsfähigkeit.

Julia Loktev betrachtet diese Entwicklung ironisch und richtet den Kamerablick in ihrem Video *Press Shots* auf die schmerzhafte Seite der Arbeit am männlichen Körperideal. Doch steht nicht der gequälte Körper im Mittelpunkt ihrer Aufmerksamkeit, sondern die Mimik der jugendlichen Gesichter in ihrer Mischung aus höchstem Schmerz und tief empfundener Entspannung. Loktev setzt die Kamera dabei

ein wie einen Spiegel, in dem sich eine intime, verletzliche und gänzlich unheroische Seite pubertärer Männlichkeit reflektiert, die im krassen Widerspruch zum angestrebten Ideal steht.

Selbstkasteiung als Freizeitspaß ist auch das Thema des ungarischen Künstlers Antal Lakner, der mit seinem Angebot an absurden Trainingsgeräten den populären Fitnesskult karikiert. Doch seine *Home Transporter* und *Forest Master* sind mehr als die bloße Persiflage von Sportgeräten. Es sind Kunstwerke – Installationen, die im Kontext einer Ausstellung durchaus Anwendung beim Kunstpublikum finden könnten. Diese Verschränkung von Sport und Kunst in einem Objekt, das gleichzeitig der Betrachtung wie der Bewegung dient und keine der damit verbundenen Erwartungen konsequent erfüllt, führt die konstruierte Differenz zwischen geistiger Tätigkeit (Kunst) und körperlicher Betätigung (Sport/Arbeit) ad absurdum.

Auch der Schweizer Stefan Banz stellt Sportequipment in den Mittelpunkt seiner Installation – allerdings in Form von Turngeräten, die wie Vitrinenobjekte in gläsernen Kabinen präsentiert werden. Zur Leibesertüchtigung taugen sie wenig und dienen eher der Anschauung und Besinnung auf den gesunden, kreativen Widerstand gegenüber den Regeln, nach denen wir gelernt haben, als Sozialkörper zu funktionieren. Die künstlerische Skepsis gegenüber dem System entfaltet sich dabei als fragiles Gebilde von höchstem ästhetischen Reiz.

So nehmen Lakner und Banz die ideologische Seite sportlicher wie künstlerischer Auseinandersetzung ironisch unter die Lupe, indem sie in ihren installativen Arbeiten immer auch die Erfahrung und Perspektive der Gegenseite zulassen.

III.

Konzentrieren sich diese Künstler auf die verschiedensten Akte individueller Selbstverwirklichung, so lenkt ein weiterer Part der Ausstellung die Aufmerksamkeit auf die sozialpsychologischen, kulturell motivierten Seiten des Sports in ihrer extremen Form von Starkult und Massenbegeisterung. Der allzu menschliche Wunsch nach Gemeinschaftserfahrung, nach erhebenden Momenten, die den Alltag ver-

gessen machen, nach Ritualen und Feierlichkeit steht im Hintergrund dieser Reaktionen. Unbedingte Voraussetzung dafür ist die mediengerechte Aufbereitung und Verbreitung des Sportereignisses selbst. Doch im Unterschied zu den Bildern und Klischees, die von der Werbung oder der Sportberichterstattung hervorgebracht werden, um Sportlerpersönlichkeiten, bestimmte Sportarten oder auch nur einen Energieriegel möglichst fernsehtauglich zu vermarkten, zeichnet sich in der aktuellen Kunst eine Auseinandersetzung ab, die versucht, den damit verbundenen Strategien der Idealisierung und Inszenierung auf den Grund zu gehen.

Karen Shaws »Mannschaft« von Fußballer- und Basketballertrikots hat Mühe, sich ihrer Heldenhaftigkeit zu versichern. Nun, da sie ihren Anspruch als Insignien männlicher Sportlichkeit und Sexualität eingebüßt haben, aufgelöst im zarten Gespinst eines nur mehr aus Baumwollfäden bestehenden T-shirts, das bis zum Boden reicht. Shaws Zeichnungen zeigen die Spieler in hinreißenden Aktionen, in denen das zum Ballkleid mutierte Trikot den einen fast zu Fall bringt und des anderen Körper zusätzlich erotisiert. So oberflächlich diese Übertragung »weiblich« definierter Attribute auf Sportler als Verkörperungen »reiner« Männlichkeit zunächst anmuten mag, so sehr fordert ihre differenzierte künstlerische Umsetzung die genaue Beobachtung heraus.

Die Stuttgarter Künstlerinnen Sonya Horn und Tina Schneider nehmen die Show um Erotik und Sport mit einer Persiflage auf die Heldinnen von Wimbledon gehörig aufs Korn. Was den Spielern der National Basketball Association recht ist, ist den weiblichen Tennisprofis billig. Sex sells – im Sport wie im Business. Da gereicht die Kuscheldecke zum Center Court, eingefasst von gegenüberliegenden Monitoren mit zwei Spielerinnen, die in unermüdlicher Selbstdarstellung wetteifern.

Diese Installationen hegen durchaus feministische Absichten, ohne jedoch mit dem erhobenen Zeigefinger patriarchale Diskriminierungspraktiken im Sport anzuprangern. Vielmehr nehmen sie sich mit dem Blick auf erotische Selbstinszenierung auch gerade jene »weiblichen« Strategien vor, die das patriarchale System zwar augenzwinkernd unterlaufen, zugleich aber beharrlich am Leben erhalten.

IV.

Warum bestimmte Sportarten wie Fußball, Tennis, Leichtathletik oder die Formel 1 in Europa Massenbegeisterung auslösen können, hängt mit nationalen Standards, Tugenden und Traditionen, in der Hauptsache aber mit ihrem Potenzial an Projektions- und Identifikationsmöglichkeiten zusammen. Die unterschiedliche Beliebtheit einer Mannschaftssportart wie der des Fußballs offenbart die

gesellschaftliche Konstruiertheit ihrer Definitionen, Grenzen und Möglichkeiten. Während Fußball in Europa sowohl in den Medien als auch in Sportvereinen und auf der Straße als reine »Männersache« verhandelt wird, gilt dasselbe Spiel in den USA als »Frauensport«. Die darin enthaltene Abwertung steht aus US-amerikanischer Perspektive in keinerlei Widerspruch zu der Tatsache, dass in südamerikanischen Ländern – allen voran Brasilien und Mexiko – der Fußball als Nationalsport und ergo als »Männersport« eine zentrale Rolle spielt.[5]

Wie die Ausstellung zeigt, findet diese kulturelle Relevanz des Sports als Instrument politischer Manipulation Eingang in die künstlerischen Diskurse auf internationaler Ebene und beschränkt sich nicht auf die Perspektive der westlichen Industriegesellschaften. Südamerikanische oder afrikanische Künstler wie Gustavo Artigas oder Godfried Donkor reflektieren Sport als globales wie regionales Phänomen in seinen rassenpolitischen und gesellschaftlichen Dimensionen. In seinem Katalogbeitrag »Die Sprache des Sports: Spielregeln, Machtspiele und die Kraft der Region« knüpft der australische Autor Ihor Holubizky unmittelbar an diesen Perspektivwechsel an und skizziert die enge Verbindung zwischen Sport und Kultur im regionalen und vorkolonialen Kontext kanadischer, nordamerikani-

scher sowie australischer Traditionen und macht zugleich den Verlust dieser vielschichtigen Beziehungen im Rahmen einer globalisierten Sportindustrie sichtbar.

Der Mexikaner Gustavo Artigas zeichnet in seiner Videoarbeit *The Rules of the Game* auf sehr sensible Weise die Momente nach, die ein harmloses Ballspiel an der Grenze zwischen Mexiko und den USA in sich hat. Es ist ein Spiel, bei dem der Ball auch einmal über die Mauer gehen kann, die beide Staaten trennt, ein Spiel, das für einen kurzen Moment den eigenen Regeln folgend, die gesetzlichen Regeln bricht.

Für den aus Ghana stammenden Londoner Künstler Godfried Donkor verknüpfen sich im Boxsport Vergangenheit und Gegenwart. Die Kraft und Dynamik schwarzer Profi-Boxer triumphieren in seinen Bildern über die grausame Vergangenheit, die afrikanische Völker als Sklaven in der Neuen Welt erdulden mussten. Zugleich repräsentiert die Figur des schwarzen Boxers den Anspruch auf eine eigene – schwarze – Tradition des Boxsports, der nicht in der westlichen Welt, sondern auf dem schwarzen Kontinent wurzelt.

Ebenso kritisch befasst sich der New Yorker Satch Hoyt, der die eigenen Wurzeln in Jamaica mit seinem besonderen Interesse am – schwarzen – Boxsport verbindet, mit der Tradition und Inszenierung von Boxkämpfen in den USA. Seine Installation eines Boxrings im Kuppelsaal des Württembergischen Kunstvereins Stuttgart mit der dazugehörigen Figur eines aus Boxhandschuhen bestehenden, stilisierten Boxers, setzt auf die Intervention und Interaktion des Publikums, das aufgefordert ist, selbst Position zu beziehen.

Themen, die sich mit Sport beschäftigen und in der aktuellen Kunst auf verstärktes Interesse stoßen, beziehen sich wesentlich häufiger auf den Boxkampf als auf andere Sportarten. Vor dem Hintergrund einer langen Tradition in der Kunst und Literatur des 20. Jahrhunderts, in der Boxer als Identifikationsfiguren fungierten oder Literaten wie Arthur Cravan sich selbst als Profi-Boxer stilisierten, überrascht diese Faszination nicht. Was allerdings erstaunt, ist die Anzahl teilweise sehr junger Künstlerinnen, die sich heute in ihren Arbeiten mit dem Mythos des Boxens auseinander setzen.

So zeigt Ana Bustos Videoarbeit einen Boxkampf inmitten einer Ausstellung, in der ihre eigenen Fotografien von Boxern präsentiert werden. Zu ihrer Eröffnung versammelt sich um den Boxring ein gemischtes Publikum, bestehend aus Kunstinteressierten und Boxfans. Das Aufeinandertreffen zweier verschiedener Welten spielt hier eine zentrale Rolle. Bustos Video offenbart die Differenz, aber auch die Sprachlosigkeit, die beide Parteien voneinander trennt.

Und sie zeigt, dass vermeintlich emotionale, affektive Äußerungen im Grunde antrainiert sind und die mangelnde Vertrautheit mit gruppendynamischen Codes und Spielregeln zu Unverständnis und Gleichgültigkeit führen kann. Das gilt letztlich auch für die Kunst, deren spezifisches Vokabular noch sehr viel stärker ausgrenzt als integriert.

Sport diente immer wieder als Metapher für künstlerische Arbeit. Boxen wird dabei zum Inbegriff oder Kulminationspunkt dieser Überschneidung von sportlicher und künstlerischer Aktivität. Dabei ist nicht zu übersehen, dass dieser Schnittpunkt zum Gradmesser für Männlichkeit avanciert: »Ein Boxer bringt alles in den Kampf ein [...], sein Körper-Ich, seine Männlichkeit [...], die ›Schicht‹ unter seinem ›Ich‹.«[6] Dasselbe ist auch immer wieder vom männlichen Künstlergenie behauptet worden, ungeachtet der allzu durchschaubaren Strategien, Künstlertum auf diesem Wege zu mystifizieren und Autorschaft in einen Bereich zu projizieren, der durch sein extremes Abweichen vom Alltäglichen höhere Weihen verspricht. Diese Form der Selbstinszenierung gehört genauso zum Boxermythos wie zum Klischee des modernen Künstlergenies, die beide unmittelbar an Männlichkeitsfantasien geknüpft sind: »Die ›süße Kunst zu verletzen‹ ist ein Hohelied auf den männlichen Körper [...] Obwohl männliche Zuschauer sich mit Boxern identifizieren, verhält sich kein Boxer, sobald er im Ring ist, je wie ein ›normaler‹ Mann, und keine Kombination von Schlägen ist ›natürlich‹. Alles ist Stil.«[7]

In ihrer Videoarbeit *I Wish I Was Roy Jones Jr.* absolviert die New Yorker Künstlerin Caitlin Parker eine Gratwanderung zwischen Hommage und Parodie auf diese männliche Tradition. Indem sie selbst in den Ring steigt, um ein Match zwischen dem ehemaligen Profi-Boxweltmeister Roy Jones Jr. und Vinny Pazienza nachzustellen, eignet sie sich eine Rolle an, die bislang ausschließlich dem männlichen Künstler vorbehalten war.[8] Doch sie betreibt diesen Rollenwechsel mit einem Augenzwinkern, hat sie doch als Regisseurin und Hauptdarstellerin leichtes Spiel und den Applaus in jedem Fall auf ihrer Seite.

Claudia Lüersens Beitrag »Die süße Kunst zu verletzen« unterzieht das Verhältnis von Frauen, Männern und Boxsport – im Hinblick auf das künstlerische Interesse an Boxen und Boxern – einer kritischen Analyse. Ihre Betrachtungen gehen aus von Joyce Carol Oates' Essay *Über Boxen* und diskutieren neben der sportlichen Praxis und ihrer Überhöhung in der literarischen Tradition auch die Möglichkeiten feministischer und ideologiekritischer Interventionen in den Werken der ausstellenden Künstler und Künstlerinnen.

V.

Sport braucht die Öffentlichkeit wie jede andere Inszenierung oder Performance, sei es im Theater oder im Ausstellungsraum. Sport braucht ein Publikum, das die Codes und die Regeln kennt, eine gemeinsame Sprache spricht und sich gewisse Wahrnehmungsmodi antrainiert hat. Anders gesagt, gehen eingefleischte Sportfans ebenso wie die Liebhaber aktueller Kunst so vollkommen in ihrer Rolle als Zuschauer oder Betrachter auf, dass Unbeteiligte dies allenfalls als Spleen auffassen können. (Wen kümmert schließlich die Meditation über Farbspuren auf einer Leinwand oder das Schicksal eines Stück runden Leders?)

Nur wer die Regeln und die Rhetorik kennt, die dieser bisweilen äußerst emotionalen Verbundenheit zugrunde liegen, ist imstande, sie auch selbst zu erfahren. Allen anderen bleiben die Gründe für eine Hingabe an die Kunst oder die Erregung über einen Wettkampf solange verborgen, bis sie sich deren spezifische Sprache selbst angeeignet haben.

Der Engländer Alan Uglow gehört zu den wenigen Malern dieser Ausstellung und stellt mit seiner »Trainerbank« unter Beweis, wie viel die Sprache und Ausdruckskraft der Malerei mit der Faszination und Einfühlung zu tun haben können, die das Geschehen auf dem Fußballplatz begleitet. Die Ästhetik des Ballsports entfaltet sich schließlich nochmals in der Installation *Ballpark XX* des New Yorker Malers Russell Maltz. Seine in Schichten auf Drahtglas aufgetragene Malerei evoziert über den strengen Kontrast von Grün und Weiß den Raum und die Erinnerung an den Alltag, die Hoffnungen und Höhepunkte auf dem Spielfeld. Wie die Gemälde Uglows äußern sich auch seine Abstraktionen über die Poesie des Sports in der Sprache einer autonomen Kunst.

Angesichts der unterschiedlichen Perspektiven und Auseinandersetzungen mit dem Sport in der aktuellen Kunst, die in der Ausstellung »Body Power/Power Play« sichtbar werden, zeichnet sich eine gemeinsame Motivation ab, die allen Werken vorausgeht: die Anziehung, die Sport auf Künstler hinsichtlich dessen ausübt, »dass es ein Schauspiel ohne Worte ist, sprachlos, dass es andere braucht, es in Worte zu fassen«.[9] Im Falle der ausgestellten Werke sind es Videobilder, Installationen, Fotografien und Malereien, die dieser Anziehung Ausdruck verleihen.

Kommen wir nach diesen Betrachtungen auf die Anregung von Martin und Miller zurück, darüber nachzudenken, was eigentlich im Prozess der Wahrnehmung verloren geht, wenn wir beim Reden über Sport unermüdlich das verbalisieren, was im Moment des Sprechens bereits der Vergangenheit angehört, dann zeigt die Ausstellung mit ihrer Auswahl an künstlerischen Positionen, dass gerade die aktuelle Kunst Methoden oder analytische Herangehensweisen entwickelt, die dazu in der Lage sind, das zu erfassen, was die Komplexität des Sports ausmacht. Mit ihren unterschiedlichen medialen Möglichkeiten erreicht sie es, für das Ereignis des Sports in seiner Kontingenz und Performativität eine Sprache zu finden und es in seinen Strukturen und Strategien transparent zu machen.

1 Randy Martin und Toby Miller, »Fielding Sport: A Preface to Politics?«, in: dies., *SportCult*, Minneapolis 1999, S. 12.

2 Um nur eine kleine Auswahl zu nennen: Walter Nowojksi (Hrsg.), *Der Kinnhaken*, Berlin 1993, Jan Philipp Reemtsma, *Mehr als ein Champion – Über den Stil des Boxers Muhammad Ali*, Reinbek bei Hamburg 1997, Elfriede Jelinek, *Ein Sportstück*, Reinbek bei Hamburg 1998, Nick Hornby, *Fever Pitch*, New York 1992, Antonia Logue, *Die Könige von Amerika*, Reinbek bei Hamburg 2001.

3 Joyce Carol Oates, *Über Boxen*, Zürich 1988, S. 11.

4 Ebd., S. 15.

5 Böse Zungen mögen behaupten, Südamerikaner genössen in der weißen, angelsächsisch-protestantischen Kultur der USA keinesfalls mehr Autorität als Frauen!

6 Oates 1988 (Anm. 3), S. 13.

7 Ebd.

8 Noch vor ihrer Karriere als feministische Künstlerin hatte sich Judy Chicago 1970 einmal als Boxer (!) für eine Anzeige in der Zeitschrift *Artforum* in Pose gestellt, um ihrer Coolness Ausdruck zu geben und in den angesagten (von Männern dominierten) Künstlerkreisen in Los Angeles akzeptiert zu werden.

9 Oates 1988 (Anm. 3), S. 53.

BODY POWER / POWER PLAY

VIEWS ON SPORTS IN CONTEMPOR-ARY ART

Andrea Jahn

'It may be useful to speak of a sporting sublime, an urge to speak of what is lost to speech, when we talk so incessantly about what is already past. These complexities suggest that sport will not be conquered by a single method or analytic approach and that perhaps a palpable decentering of our habits of thinking about sport is necessary before we can understand it.'[1]

I.

In my search for texts on sports and art, I began to suspect at some point that, at least since the 1990s, the relationship between the two was one of mutual scepticism or lack of interest. Only in literature does one find writings – enthusiastic, humorous and sometimes mocking novels and essays – that view and explore the theme from an artistic perspective.[2] The silence on the part of art studies and criticism, in turn, bears no relation to actual artistic production, which has shown an increasing interest since the 1990s in sports as a media event and a leisure-time ritual. Not coincidentally, this interest is expressed above all in video works and installations that examine – in terms both of content and aesthetics – the body in competition, the stage of space as a playing field, and the transmission of sporting events by the media as well as the myths associated with all these things.

The complexity of the themes thus corresponds to complex artistic concepts that, as Randy Miller and Toby Martin emphasize in the epigraph, cannot be adequately understood from a single vantage point. The title of this exhibition, *Body Power/Power Play*, focuses on the aura and fascination of the body in athletic motion as well as on the meaning that the body has in play and in the power struggle over prizes, media attention and commerce. In sports, the body is the stage and the protagonist in a drama, in a performative artwork. Every race, every game, every competition is, as Joyce Carol Oates observes in *On Boxing*, 'a unique and highly compressed drama without words'[3] and also a story whose 'text is improvised in action ... a dialogue between the boxers of the most refined sort ... in a joint response to ... the audience.'[4] Not coincidentally, the fictional, staged aspect of every athletic action and finally the specialization and construction of the body itself in contemporary art receive particular attention.

João Penalva's video piece *The Prize Song* has an elaborate aesthetic structure and confronts us with deliberately chosen details and close-ups of the athletic movements of a gymnast. The visual and acoustic intensity of these movements expresses the physical discipline of the body, as brutal as it is fascinating. The gymnast is a body and nothing more; he is fragmented by the image and seems to be caught in the endless repetition of the loop. The aesthetic of the body plays the decisive role – not its idealization, which would ultimately depend on an image of a whole body, but a visual approximation of physicality in motion, which gets under our skin with its power and vulnerability.

In her multi-part video installation *Turf*, Tamara Grcic also works against the dramatization of sporting images as spectacle. The charged atmosphere of a horse race focuses here on details of the bodies of horses passing by, with the camera close in on the movements of their muscles to capture the whole dynamic tension and exhaustion that make up a race. Physicality and movement are so often at the centre of artistic attention rather than achievement, results and entertainment.

II.

The gaze at the body is, however, just one of the exhibition's perspectives. Another aspect that the exhibition expresses is the artistic engagement with sports as a phenomenon that determines our daily life to a greater extent than anything else. A central role in this is played by the commercialization of sport, from fitness training to competitive sports. The cult of youth demands its tribute into advanced age, and athleticism becomes a prerequisite and an expression of performance at home and at work.

Julia Loktev examines this development through the lens of irony. In her video *Press Shots* she focuses her camera on the painful aspects of working for the ideal male body. It is not, however, the tortured body that is the focus of her attention but rather the expressions of the youthful faces in their mixture of extreme pain and deeply felt relief. Loktev uses the camera like a mirror that reflects an intimate, vulnerable and totally unheroic side of male puberty, which stands in crass contradiction with the desired ideal. Self-mortification as leisure activity is also the theme of the Hungarian artist Antal Lakner, who caricatures the popular cult of fitness with his absurd training equipment. His *Home Transporter* and *Forest Master* are, however, more than simply caricatures of athletic equipment. They are artworks – installations that can by all means be used by the art public in the context of an exhibition. This reduction of sports and art to an object that serves both observation and movement, and thus does not satisfy the expectations associated with either, reduces to the absurd the constructed difference between intellectual activity (art) and physical activity (sports/work).

The Swiss artist Stefan Banz also places sporting equipment at the centre of his installation – though here it takes the form of gym equipment presented in glass cabinets like objects in display cases. The objects are of little use for physical training and are more to be looked at and to make us think of healthy, creative resistance against the rules that we have learned to function as social bodies. Artistic scepticism about the system thus develops into a fragile form of great aesthetic appeal.

Thus Lakner and Banz view the ideological side of sporting and artistic activity through the lens of irony, in that their installations always permit opposed experience and perspectives.

III.

While those two artists concentrate on the very different approaches to individual self-realization, another part of the exhibition focuses our attention on the socio-psychological and culturally motivated aspects of sports, in the extreme forms of star cults and mass crazes. Behind all these reactions stands the all too human desire for communal experience, for moments that elevate us and make us forget the ordeal of everyday life, for rituals and ceremony. The inevitable prerequisite for this is a proper preparation and transmission of the sporting event through the media. Even so, in contrast to the images and clichés that are produced by advertising and sports reporting, which try to market sports personalities, particular sports, or even energy bars in a way best suited to television, contemporary art has shown an interest in trying to get at the root of the associated strategies of idealization and dramatization.

Karen Shaw's 'team' of football and basketball jerseys have trouble convincing themselves of their heroic stature now that they have lost their claim to be insignia of male athleticism and sexuality and have turned into mere t-shirts dissolving into cotton threads in a delicate weave that reaches to the floor. Shaw's drawings show the players in thrilling actions in which the tricot, mutated into a ball gown, almost brings one of them down and also eroticizes the body of the other. As superficial as this application of attributes defined as 'feminine' to athletes as the embodiment of 'pure' masculinity might seem at first, its highly differentiated employment in art calls for careful consideration.

The Stuttgart artists Sonya Horn and Tina Schneider draw a bead on the show of eroticism and sports with a satire of the heroines of Wimbledon. What is good for NBA players is cheap for women tennis players. Sex sells – in sports as in business. The centre court becomes a bedspread, framed by the grunts of two female players, who compete indefatigably in self-promotion on two facing video monitors.

These installations certainly foster feminist views, but they refrain from pointing fingers to denounce practices of patriarchal discrimination in sports. Rather, in their look at erotic self-promotion they pursue 'feminine' strategies that circumvent with a wink the patriarchal system but at the same time keep it alive.

IV.

The reason certain types of sports, like soccer, tennis, track and field or Formula I, can arouse such mass enthusiasm in Europe is connected with national standards, virtues and traditions but above all with their potential to permit projection and identification. The relative popularity of a team sport, like soccer, demonstrates that its definitions, limits and possibilities are socially constructed. Whereas soccer in Europe is treated as a 'man's affair' – in the media as well as in the sports clubs and on the streets – the same game is considered a 'woman's sport' in the United States. The corresponding lack of interest in the sport in the United States is by no means in contradiction with the fact that in Central and South America – especially Mexico and Brazil – soccer is the national sport and thus plays an essential role as the 'man's sport'.[5]

As this exhibition demonstrates, the cultural relevance of sports as an instrument of political manipulation becomes part of artistic discourse on an international level and is not restricted to the perspective of Western industrialized societies. Central American and African artists, like Gustavo Artigas and Godfried Donkor, reflect on sports as a global and regional phenomenon in terms of its role in race politics and society. In his catalogue essay 'The Language of Sports: The Rules of the Game, and the Play of Power and Region' the Australian writer Ihor Holubizky picks up on precisely this change of perspectives and sketches a picture of the close connection between sports and culture in a regional and pre-colonial context in the respective traditions of Canada, the United States and Australia. At the same time, he makes it evident that these multi-layered connections have been lost as the sports industry has become global.

In his video piece *The Rules of the Game* the Mexican artist Gustavo Artigas traces in a very sensitive way the elements of a harmless ball game on the border between Mexico and the United States. It is a game in which the ball can sometimes go over the wall that divides the two countries; a game that, following its own rules for a brief moment, can break the rules set down in laws.

For Godfried Donkor, a London-based artist from Ghana, past and present combine in boxing. In his paintings, the power and strength of black professional boxers triumphs over the cruel past that the African people had to suffer as slaves in the New World. At the same time, the figure of the black boxer represents a claim for an independent (i.e., black) tradition of boxing that has its roots not in the Western world but on the 'Dark Continent'.

The New York artist Satch Hoyt, whose origins in Jamaica also give him a special interest in blacks in boxing, is equally critical of the tradition and staging of boxing matches in the United States. His installation of a boxing ring in the cupola hall of the Württembergischer Kunstverein Stuttgart, along with a stylized boxer made up of boxing gloves, depends on the intervention and interaction of the public, which is challenged to take its own position.

Sports-related themes that have awakened a strong interest in contemporary art are decidedly more often related to boxing than to other sports. This fascination is hardly surprising when viewed against the background of a long tradition in twentieth-century art and literature in which artists identified with the boxer or even presented themselves as professional boxers, as the writer Arthur Cravan did. What is astonishing, however, is the number of women artists, some quite young, whose work addresses the myth of boxing.

For example, Ana Busto's video piece shows a boxing match in the middle of an exhibition in which her own photographs of boxers are shown. At the opening, the ring was surrounded by a mixed crowd consisting of both art lovers and boxing fans. The meeting of two different worlds plays a central role in the work. Busto's video reveals the difference, as well as the silence, that separates the two groups. She also shows that supposedly emotional, affective expressions are essentially learned traits and that a lack

of familiarity with the codes of group dynamics and the rules of the game can lead to a lack of understanding and to indifference. This is also true of art, since its specialized vocabulary tends to exclude much more than it integrates. Sports have frequently been used as a metaphor for artistic labour. Boxing has been seen as the embodiment or culmination of this intersection of athletics and art. One cannot fail to note that this point of intersection has been advanced as the measure of masculinity. 'The boxers will bring to the fight everything that is themselves. ... The physical self, the maleness, ... underlying the "self".'[6] The same claim has often been made for the male artist-genius, ignoring the all too transparent strategies for mystifying the artist in this way and for projecting authorship into a realm that promises greater glory by means of its extreme removal from the quotidian. This form of self-presentation is just as much part of the myth of the boxer as it is a cliché of the modern artist-genius, and both are directly associated with fantasies of masculinity: '"The Sweet Science of Bruising" celebrates the physicality of men. ... Though male spectators identify with boxers no boxer behaves like a "normal" man when he is in the ring and no combination of blows is "natural". All is style.'[7]

In her video piece *I Wish I Was Roy Jones Jr.* the New York artist Caitlin Parker manages a tightrope walk between homage to and parody of this masculine tradition. By climbing into the ring herself to reconstruct a match between the former world-champion professional boxer Roy Jones Jr. and Vinny Pazienza, she is adopting a role that had previously been the exclusive property of male artists.[8] She performs this change of roles with a wink, however: as director and main actor she has it easy, and the applause is always on her side.

Claudia Lüersen's essay 'The Sweet Science of Bruising' subjects the relationship of women, men and boxing to a critical analysis – from the perspective of artists' interest in boxing and boxers. Her remarks take Joyce Carol Oates's book *On Boxing* as their starting point and address not only the practice of the sport and its elevation into the literary tradition but also the possibilities for approaching the works of the artists exhibited from the perspectives of feminism or the critique of ideology.

V.

Sports need a public just as much as any other staging or performance does, in the theatre or in the exhibition. Sports need a public that understands the codes and rules, that speaks a common language, and that has learned certain modes of perception. To put it another way, dyed-in-the-wool sports fans become just as completely involved in their roles as do viewers or lovers of contemporary art, so that outsiders can at best understand it as a form of spleen. (After all, who is really affected by meditations about traces of paint on a canvas, or the fate of a round piece of leather?) Only someone who knows the rules and the rhetoric that form the basis of this sometimes extremely emotional connection is in a position to experience it. For everyone else, the reasons for devoting oneself to art or getting excited about a match will remain hidden until they have learned for themselves the specific language.

The British artist Alan Uglow is one of the few painters in this exhibition, and his *Coach's Bench* demonstrates how much the language and expressive power of painting can have to do with the fascination and empathy that accompany events on the soccer field. The aesthetics of the ball game are also developed in the installation *Ballpark XX* by the New York painter Russell Maltz. He applies paint in layers on wire-reinforced glass, and the resulting strong contrast of green and white evokes the space and memory of

the daily life, the hopes and the high points on the field. Like Uglow's paintings, his abstractions also speak of the poetry of sports in the language of autonomous art.

Despite the varied perspectives on and approaches to sports within contemporary art that can be seen in the exhibition *Body Power/Power Play*, we can recognize a shared motivation behind all of the works: the attraction that sport has for artists as a 'spectacle, in itself wordless, lacking a language, that requires others to define it'.[9] In the case of the works exhibited here, it is video images, installations, photographs and paintings that give expression to this attraction.

If, after making the observations above, we return to Martin and Miller's injunction to consider what is lost in the process of perception when in speaking about sports we try incessantly to verbalize something that at the moment of speaking about it is already past, then the exhibition, with its selection of artistic positions, demonstrates that contemporary art itself has developed methods and analytical approaches that make it possible to understand what gives sports their complexity. The various media available to contemporary art have made it possible to find a language for the sporting event in its contingency and performativity and to make its structures and strategies transparent.

1 Randy Martin and Toby Miller, 'Fielding Sport: A Preface to Politics?' in idem, *SportCult: A Cultural Politics Book for the Social Text Collective*, Minneapolis 1999, p. 12.

2 To give just a small selection: Walter Nowojksi, ed., *Der Kinnhaken: Sportgeschichten aus aller Welt*, Berlin 1993; Jan Philipp Reemtsma, *More than a Champion: The Style of Muhammad Ali* (trans. John E. Woods), New York 1998; Elfriede Jelinek, *Ein Sportstück*, Reinbek 1998; Nick Hornby, *Fever Pitch*, New York 1992; Antonia Logue, *Die Könige von Amerika*, Reinbek 2001.

3 Joyce Carol Oates, *On Boxing*, Garden City, N.Y. 1987, p. 8.

4 Ibid., p. 13.

5 Cynics might claim that South Americans enjoy no more authority than women do in the white Anglo-Saxon Protestant culture of the United States.

6 Oates 1987 (note 3), p. 9.

7 Ibid.

8 Before establishing her career as a feminist artist, Judy Chicago posed as a boxer for an ad in *Artforum* in 1970 in order to express her 'coolness' and to find acceptance in artists' circles in Los Angeles, which were said to be dominated by men.

9 Oates 1987 (note 3), p. 50.

GUSTAVO **ARTIGAS**

The Rules of the Game, 2000/01

Ralf Christofori

Gustavo Artigas' zweiteilige Videoarbeit *The Rules of the Game* schildert den Sport als eine besondere Art der Grenzerfahrung, wenngleich es darin um die Herausforderungen einer weniger körperlichen denn kulturellen Identität geht. Schauplatz der Arbeit *The Rules of the Game (Part 1)* ist der Ort Colonia Libertad in der Region Tijuana, Mexiko. Die Kamera verfolgt in langsamer Fahrt jene Mauer, die auf Initiative des US-amerikanischen Grenzschutzes entlang der mexikanischen Landesgrenze errichtet wurde. Direkt an der Mauer erscheint plötzlich eine weitere grün getünchte Wand, davor ein eingeebneter Platz, auf dem einige Jungs Pelota spielen. Ein kleiner Ball wird gegen die Wand geworfen, prallt zurück, um von einem anderen Jungen möglichst waghalsig wieder gegen die Wand geschlagen zu werden. Schließlich kommt es, wie es kommen musste: Der Ball fliegt über die Wand, über die Grenzmauer hinweg in Richtung Kalifornien und verschwindet dahinter. Ein paar der mexikanischen Jungs machen sich auf, über die Grenzbefestigung zu klettern, holen den Spielball und kehren zurück aufs Spielfeld.

Szenenwechsel. In *The Rules of the Game (Part 2)* verlegt Artigas das Spiel in eine Turnhalle. Es wird Fußball gespielt. Per Videoaufzeichnung beobachtet man »die Spieler beider Teams in ihrem Kampf miteinander«, mithin die »Figuration des Spiels« selbst, wie es Norbert Elias und Eric Dunning formulieren.[1] Nun wird diese Beobachtung in Artigas' Video erheblich erschwert, denn das Fußballspiel mit seinen Regeln und Spielzügen markiert darin nur ein mannschaftliches Aufeinandertreffen von zweien. Hinzu kommen zwei weitere Basketballteams, die wiederum nach ihren Regeln mehr oder weniger erfolgreiche Spielzüge durchführen. Der Künstler lässt alle Mannschaften auf ein und demselben Spielfeld gegeneinander antreten: Jedem Spiel ein Ball, rechts und links zwei Tore, direkt über den Toren die beiden Körbe, enthusiastische Fangruppen auf den Rängen.

Zur bloßen Figuration beider Spiele aber tritt in Gustavo Artigas' Projekt eine weitere, die weit über das bloße Aufeinandertreffen vierer Mannschaften hinausgeht. Denn mit der Wahl der Sportarten und der jeweiligen Teams bringt der Künstler unweigerlich ebenso politische wie kulturelle Motive ins Spiel. Die beiden Teams aus San Diego spielen Basketball, die aus Tijuana spielen Fußball. Wiederum kommt hier die beschriebene Grenzerfahrung kultu-

reller Identitäten und Identifikationen ins Spiel – Identifikationen, die nicht zuletzt in der Bedeutung der Sportarten selbst zum Ausdruck kommen. Denn während vom Fußball behauptet wird, er ginge auf ein Ballspiel der Mayas zurück, kann Basketball wohl als die US-amerikanische Domäne des Sports bezeichnet werden. Hier aber trifft nicht etwa der Underdog USA auf die Fußballnation Mexiko oder die Mexikaner auf die Basketballmacht USA. Stattdessen lässt Artigas die beiden Basketballteams aus San Diego gegeneinander antreten sowie die beiden Fußballteams aus Tijuana.

Mit dem Anpfiff werden die Spielzüge kaum noch beobachtbar, die Identifikation der Trikots wird zunehmend schwieriger. Als Beobachter sind wir nicht immer am Ball oder im Bilde. Eine Kamera verfolgt vom Spielfeldrand aus das Geschehen, eine weitere dokumentiert die Bewegungen von Ball und Spielern aus der Vogelperspektive. Artigas schneidet das Filmmaterial, spielt mit verschiedenen Kameraeinstellungen und Zeitlupenwiederholungen – insbesondere dann, wenn eine der Mannschaften einen Angriff erfolgreich abschließt. Das erwartbare Chaos bleibt indes aus, die Spieler und ihre Mannschaften versuchen Strategien, Spielzüge und Bewegungen möglichst kontrolliert zu organisieren.

Mag es auch schwer fallen, die Dynamik dieser Konstellation en detail zu verfolgen, so scheinen sich die Protagonisten doch auf ein bilaterales Arrangement geeinigt zu haben, um ihr Spiel überhaupt spielen zu können. Zwar fällt hie und da ein Tor, gelingt ein Korbwurf, es wird gekämpft und gefoult – das Geschehen auf dem Spielfeld aber offenbart sich dem Betrachter als eine Spannung, die jenseits von Rivalität, Konkurrenz und nationaler Identifikation aus den Konturen einer weitgehend egalitären Figuration erwächst. Dies umso mehr, als sich eine »Polarität zwischen freundlicher Identifikation und feindlicher Rivalität mit den Gegnern«[2] weder auf dem Spielfeld noch auf den Zuschauerrängen eindeutig ausmachen lässt. So begnügen wir uns schließlich damit, eine Art zweckfreier Dynamik zu beobachten, an deren Ende keines der Teams als Sieger vom Platz geht, keines sich geschlagen geben muss und alle Spieler – Basketballer wie Fußballer, US-Amerikaner und Mexikaner – einen Pokal überreicht bekommen.

1 Norbert Elias und Eric Dunning, »Zur Dynamik von Sportgruppen – unter besonderer Berücksichtigung von Fußballgruppen« (1966), in: dies., *Sport im Zivilisationsprozeß*, hrsg. von Wilhelm Hopf, Münster o. J., S. 109.

2 Ebd., S. 119.

The Rules of the Game, 2000/01

Ralf Christofori

Gustavo Artigas's two-part video piece *The Rules of the Game* characterizes sport as a special case of the experience of limits and frontiers, even though the artist is here concerned not so much with the challenge to physical capacities as with the challenge to cultural identity. *The Rules of the Game (Part 1)* is set in the village of Colonia Libertad in the Tijuana region of Mexico. The camera pans slowly along the barrier set up along the land frontier with Mexico by the United States Border Control. Suddenly there appears, directly next to this frontier marker, a second, green-painted wall, with a levelled square in front of it, on which a few youths are playing pelota. A small ball is thrown against the wall; it bounces back and is then hit back at the wall, as daringly as possible, by another youth. Eventually, the inevitable happens. The ball flies over the green wall, then right over the frontier marker and (heading in the direction of California) disappears behind it. Two of the Mexican youths proceed to climb over the barrier; they retrieve the ball, then come back to their playing field. A change of scene. In *The Rules of the Game (Part 2)* Artigas takes us to another arena: a sports hall. In this case we are watching a game of football. The video sequence is edited in such a way that we observe 'the players in both teams in their battle against each other' and, consequently, what Norbert Elias and Eric Dunning have termed the 'figuration of the game' itself.[1] In Artigas's video our observation of this aspect is, however, made considerably more difficult because the football game, with its rules and its particular characteristics, forces us to attend only to the encounter of one team with another. The football teams are, moreover, joined by two basketball teams, these too playing, with more or less success, according to the rules of their own game. The artist makes all the teams compete against each other on one and the same playing area, which serves as both football pitch and basketball court: in both cases there is a goal at each end fitted with a net; each game uses a ball; and each team is watched and supported by enthusiastic fans seated on the surrounding benches.

To the mere figuration of the two games, however, Gustavo Artigas's project introduces a further type of figuration, which goes much further than just the competition between the teams. For, in his very choice of types of sport and the teams engaged in each, the artist inevitably brings into play motifs that are essentially cultural and political. The two teams playing basketball are from San Diego, while the two playing football are from Tijuana. Yet again, we are confronted with the aforementioned experience of frontiers in cultural identity and identification – an identification that finds expression not least in the significance of the two types of sport. For, while it is claimed that football ultimately derives from a ball game played by the Mayas,

basketball is a sport undeniably associated with the United States. Here, however, we are not witnessing the footballers of the USA as underdogs in competition with the players of Mexico as a real nation of footballers; nor are we watching Mexican basketball players ranged against those from the USA as the indisputable Great Power of the basketball world. Instead, Artigas makes both of the basketball teams from San Diego and both of the football teams from Tijuana compete against each other.

When the starting whistle blows it becomes much more difficult to tell one game from another, and it is increasingly harder to tell the teams apart through their strip. As observers, we are not always in possession of the ball nor are we entirely in the picture. One camera records the action from the edge of the pitch/court; another adopts a bird's-eye view to document the movements of the ball and of the players. Artigas edits his footage, plays with a variety of camera positions and with repeating loops of film – in particular when one of the teams successfully executes an attacking manoeuvre. Yet the visual chaos that one might expect to result from such a procedure does not occur; for the individual players and their teams endeavour to keep their strategies, manoeuvres and movements under as much control as possible.

While it may be difficult to follow the simultaneous matches in detail, it appears that the protagonists have reached a bilateral agreement that each team be allowed to play its own game. Of course, now and again, someone scores a goal or gets a basket, there is a bit of a tussle and an occasional foul. But what is happening on the pitch/court is offered to the spectator as an exciting form of entertainment emerging from the contours of a largely egalitarian figuration that goes beyond rivalry, competition and national identification. This is all the more so in that neither on the pitch/court nor among the rows of watching fans can one detect a 'polarity between friendly identification and antagonistic rivalry with opponents'.[2] Ultimately, we are content here to observe a benignly 'aimless' dynamic, at the end of which no team leaves the field of play as a winner nor has to embrace defeat, and where eventually all the participants – basketball players and footballers, those from the United States and those from Mexico – find themselves in possession of a cup.

1 Norbert Elias and Eric Dunning, *Zur Dynamik von Sportgruppen – unter besonderer Berücksichtigung von Fussballgruppen* (1966), reprinted in: Wilhelm Hopf, ed., *Sport im Zivilisationsprozess*, Münster n.d., p. 109.
2 Ibid., p. 119.

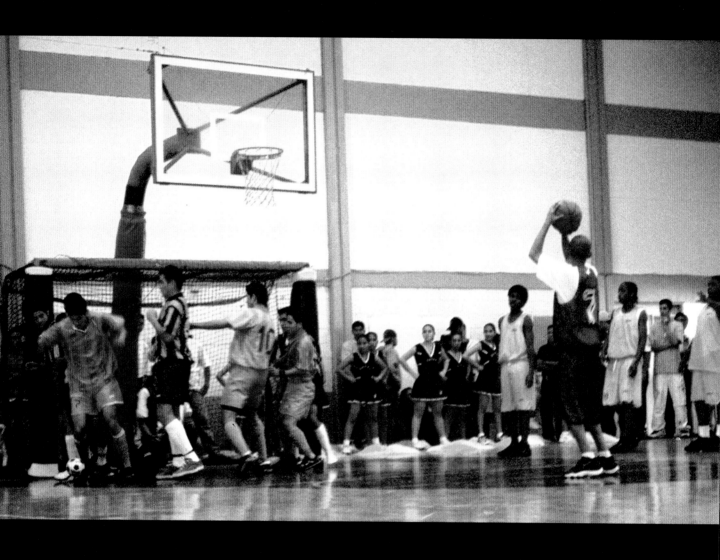

Gustavo Artigas | **The Rules of the Game** | 2000/01 | Videoprojektion/video projection | Courtesy Nina Menocal, Mexico City

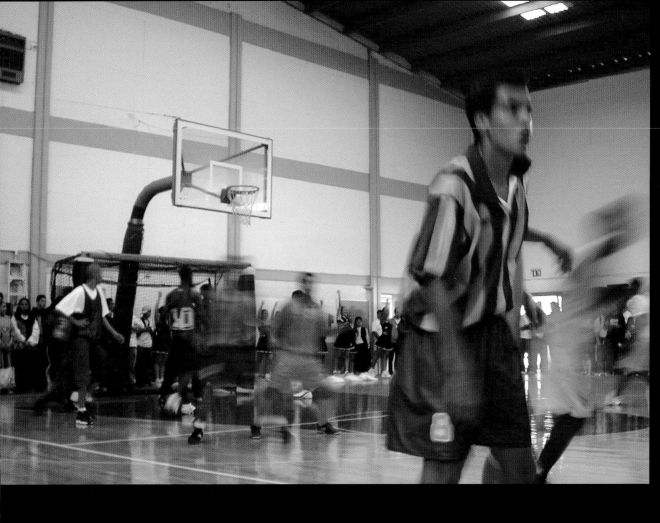
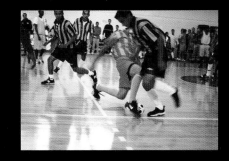

STEFAN **BANZ**

How Many Nights I Prayed For This,

1996 – 1998

Ralf Christofori

Es ist müßig, über Sinn und Unsinn jener Sportgeräte und Übungen zu streiten, zu denen wir allesamt im Zuge eines mehr oder weniger erfolgreichen Sportunterrichts verdammt wurden. Es gab immer diese Streber, deren Muskelkraft und Geschicklichkeit sie als erste auf die Sprossenwand oder das Seil hinaufhievten; und es wird immer die unsportlichen Nerds geben, die argumentativ versuchen, den gestählten Sportlehrer von der Vergeblichkeit eines solchen Bemühens zu überzeugen.

Vor Stefan Banz' Sportgeräten sind alle Streber, Nerds und Sportlehrer gleich. Niemand wird genötigt oder ermutigt, Feldaufschwünge zu kurbeln oder eine Kerze an den Ringen zu stemmen. Und kaum jemand wird sich freiwillig und auf eigene Gefahr an diese Reckstange hängen oder den ernsthaften Versuch unternehmen wollen, die Sprossenwand hinaufzuklettern. Banz' Geräte nämlich werden von Plexiglasquadern getragen, sind an einer Seite offen, wirken wie transparente Kabinen, in denen zumindest ein imaginärer Turner seine Übungen zur Schau stellen könnte. Die Ordnung der Dinge wird in Banz' Installation *How Many Nights I Prayed For This* (1996 – 1998) der Funktionalität eines ursprünglichen Verweisungszusammenhangs beraubt. Denn: Zieht man die Statik der Plexiglaskästen in Zweifel, so bleibt der Charakter musealer Vitrinenobjekte, der sogar dem banalen Sportgerät die Aura eines veritablen Artefaktes zu verleihen vermag.

Die Regeln des Spiels sind hier also offensichtlich andere. Sie leben nicht vom Vollzug, sondern in erster Linie von der Anschauung, Erinnerung und Vorstellung. In einem Selbstinterview erzählt Stefan Banz, sein Vater sei aktiver Kunstturner gewesen, sein ältester Bruder habe es in den sechziger Jahren gar in den Kader der Schweizer Kunstturn-Nationalmannschaft geschafft. Der 1961 geborene Stefan selbst scheint hingegen eher einer jener Schüler gewesen zu sein, die Spiele erfinden und deren Regeln bestimmen. Bereits im Alter von zehn Jahren hat er für die Kinder seiner Nachbarschaft »Olympiaden mit selbst erfundenen Disziplinen und Bewertungssystemen« veranstaltet, etwa zwei Jahre lang, immer während der Schulferien.[1]

Wenngleich Banz sich nicht genauer zu den erfundenen Disziplinen äußert, so führt diese biografische Notiz zumindest auf eine Fährte. Es scheint ihm nicht um das Spiel selbst zu gehen, sondern um die Regeln des Spiels. Wer sie aufstellt, sieht sich in die Lage versetzt, gewissermaßen auf einer vorsportlichen Ebene sein Talent einzubringen. Dass dieses Talent ein anderes ist als dasjenige, welches in Sportgymnasien, Bundesleistungszentren und ähnlichen Kaderschmieden gefördert wird, dürfte klar sein. Dass Stefan Banz dieses Talent auch und gerade im Hinblick auf seine künstlerische Arbeit stets aufs Neue unter Beweis stellt, davon zeugt sein vielseitiges Werk.

Es ist »das Phänomen der Realitätsverschiebung«, das Banz vornehmlich interessiert und an dem er sein Talent erprobt. Und zwar im Hinblick auf seine Malerei genauso wie unter Verwendung der Foto- oder Videokamera sowie in raumgreifenden Installationen. Die Perspektive Gullivers ist ihm dabei ebenso probates Mittel wie der voyeuristische oder privatistische Blick, den er in großformatigen Fotografien und Videoprojektionen ausbreitet. Im Rekurs auf E. T. A. Hoffmanns Erzählung *Des Vetters Eckfenster* konstatiert der Künstler: »Die Interpretation, die Reflexion oder die Wahrnehmung wird hier in vielfacher Weise als Realitätsverschiebung vorgeführt und in ihrer Relativität enthüllt.«[2]

Wer Realität solchermaßen verschiebt wie Stefan Banz, der versetzt die Parameter der bloßen Anschauung unweigerlich in Bewegung, denn Erinnerung wie Vorstellung schleichen sich in den interpretatorischen Rahmen ein, um die Relativität dieser Realitätserfahrung nur noch inständiger zu betonen. Dies genau ist in *How Many Nights I Prayed For This* der Fall. Indem Banz die Sportgeräte wie Vitrinenobjekte präsentiert, weitgehend haltlos in einem klar bezeichneten Ausstellungsraum, scheint alles auf eine besondere Anschauung hinauszulaufen, auf eine Begegnung ohne Vollzug. Hinterrücks aber schleicht sich die Erinnerung durch die offene Schauseite dieser Vitrinen, stellt eine Turnübung vor, und man hat Mühe, mit dem Schauen überhaupt nachzukommen.

Dabei wird der interpretatorische Spielraum dem Streber zweifelsohne andere Erinnerungen und Vorstellungen vergönnen als dem Nerd, der sich einmal mehr von der Absurdität und Vergeblichkeit sportlichen Bemühens überzeugt zeigen wird. Und doch sind, wie gesagt, vor Stefan Banz' Sportgeräten alle gleich. Weil eben die Regeln andere sind. Die Angst vor dem Feldaufschwung jedenfalls erweist sich als ebenso relativ wie der Ehrgeiz möglichst vieler Klimmzüge. So beschreiben Ehrgeiz und Ängste letztlich nur graduell unterschiedliche Valenzen innerhalb dieses fragilen, aber grundlegend egalitären Gefüges. Wer diese Realitätsverschiebung internalisiert hat, erweist sich als der wahre Meister aller Klassen.

1 Vgl. »Echos – Interview von und mit Stefan Banz. Ein Selbstportrait«, in: *Stefan Banz. Echoes*, Dallenwil 2000, S. 63 – 136.
2 Ebd., S. 101.

How Many Nights I Prayed For This, 1996–1998

Ralf Christofori

There is no point arguing about those pieces of sports equipment and exercises to which we were all condemned during games lessons at school. There have always been 'self-assertive' types, those whose muscle power and skill meant that they were always the first to heave themselves up the wall bars and the rope; and there will always be the nerds, those apparently lacking anything remotely resembling sportiness and who, by force of argument, attempt to convince the 'hard-as-steel' sports teacher of the pointlessness of any effort to change the situation.

Before Stefan Banz's sports equipment, however, assertive types, nerds and sport teachers are all equal. Nobody is forced or even encouraged to do pull-ups or perform a shoulder stand in the ring with arms akimbo. And few would risk the dangers involved in hanging on the horizontal bar, or would seriously contemplate voluntarily climbing the wall bars. Banz's equipment is made of plexiglas squares, which are open at the side and are like transparent cubes in which, at least, if nothing else, an imaginary gymnast could perform his or her exercises. In Banz's installation *How Many Nights I Prayed For This*, the order of things is robbed of the functionality of its original points of reference. As soon as one puts the static of the plexiglas boxes in doubt, what remains has the character of museum exhibits in display cases – which, in fact, lends the banal sport equipment the aura of a veritable artefact. Here, clearly, the rules of the game are different. They do not arise from being carried out but, first and foremost, from their being contemplated, recollected and imagined. In an interview Stefan Banz explains that his father was an active gymnast, while his elder brother succeeded in becoming part of the Swiss national artistic gymnastics team in the 1960s. Born in 1961, Stefan himself appears to have been one of those pupils who invent games and who define their rules. At the age of ten he was already organizing 'Olympic games with made-up disciplines and evaluation systems' for the children of his neighbourhood – something he did over a period of two years and always during the school holidays.[1]

While Banz does not provide us with more precise information regarding the games he invented, this biographical note at least points us in the right direction. It has less to do with the game itself than with the rules of the game. Whoever makes these rules sees him or herself to be in a position to introduce their talent, in one way or another, at the pre-sport level. That this talent is different to that promoted in gyms, national achievement centres and sports squads is clear. Stefan Banz continually puts this talent under scrutiny with respect to his artistic production, and the multi-faceted character of his work is testimony to this. What is of primary interest for Banz, and that against which he measures himself, is 'the phenomenon of shifting realities'. This is equally true of his painting, his photographic and video work, and his spatial installations. Gulliver's perspective is no less a familiar medium than the voyeuristic or private view, which he displays in large format photographs and video projects. With recourse to E.T.A. Hoffmann's story 'The Brother's Corner Window', the artist remarks: 'The interpretation, reflection or perception is presented as a reality shift in a plurality of ways and is revealed in its relativity.'[2]

Anyone shifting reality in the way Stefan Banz does inevitably shifts the parameters of mere appearance – since memory, like imagination, steals into interpretative frameworks in order further to emphasize the relativity of this experience. This is most certainly the case in *How Many Nights I Prayed For This*. In so far as Banz presents the sports equipment like objects in showcases, to a large degree without support and in a clearly labelled exhibition space, everything appears to amount to a particular view – to an encounter without completion. However, almost as if behind one's back, memory steals its way through the open viewing side of the showcase, presenting a gymnastic exercise, and it is indeed difficult for the viewer to keep up with the presentation.

Here, without doubt, the interpretative scope will provide the self-assertive type with memories and ideas that differ from those of the nerd who, yet again, will show himself convinced of the absurdity and futility of sporting activities. And yet, as has been said, before Stefan Banz's sports equipment, all are equal. It is because the rules are different. In any case, the anxiety surrounding the pull-up is shown to be just as relevant as the ambition to do as many pull-ups as possible. Thus, in the end, ambition and anxiety describe only partial valency within this fragile, though fundamentally egalitarian, structure. Whoever has internalized this shift of reality has shown himself to be the true master of all classes.

1 Cf. *Echos – Interview von und mit Stefan Banz. Ein Selbstportrait*, in Stefan Banz, *Echoes*, Dallenwil 2000, pp. 63–136.
2 Ibid., p. 101.

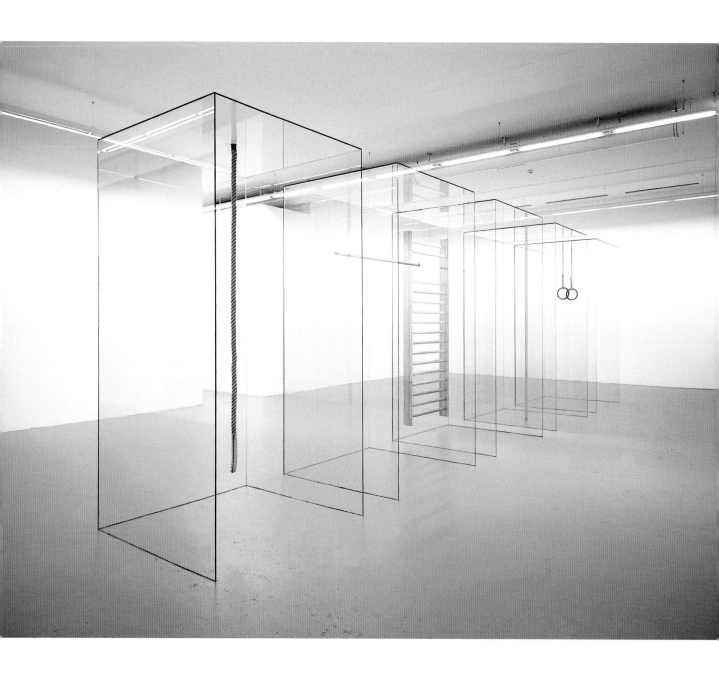

Stefan Banz | **How Many Nights I Prayed For This** | 1996–1998 | Glas | Gymnastikgeräte/glass | gym equipment | 300 x 150 x 950 cm | Kunsthaus Zürich,
Vereinigung Zürcher Kunstfreunde, Schenkung/gift of Friedrich Christian Flick

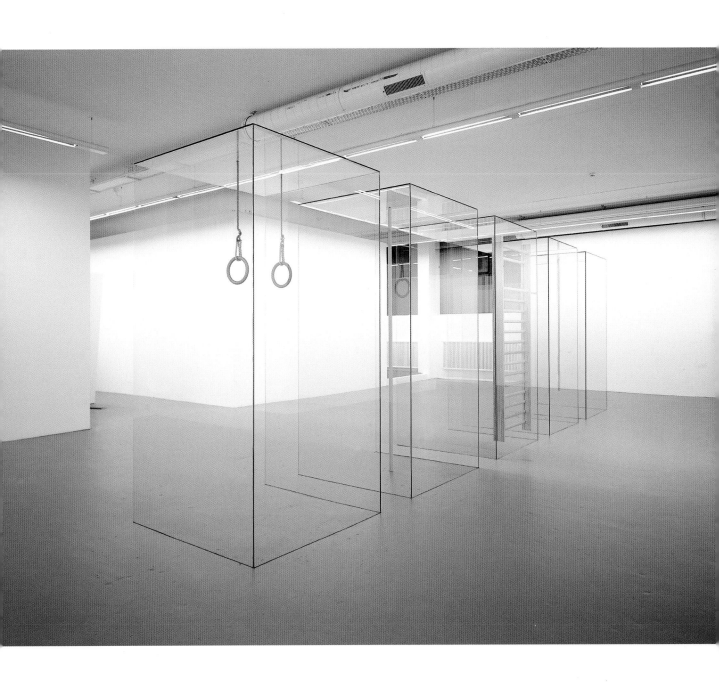

ANA BUSTO

Hannelore Paflik-Huber

Night Fights, 2000 / 2002

Boxen als sportliche Disziplin, die visuell den männlichen Körper in den Mittelpunkt stellt, fasziniert gegenwärtig immer mehr weibliche Künstler, wie etwa Marie Jo Lafontaine, Tamara Grcic oder Ana Busto. Im Vergleich zu den beiden ersten, die in ihren Videos vor allem das männliche Muskelspiel fokussieren, richtet die spanische Künstlerin ihr Interesse auf die Gesichter, die Hände und den Kontext des Kampfes. Nicht der Kampf als solcher steht im Mittelpunkt, sondern das zeitlich Vorangegangene des Dargestellten. Momente der hochentwickelten Inszenierung des Boxkampfes, die maximal zwölf Runden mit ihrer Dramaturgie, das Spektakuläre spart sie in ihren Arbeiten bewusst aus. Busto hält in ihren Videofilmen und Fotografien subtile, normalerweise nicht wahrnehmbare Nebenschauplätze fest.

Im Film *Night Fights* aus dem Jahr 2000 konzentriert sich die Kamera auf das Geschehen am Rande eines Boxrings, den Ana Busto in der Galeria Metronóm in Barcelona installiert, um dort eine Reihe von wirklichen Boxkämpfen stattfinden zu lassen. Wie der Titel sagt, finden die Kämpfe in der Nacht statt, als ob sie der dunklen Seite der menschlichen Psyche zuzuordnen wären. Das Publikum besteht aus Boxfans und Kunstinteressierten. So sind es neben impulsiven Reaktionen auch erstaunte und analysierende Blicke, welche die Kamera einfängt. Diese anfängliche Distanz der Kunstliebhaber und ihre eher skeptischen Blicke ändern sich im Laufe des Boxkampfes. Das Match fesselt auch sie immer mehr. So zeigt Busto durch ihre Kameraperspektive die Dramatik des Boxens, gespiegelt in der Mimik des Publikums. Die wenigen Aufnahmen, die den Kampf selbst zeigen, sind aus einer respektvollen Distanz aufgenommen. Sie zeigen keinen Faustschlag und kein K.o. Ana Busto konzentriert sich auf Aufnahmen, die für Fernsehübertragungen viel zu unspektakulär wären.

Für die Künstlerin steht die Tatsache im Vordergrund, zwei sehr unterschiedliche Bereiche einander gegenüberzustellen. Einer der wesentlichen Überschneidungspunkte sind die Reaktionen des Publikums selbst, die sie mit ihren subtil geführten Kameraschwenks einfängt. Dass sich die Erwartung der Künstlerin, die Betrachter mit ihren Arbeiten zu überraschen, erfüllt, wird in den Gesichtern des Boxkampfpublikums sichtbar. Beide Welten, die Kunstwelt wie die des Boxkampfes, wollen die Gefühle ihres jeweiligen Publikums ansprechen, nicht einen objektiven, neutral distanzierten Beobachter.

Am subtilsten sind Bustos fotografische Porträts, welche in ihrer Konzentriertheit als Statements zu lesen sind. Das Talent zum Boxen und die sich daran anknüpfende Arbeit hängen von vielen Komponenten ab, nicht nur vom Kraftaufwand alleine. So manifestiert sich die gesamte Bandbreite möglicher Emotionen in den Aufnahmen der Boxer nach dem Kampf: Ängstlichkeit, Selbstbewusstsein, Unsicherheit, Verletzbarkeit, Erschöpfung und Resignation. Es ist unwichtig, ob hier der Sieger oder der Besiegte festgehalten ist. Das einzelne Porträt stellt Busto in direkten Bezug zu den Händen der Boxer, die meist bandagiert gezeigt werden. Dagegen tragen die sensibel eingefangenen Gesichter in doppeltem Sinne keine Masken. Sie eröffnen den Zugang zu einer konkreten Person und nicht einem abstrakten Kämpfer.

Wie in ihrem Film, so eröffnet Ana Busto auch in der Fotografie einen Blickwinkel, der sonst in der medialen Präsentation des Sports ausgespart bleibt. Die Methodik, die sie anwendet, ist an das Medium der Kunst gebunden und nicht in Analogie zu den Mitteln des Sportes gesetzt. Busto lenkt den Blick dabei nicht nur auf eine bestimmte Wahrnehmungsform, sondern eröffnet viele verschiedene Perspektiven. Diese sind so angelegt, dass wir als Betrachter aufgefordert sind, die vorgegebene, während des Boxkampfes eingeschränkte Wahrnehmung zu erweitern.

Dabei stehen die fotografischen Porträts nicht isoliert. Busto ergänzt die Bilderzählung, indem sie einem offen dargebotenen Gesicht die Ansichten bandagierter und geschützter Hände hinzufügt. Am intensivsten ist die Verletzbarkeit der Kämpfer in den Aufnahmen visualisiert, welche die geschützten Genitalien der Männer zeigen. Ohne Schutz und ohne Masken kann ein Kampf nicht stattfinden. Sie markieren seine Grenzen und Regeln.

Mit *Night Fights* unternimmt Busto den Versuch, die Berührungsängste, die zwischen der Kunst- und der Sportwelt liegen mögen, aufzuheben, indem sie im Rahmen einer Galerie-Ausstellung eigener Fotos einen Boxkampf inszeniert. Wesentlicher Teil dieser Inszenierung sind die Kamerafahrten des Filmes entlang der Eingrenzung des Kampfringes. Die Porträts der Kämpfer bringen dabei eine ästhetische Formulierung ins Spiel, die eine sinnliche Erkenntnis anregt, welche nur so und unter diesen Bedingungen gemacht werden kann.

Night Fights, 2000/2002

Hannelore Paflik-Huber

Boxing – a sport that focuses attention on the male body – fascinates an increasing number of women artists, among them Marie Jo Lafontaine, Tamara Grcic and Ana Busto. In contrast to the first two of these – who, in their video pieces, focus above all on the play of male muscles – the Spanish artist turns her attention to faces and hands and to the context of the contest. Central to her work is not the boxing match itself but rather what has preceded it and what lingers in the minds of those who have watched the display. In her work she consciously eschews the most highly developed aspects of filmed presentations of boxing matches: the element of spectacle, with as many as twelve rounds and all the drama those rounds contain. Rather, in her videos and photographs Busto focuses her attention on subtle, and usually unnoticed, secondary aspects and processes.

In the film *Night Fights*, the camera concentrates on what is going on at the edge of the boxing ring – a ring that Ana Busto had installed in the Galeria Metronóm in Barcelona in order to stage a series of real boxing matches. As the title indicates, the fights took place at night, as if to suggest an association with the dark side of the human psyche. On account of the location, the crowd watching the matches consisted partly of boxing fans and partly of gallery visitors. Accordingly, the camera was able to capture both the spontaneous reactions of the former and the astonished and analytical expressions of the latter. Neither the initial disengagement of the art lovers nor their somewhat sceptical air survived for long, however; during the course of the fights the gallery visitors became increasingly thrilled and gripped by the action. Thus was Busto able to convey the drama of boxing as reflected in the facial expressions of the watching crowds, as captured by her camera. The few shots in which the camera is actually directed at the boxers are filmed from a respectful distance; and they do not record any punches or knock-outs. Ana Busto favours shots that would be far too unspectacular for a TV broadcast.

Above all, this set-up offered Ana Busto an opportunity to juxtapose two very different worlds. One of the most significant points of their intersection is to be found in the public's perception of the boxing match, which she is able to capture through her subtle camera work. The artist's expectation that she would be able to astonish the spectator with her work is confirmed by the faces of the crowd watching the boxing match. Each world – that of art and that of boxing – hopes to reach the emotions of its own public, neither of which is an objective, distanced or neutral observer.

Ana Busto is at her most subtle in her photographic portraits of individuals, which, on account of their degree of concentration, are to be read as conclusive statements. The talent to excel at boxing and the effort and work that this involves are dependent on many components, not only on the expenditure of strength. The entire gamut of emotions can be seen in the shots of boxers after a fight: anxiety, self-confidence, insecurity, vulnerability, exhaustion and resignation. It is of no importance whether a particular individual won or lost the match he has just fought. The individual portrait also places Busto in direct dialogue with the hands of the boxer, which are mostly shown with bandages. The sensitively captured faces are shown to be doubly unmasked. They allow us access to a real live person rather than merely the abstract notion of a fighter.

As with her films, Ana Busto's photographs open up a new perspective – one that we have not before encountered in the way sport is presented in the media. The attentiveness that she brings to her subject is structured in a way that connects it with the medium of art; it is not intended as an analogy with the points of view traditionally associated with sport. Nor does Busto employ one particular form of perception; rather, she opens up a diversity of possible perspectives. These are applied in such a way that we, as observers, are challenged to broaden the conventionally narrow parameters of perception that we bring to our actual viewing of the boxing match.

The photographic portrait is not an autonomous work, however. Busto supplements her visual narrative by adding to the openly offered face views of bandaged and protected hands. However, it is in those shots that show the boxers' protected genitals that the vulnerability of the fighters is conveyed with the greatest intensity. We recognize that no fight can take place without such protection and without masks. These stake out its limits and its rules. By staging a boxing match within a gallery exhibition of her own photographs, Busto attempts to remove the mutual fear that may be found to exist between the worlds of art and of sport. Central to the *Night Fights* installation is the footage filmed with the camera panning along the edge of the boxing ring. The portraits of the boxers, meanwhile, have more of an aesthetic dimension, appealing to the senses more directly than do other aspects of this work.

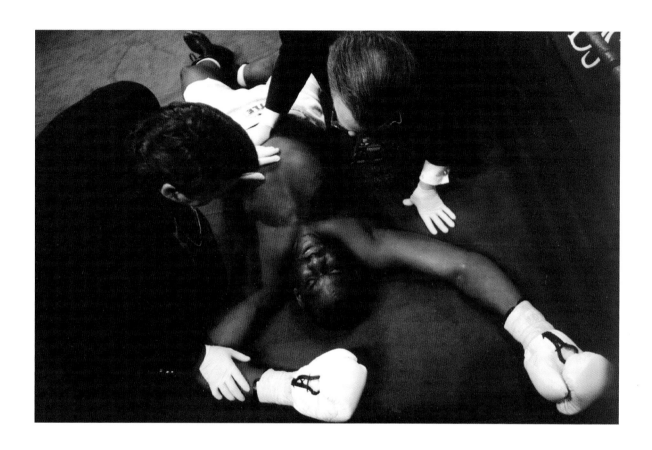

Ana Busto | **Night Fights** | 2002 | Fotografien/photographs | 200 x 150 cm

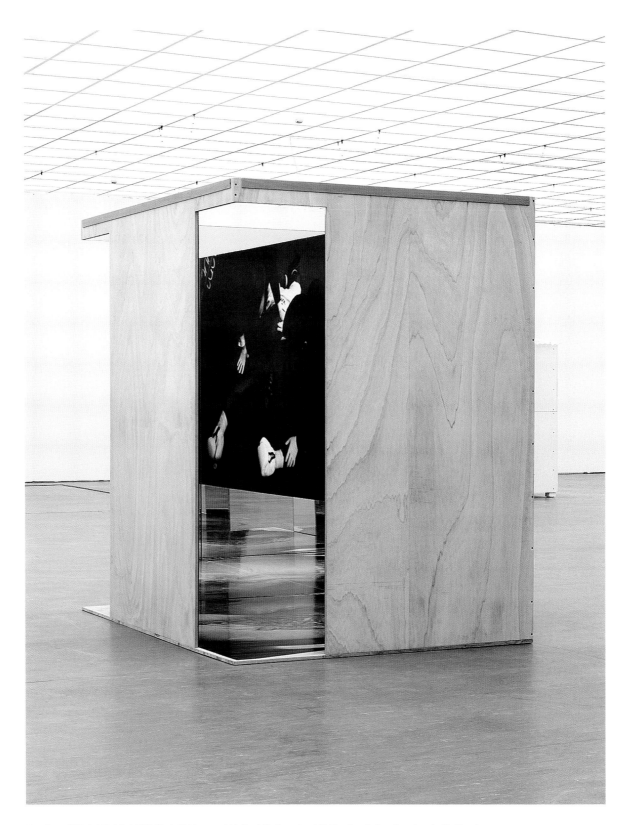

Ana Busto | **Night Fights** | 2002 | Installationsansicht / installation view, Württembergischer Kunstverein Stuttgart

GODFRIED DONKOR

Financial Times I – IV, 2002

Andrea Jahn

»Die Geschichte des Boxens – des Kämpfens überhaupt –
ist in Amerika die Geschichte des schwarzen Mannes.«

Joyce Carol Oates

Unter dem Titel *Financial Times* arbeitet der in Ghana
geborene Londoner Godfried Donkor seit Mitte der neunzi-
ger Jahre an einer Serie von Collagen, Gemälden und Sieb-
drucken, in denen er sich mit dem Motiv des Boxers aus-
einander setzt. Genauer gesagt sind es die schwarzen
Champions, die in seinen Bildern einen vorrangigen Platz
einnehmen: Muhammad Ali, Larry Holmes, Sugar Ray
Robinson und historische Gestalten wie Bill Richmond. Sie
erscheinen in Kämpferpose vor dem Hintergrund alter
Stiche von Sklavenschiffen, auf denen die zusammenge-
pferchten Körper von Menschen zu erkennen sind, die in
die Neue Welt verkauft wurden. In anderen Beispielen sind
es Stiche aus dem 19. Jahrhundert, die Gesellschaftsszenen
mit Schwarzen im kolonialen England wiedergeben und
der Figur des Boxers als Folie dienen.
Donkors Boxer stellen ihren nackten Oberkörper zur
Schau, spielen mit den Muskeln und zugleich mit der Auf-
merksamkeit der Betrachter. In Blick und Pose äußert sich
das Bedürfnis nach Anerkennung und Respekt vonseiten
des Publikums. Zugleich weckt ihr Imponiergehabe vor
dem historischen Hintergrund von Sklaverei und Diskri-
minierung Mitgefühl und relativiert die Klischees von Ma-
chismo und Kraftmeierei.
Dass Donkor gerade die Figur des Boxers auswählt, um den
Kampf der Schwarzen um Selbstbehauptung und gesell-
schaftliche Akzeptanz ins Bild zu setzen, hängt eng mit
den traditionellen westlichen Klischees von »schwarzer
Identität« zusammen, die in erster Linie über den Körper
definiert wird. Wenn Joyce Carol Oates schreibt, man könne

»Boxer mit Tänzern vergleichen: Beide ›sind‹ Körper und
nichts anderes«,[1] dann gilt dies in doppeltem Maße für den
schwarzen Boxer, der durch die faszinierende Besonder-
heit – man könnte auch sagen »Andersheit« – seines Kör-
pers für diskriminierende wie idealisierende Merkmale
schwarzer Identität und Vergangenheit steht. Doch statt
den Körper des Boxers zum Objekt des voyeuristischen
Blicks zu machen, durchkreuzt Donkor dieses Verfahren
zur Herstellung von Differenz, indem sich der Blick des
Betrachters direkt mit dem Blick des Boxers trifft. Donkor
zeigt ihn so in einer ambivalenten Position zwischen Sehen
und Gesehen-Werden und macht bewusst, wie unmittelbar
die Definition und Hervorbringung von Identität mit der
Kontrolle des Blicks verbunden ist.
Während Donkors Darstellungen durch ihre Entlehnungen
aus der Porträt- und Sportfotografie sowie ihren Bezug zu
historischem Archivmaterial zunächst etwas anachronis-
tisch erscheinen, so verdeutlichen sie auf den zweiten
Blick, wie differenziert der Künstler die Strategien der
Massenmedien einsetzt, um eben dieses dokumentarische
Material aus zwei unterschiedlichen Epochen miteinander
kurzzuschließen. In den meisten Fällen sind seine Bilder
von eher minimalistischem Charakter, mit wenigen Details
oder gar sichtbarem Pinselduktus. Die bisweilen etwas
ungelenk anmutenden Boxerfiguren sind häufig vor einen
monochromen Hintergrund gesetzt, der ihre zentrale
Position hervorhebt und die Aufmerksamkeit ganz auf ihre
Gestalt lenkt. Die historischen Motive, die in der unteren
Bildhälfte als Fonds eingezogen sind, ergänzen die erzäh-
lerische Pose des Kämpfers und betonen deren Ambivalenz
und Plakativität.
Donkor spielt diese plakative Wirkung in seinen Bildern
bewusst aus, um die Repräsentationsmechanismen trans-
parent zu machen, die das »schwarze« Subjekt in der west-
lichen Welt definieren – seien es alte Stiche oder Bilder aus
der Werbe- und Sportfotografie – was die Medien produzie-
ren, sind vor allen Dingen Klischees, die Donkor als histo-
rische Konstruktionen entlarvt. Ob seine Bilderfindungen
allerdings dazu beitragen, diese Stereotypen zu unterlaufen,
hängt sehr stark davon ab, inwiefern wir als Betrach-
ter bereit sind, eigene stereotype Vorstellungen zu über-
denken und uns auf einen unkonventionellen Umgang mit
Bildtraditionen einzulassen, die vordergründig vertraut
erscheinen, auf den zweiten Blick jedoch deutlich irritie-
ren.

1 Joyce Carol Oates, *Über Boxen*, Zürich 1987, S. 8.

Financial Times I – IV, 2002

Andrea Jahn

'In America the history of boxing – indeed, of fighting in general – is the history of the black man.'

Joyce Carol Oates

Since the mid-1990s Godfried Donkor, a London artist of Ghanaian origin, has been working on a series of collages, paintings and screen prints entitled *Financial Times*, in which he engages with the motif of the boxer. His principal subjects are, to be more precise, the Black champions of boxing: Muhammad Ali, Larry Holmes, Sugar Ray Robinson, as well as celebrated figures from the more distant history of the sport, such as Bill Richmond. He shows these men poised to fight, against backgrounds incorporating old engravings of slave ships, in which we can see, crammed together, the bodies of those Africans who were sold into slavery in the New World. In other works we find 19th-century engravings showing scenes from English society, in which the presence of Blacks alludes to English colonialism. These images serve as a foil for the figure of the Black man as boxer.

Donkor's boxers display their naked upper bodies, playing not only with their muscles but at the same time with the attention of the spectator. In their expressions, as in their poses, they evince a need for recognition and respect from the public. At the same time, given the historical background of slavery and discrimination, their attempt to impress arouses sympathy, and this in turn adds nuance and complexity to the cliché of machismo and strong-arm tactics.

The fact that it is the figure of the boxer that Donkor has chosen in order to illustrate the Black man's struggle for self-assertion and social acceptance is closely related to the conventional Western notion of 'Black identity' primarily defined in terms of the body. If, as Joyce Carol Oates observes, one can 'compare boxers with dancers: both "are" bodies and nothing else',[1] this is doubly true for the Black boxer, who embodies both the discriminating and the idealizing characteristics of Black identity and the Black past on account of the fascinating particularity – one could almost say 'otherness' – of his body. Yet, instead of making the body of the boxer into an object for the voyeuristic gaze, Donkor thwarts this procedure in order to establish a sense of distance: he has the spectator look the boxer directly in the eye. By this means, Donkor shows the boxer to be occupying an ambivalent position between seeing and being seen, and makes us aware to what extent the definition and accentuation of identity is directly connected with the control of the gaze.

While Donkor's portrayal of boxers, on account of the extent to which it draws on portrait and sports photography and incorporates historical archive material, may initially appear somewhat anachronistic, it nonetheless rewards closer attention in revealing how variously this artist employs the strategies of mass media to establish a provocative connection between documentary material from two distinct periods. In most cases these are images of a rather minimalist character, with few details or even visible brush strokes. The occasionally somewhat awkward figures of the boxers are frequently set against a monochrome background, which emphasizes the centrality of their positioning and makes them the focus of attention. The historical motifs that Donkor incorporates as backgrounds within the lower half of each image complement the narrative implications in the fighter's pose and underline its ambivalence and its element of bluff and self-promotion.

Donkor consciously plays up this aspect of his images in order to render transparent the mechanisms of representation that the media – be it old engravings or images from advertising or sports photography – have used in order to define the 'Black' subject in the West, and to show these mechanisms to be informed, above all, by clichés, which he in turn unmasks as historically conditioned constructions. Admittedly, whether or not Donkor's pictorial inventions will help undermine these stereotypes is very much dependent on how far we, as spectators, are ready to reconsider our own stereotyped conceptions and to embark on an unconventional engagement with pictorial traditions that are superficially familiar and yet are revealed, on deeper investigation, to provoke a strong degree of irritation.

1 Joyce Carol Oates, *On Boxing*, Garden City, N.Y. 1987, p. 8.

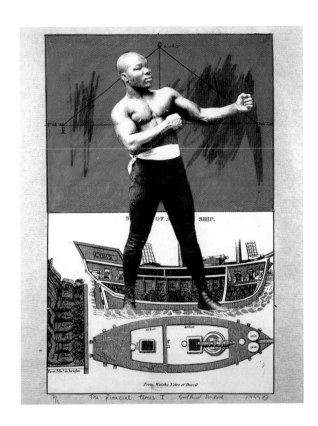

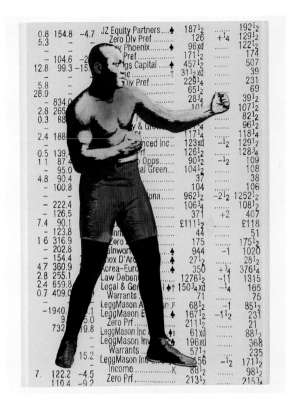

Links/left | Godfried Donkor | **From Slave to Champ IV** | 1998 | Mischtechnik auf Leinwand/mixed media on canvas | 59,4 x 84,1 cm
Rechts/right | Godfried Donkor | **Financial Times I – IV** | 2002 | Mischtechnik auf Leinwand/mixed media on canvas | 182 x 122 cm

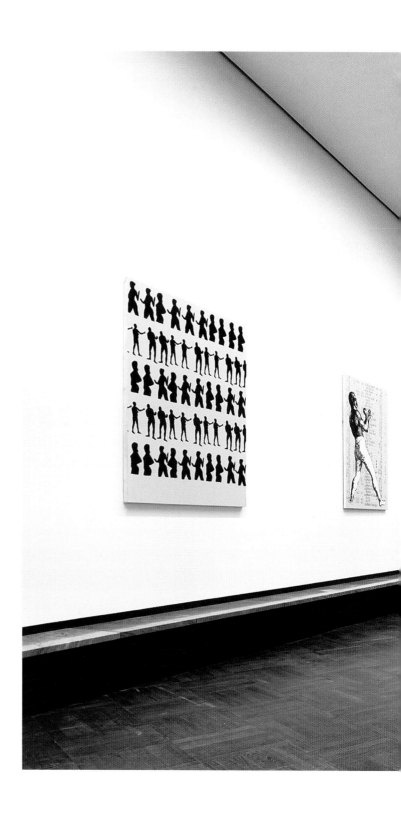

Godfried Donkor | **Financial Times I – IV** | 2002 | Mischtechnik auf Leinwand/mixed media on canvas | Installationsansicht/installation view,
Württembergischer Kunstverein Stuttgart

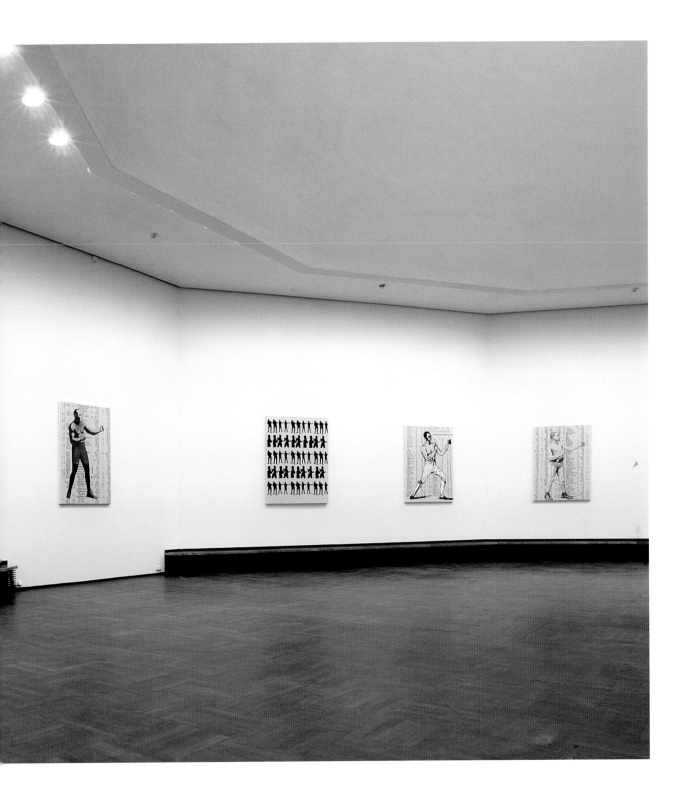

TAMARA GRCIC

Turf, 1999 / Let's Go, Let's Go, 2002

Andrea Jahn

»You don't watch video work, you coexist with it for a spell.«
Peter Schjeldahl

Überdimensional erscheinen die Ausschnitte der an uns vorbeiziehenden Pferdekörper aus dem Video *Turf* (1999), das Tamara Grcic in einer Reihe von sechs Projektionen auf einer 27 Meter langen Wand präsentiert. Zum Greifen nahe kommen uns die überaus ästhetischen, fast schon abstrakt anmutenden Oberflächen von frisch gestriegelten braunen, schwarzen oder fuchsroten Schultern und Flanken vor, deren Bewegungen die nervöse Anspannung erkennen lassen, die den Beginn eines Rennens bestimmt. Legt sich im ersten Bild ein Paar roter und schwarzer Zügel über einen dunklen Pferdehals, erscheinen im nächsten Stiefelabsätze und Steigbügel, die Hand eines Jockeys, der seinen Sattelgurt nachzieht, dann eine vorbeiziehende Hinterhand, deren muskulöse Struktur das Sprungpotenzial des Pferdes bereits erahnen lässt. Und immer wieder schweißglänzendes Fell, das durch die hervortretenden Muskeln und Adern Anstrengung und Erschöpfung auszuströmen scheint.

Ein Pferderennen dauert ungefähr zweieinhalb Minuten. Die Vorbereitungen, um dieser Belastung standzuhalten, finden – wie in jedem Leistungssport – außerhalb der Rennbahn statt und nehmen Jahre in Anspruch. Ein erfolgreiches Rennpferd ist im Grunde die perfekte Kreation wohlhabender und erfahrener Züchter und die Rennbahn ein probates Mittel, die Spreu vom Weizen zu trennen. Sie ist die Bühne einer Leistungsschau, auf der die Schönen und Reichen, die Buchmacher und Spieler sich ein Stelldichein geben, während Pferde und Jockeys als die eigentlichen Stars ihren Auftritt in nur wenigen Minuten absolvieren. Bei kaum einem sportlichen Ereignis spielt das Publikum eine so wichtige Rolle als Teil der Inszenierung wie im Rennsport. Dazu gehört auch die Begutachtung der Pferde im Führring vor und nach dem Rennen.

Doch während sich der kritische Blick dieses Publikums auf die Leistungsfähigkeit der Pferde richtet, konzentriert sich Tamara Grcics Aufmerksamkeit unmittelbar auf deren Körper. Sie legt ihren Blick gewissermaßen auf den Puls der Tiere und versammelt gerade durch eine statische Kameraperspektive und lange Einstellungen das gesamte Potenzial und die Dynamik des Geschehens, während sie das Rennen, das eigentliche Ereignis, ausblendet.

Wie die tänzelnden oder erschöpften Pferdekörper selbst, so folgen auch Grcics Aufnahmen einem unterschiedlichen Rhythmus, dessen Zusammenspiel wir nie als Ganzes erfassen können: Durch die Größe und Nähe der Projektionen wird unser Blick ständig von einem Bild zum anderen gelenkt, wandert und stößt so auf ästhetische Kompositionen, die sich spontan und subjektiv zusammensetzen. Das Surren eines arbeitenden Computers ist diesen Bildsequenzen unterlegt und begleitet die gleichmäßigen Muskelbewegungen der Körper. Die Künstlerin führt damit ein Moment der Distanzierung ein, macht die Konstruiertheit ihrer Bilder zum Thema und unterläuft zugleich deren naturalistische Qualität.

In ihrer jüngsten Videoinstallation *Let's Go, Let's Go* aus dem Jahr 2002 rekonstruiert Grcic die Situation eines Basketballspiels, bei dem sich das Publikum selbst mitten im Geschehen befindet. Die Installation besteht aus zwölf einfachen Holztischen, die über den Ausstellungsraum verteilt sind und einen oder zwei Monitore tragen. Auf jedem Bildschirm sind Ausschnitte von Basketballspielen zu sehen, an denen immer dieselbe Mannschaft mit Spielern unterschiedlicher nationaler Herkunft beteiligt ist.

Auch bei dieser Videoarbeit liegt Grcics Interesse in der aus dem Zusammenhang gelösten Bewegung und nicht im Ablauf oder den Ergebnissen des Spiels. Es sind nicht die Konstellationen oder Figurationen zwischen den Spielern, die für sie im Mittelpunkt stehen. Vielmehr sind es die Mimik, Gestik und Aktionen der einzelnen Spieler, die für kurze Zeit die Aufmerksamkeit der Kamera auf sich ziehen. Dadurch, dass es immer wieder dieselben Basketballer sind, die uns auf den verschiedenen Monitoren, in sich verändernden Spielsituationen und unterschiedlichen Trikots auftreten, kommen sie uns mit jeder Minute, die wir auf Grcics »Spielfeld« verbringen, bekannter vor und gewinnen an Individualität.

Anders als in *Turf* ist es nicht der Kamerablick, der uns unmittelbar an das Geschehen heranführt, sondern die Rauminstallation, die uns umgibt. Wie bei einem realen Spiel, in das wir zufällig geraten sind, stiftet die Anzahl der Bilder und Perspektiven zunächst Verwirrung. Und nur wenn wir anfangen, uns darin zu bewegen, unseren Blick von einem Spieler/Monitor zum anderen zu werfen wie einen Ball, gelangen wir selbst mit ins Spiel. Erst dann zieht uns die Arbeit in ihren Bann, und Peter Schjeldahls Verheißung vom kurzen Moment der Koexistenz zwischen Betrachter und Video scheint sich zu erfüllen.

Turf, 1999 / Let's Go, Let's Go, 2002

Andrea Jahn

'You don't watch video work, you coexist with it for a spell.'
Peter Schjeldahl

The video footage of horses' bodies moving past us – a series of six projections on a wall twenty-seven metres long, the work *Turf* (1999) of Tamara Grcic – seems larger than life. We feel that we could almost reach out and touch the extremely aesthetic, indeed almost abstracted surfaces of their freshly groomed brown, black or sorrel necks and flanks moving with that nervous tension that signals the imminent start of a race. In the first projection we see a pair of red and black reins placed across a dark horse's neck; in the next, boot heels and stirrups, the hand of a jockey tightening his saddle strap, and the hindquarters of a horse passing by, their muscular structure already an indication of an outstanding capacity for jumping. And, repeatedly, the horses' hides gleaming with sweat, their prominent muscles and veins telling of effort and exhaustion.

A horse race lasts around two and a half minutes. However, as with every competitive sport, the preparations – everything that has to be done to ensure a horse can take this strain – require years, and all take place away from the track. A successful race horse is, in essence, the perfect creation of wealthy and experienced breeders; and competition on the racing track is a proven means of separating the wheat from the chaff. It is the arena for a demonstration of peak performance, a gathering of the rich and beautiful, of bookmakers and gamblers; but the real stars, the horses and the jockeys, appear and then disappear in no time at all. In virtually no other sporting event do the spectators play so important a role in the setting as they do in the case of horse racing. Some of them, indeed, are more actively involved, being responsible, not least, for the expert appraisal of the horses in the paddock both before and after the race.

Yet, while the critical eye of the race-going public is focused on the capacities of the horses, Tamara Grcic's attention is directed exclusively at their bodies. She trains her eyes, as it were, on the animals' pulse points, absorbing through the long shots of a static camera the entire potential and dynamism of the event, while of the race itself she shows us nothing.

Like the horses themselves – which may be prancing or exhausted – the footage shot by Grcic also follows a varied rhythm, although we are never able to grasp it in its entirety. As a result of the size and proximity of the projections, our gaze is constantly drawn from one image to another; we thus may suddenly chance upon compositions that seem to come about spontaneously and subjectively. At the same time, the sequence of images and the views of the horses' regular muscle movements are shown to the accompaniment of the humming of a computer. By this means the artist introduces an element of alienation, acknowledging and accommodating the artifice in her images and simultaneously undermining their naturalistic quality.

In her most recent video installation, *Let's Go, Let's Go* (2002), Grcic effectively reconstructs a notional composite basketball game – one where the public finds itself at the centre of the event. The installation consists of twelve simple wooden tables placed around the exhibition space, each of them bearing one or two TV monitors. On each screen we can see footage of a basketball game in progress – always with the same team, with players of different nationalities. As with *Turf*, Grcic is concerned not with the course or the outcome of the game but with the continuity of the actions that have been set in motion. Her interest is not centred on the tactical formations adopted by the players but, rather, on the facial expressions, gestures and moves made by those individuals on whom the camera focuses for a moment. As it is always the same players that appear on the TV screens – albeit seen in different matches and wearing a variety of outfits – we feel that we know these better than the rest, that we have a stronger sense of them as individuals, and the more so the longer we spend on Grcic's 'playing field'.

Whereas in *Turf* it is the eye of the camera that takes us directly to the heart of the action, the result is here achieved through our own presence within the installation space. As if it were a real game into which we had wandered by chance, the sheer number of images and perspectives is initially bewildering. And it is only when we start to move within the installation and to cast our eye from one TV monitor to another, like a ball being tossed between the players, that we ourselves really become part of the 'game'. It is only then that this installation begins to cast its spell on us, only then that Peter Schjeldahl's promise of the short moment of coexistence between observer and video seems to be fulfilled.

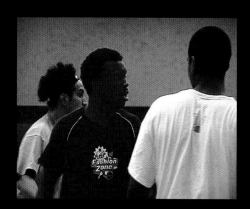

Tamara Grcic | **Let's Go, Let's Go** | 2002 | Videoinstallation/video installation | Courtesy Galerie Monika Reitz | Frankfurt am Main

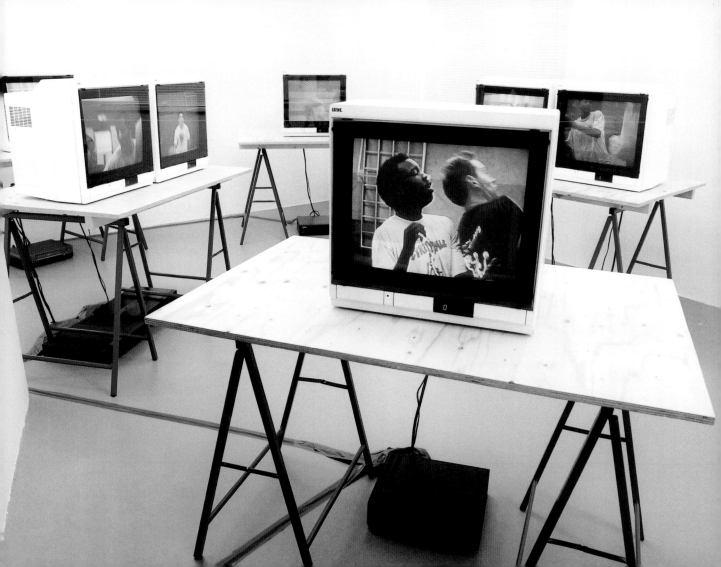

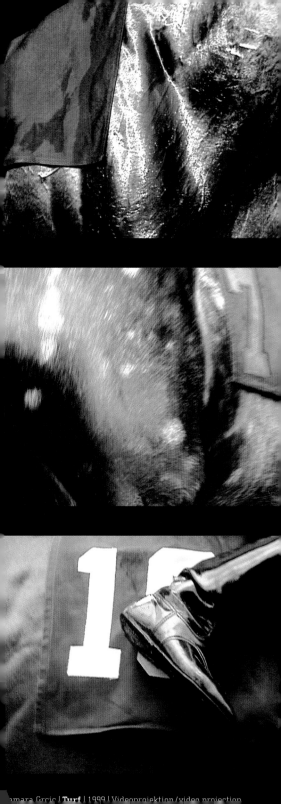

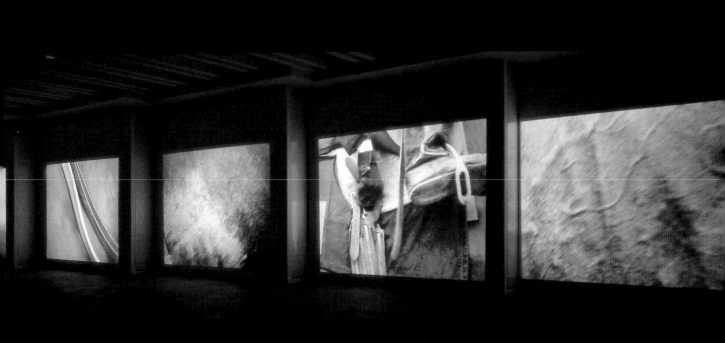

SATCH HOYT

The DonKingDom / In the Corner, 2002

Ralf Christofori

Satch Hoyts Arbeit *The DonKingDom / In the Corner*, die der Künstler erstmals im Kuppelsaal des Württembergischen Kunstvereins Stuttgart zeigt, transportiert nicht weniger als die Arena des Boxsports in den Ausstellungsraum. Im Zentrum steht ein Boxring in Originalgröße, eine erhöhte Bühne, von Seilen eingerahmt. Darin posiert eine Figur in abwartender Haltung, die Fäuste erhoben, um Schläge abwehren oder ebenso flink zuschlagen zu können. Wülste von Boxhandschuhen formen den unförmigen Körper dieser lebensgroßen Skulptur, von den Füßen bis zum zerknautschten Gesicht – auf den roten Handschuhen verheißt das Label »Everlast« eine Art programmatische Unbeugsamkeit. Als Besucher steigt man in den Ring, erhöht und allein gelassen mit diesem Monstrum, man nähert sich nur vorsichtig, schlägt verhalten zu, dann etwas stärker, gezielter, bis verschiedene Tonspuren einen besonders gelungenen Treffer anzeigen: Schläge ertönen, eine Glocke, der fordernde Beistand des Publikums. Muhammad Ali verkündet sein »I am the greatest«, Joe Louis die inneren Beweggründe seiner beruflichen Karriere: »I want to get ahead and be somebody.«

Satch Hoyts *The DonKingDom* kreist um die originäre Erfahrung einer Ambiguität, die die dunklen Seiten des Boxens mit glanzvoller Begeisterung konfrontiert und die Dichotomien von Sieg und Niederlage, Aggression und Fairness, von Ruhm und Macht Runde für Runde überhöht. Wer in den Ring steigt, wird damit geradezu physisch konfrontiert. Gegenüber dem Kontrahenten aus Boxhandschuhen jedenfalls fühlt man sich stark und ausgeliefert zugleich, man vermag sich die ganze Palette der damit verbundenen Selbst- und Fremdwahrnehmung zu vergegenwärtigen. Gleichzeitig aber handelt diese Installation vom nicht minder zwiespältigen Königreich eines der einflussreichsten Persönlichkeiten des Boxsports: vom Reich des Don King. »He is a ruler, a visionary, a percursor of his time«, so Hoyt, »an opportunist and a survivor who has rewritten the rules of the game, creating a ›kingsize‹ territory of wealth and influence with his charm, wit and clairvoyance.«[1]

Die offizielle Karriere des Box-Promoters Don King beginnt Anfang der siebziger Jahre. Im Rahmen einer Benefizveranstaltung für ein Krankenhaus in seiner Heimatstadt Cleveland heuert er 1972 einen Boxer an, der ihm fortan viel Geld, Ruhm und Macht einbringen wird: Muhammad Ali. Mehr als 500 WM-Kämpfe hat King seither organisiert und dirigiert, darunter den legendären »Rumble in the Jungle« zwischen Ali und George Foreman 1974 in Zaire. Neben Larry Holmes und Sugar Ray Leonhard nahm er Evander Holyfield und Mike Tyson in seine Obhut, fast 100 Boxer brachten es unter seinem Management auf mehr als eine Million Dollar Gage.

Mit seinen 70 Jahren ist King Celebrity, Bürgerrechtler und Wohltäter, alle Jahre wieder verteilt er Tausende von Truthähnen an die Bedürftigen im Land – in seinem Land. Don King weiß in den richtigen Momenten Shakespeare zu zitieren, gilt als außergewöhnlich intelligent, als Identifikationsfigur der Black-Power-Bewegung, nicht zuletzt als ein Exempel jenes steilen Aufstieges, der – so Kings Motto – »only in America« passieren konnte. Natürlich übergeht die offizielle Biografie jene Fama, die ihn neben sexueller Nötigung und anderer Delikte mindestens eines Mordes bezichtigt und die ihm die skrupellose Handhabung jenes Machtapparats vorwirft, der einzig darüber entscheide, wer wann Weltmeister werden dürfe. Der Phalanx seiner 100 Millionäre stehen mindestens ebenso viele Boxer gegenüber, die durch den Ring getrieben und anschließend von King über den Tisch gezogen wurden.

King promotet Boxkämpfe, »kanalisiert« Zorn und Aggression, lenkt sie auf sich, auf seine Helden und in die Bahnen eines medienträchtigen Auftritts. Er verkörpert eine boxende Leidenschaft, die sich so eigentümlich amerikanisch einzig per Faustrecht das verschafft, was einem gebührt. Dahinter aber verbirgt sich der nicht minder amerikanische Codex, demzufolge derjenige, der es geschafft hat – mit welch zweifelhaften Mitteln auch immer –, es offensichtlich auch verdient haben muss. Satch Hoyts Installation aber präsentiert diesen Codex nicht als verinnerlichte Anerkennung, sondern stellt ihn in seiner ganzen Ambiguität zur Disposition. Dass sein Boxer im Ring die schwarze Boxtradition repräsentiert, kommentiert die Gesetze des *DonKingDom* nur noch triftiger: Die Boxer selbst haben ausschließlich zu funktionieren.[2] Wir schlagen ein auf die knautschige Figur, ein linker Haken, ein »Jab« über die Schulter – die Skulptur steht und wehrt sich nicht. Hauptsache, die Show läuft. Und das Geschäft. Ja, es scheint, als hätten diese Helden wirklich groß zu sein nur in dem, was sie im Stakkato einer dumpfen »drum & bass line« gebetsmühlenartig wieder und wieder repetieren: »I am the greatest«, beteuert Ali ein letztes Mal – und referiert doch nur stellvertretend den Hoffnungsschimmer einer sich selbst erfüllenden Prophezeiung, die sich, wenn überhaupt, nur im Königreich Don Kings erfüllen kann.

1 Satch Hoyt, *The DonKingDom* (Projektbeschreibung), S. 9.
2 Ebd.

The DonKingDom / In the Corner, 2002

Ralf Christofori

Satch Hoyt's work *The DonKingDom/In the Corner*, which the artist is exhibiting for the first time in the Kuppelsaal of the Württembergischer Kunstverein Stuttgart, transfers nothing less than an entire boxing arena into the exhibition space. The centre of the space is occupied by a full-scale boxing ring – an elevated stage bound by ropes. A figure poses in the ring with upheld fists in a position of anticipation, ready to defend himself against the punches of his opponent or, conversely, to quickly respond with the same. Bulging boxing gloves form the unshapely body of this life-size sculpture, from the toes to the wizened and crumpled face – on the red gloves the label 'Everlast' promises a sort of programmatic endurance. As a visitor, one climbs into the ring, elevated and left alone with this monster; one approaches with caution, hits out with restraint, then a little harder and with greater precision until various soundtracks indicate a particularly good hit: the sound of punches resounds, a bell rings followed by the encouraging applause of the public. Muhammad Ali declares, 'I am the greatest'; Joe Louis explains the inner motivations of his professional career: 'I want to get ahead and be somebody.'

Satch Hoyt's *The DonKingDom* centres on the original experience of ambiguity that confronts the dark side of boxing, with glittering enthusiasm and the dichotomies of victory and defeat, aggression and fairness, fame and power repeated round after round. Anyone stepping into the ring thus feels him or herself to be physically confronted. In any case, when confronted with an opponent made of boxing gloves one feels both strong and vulnerable – capable of realizing the entire spectrum of self-perception and perception of the other. At the same time, this installation is also concerned with the two-sided empire of one of the most influential personalities in boxing: Don King. 'He is a ruler, a visionary, a precursor of his time', according to Hoyt, 'an opportunist and a survivor who has rewritten the rules of the game, creating a "king-size" territory of wealth and influence with his charm, wit and clairvoyance.'[1]

The official career of boxing promoter Don King began in the early 1970s. In 1972, as part of a hospital benefit event in his home town of Cleveland, he hired a boxer who, from then on, was to bring him wealth, power and widespread fame: Muhammad Ali. Since then, King has organized and directed over 500 world championship fights, among them the legendary 'Rumble in the Jungle' between Ali and George Foreman in 1974, which took place in Zaire. Alongside Larry Holmes and Sugar Ray Leonard, he took Evander Holyfield and Mike Tyson under his wing; overall he has managed almost one hundred boxers, each of them commanding fees of more than a million dollars.

Now aged seventy, King is a celebrity, civil rights campaigner and benefactor (every year he distributes thousands of turkeys to the needy of his state). He is someone who knows when to quote Shakespeare; considered extraordinarily intelligent, Don King is a figure the Black Consciousness movement identifies with and living proof of the kind of rapid rise to success which, in King's own words, 'could only happen in America'. Naturally, the official biography ignores the various defamatory rumours that surround him: rumours of sexual coercion and various other offences including at least one murder; accusations concerning the unscrupulous management of an apparatus of power that alone decides who may and may not become World Champion. In the shadow of his hundred millionaires there are at least as many boxers who have been driven through the ring and whom King has betrayed.

King promotes boxing events, 'channelling' anger and aggression and directing these towards himself and his heroes, creating a media-worthy presence. The passion for boxing that he embodies is expressed in a manner characteristic of the US, namely, according to the law of the jungle. Behind this, however, there exists the no less American unwritten rule that whoever manages to succeed must have clearly earned it – however dubious the means for achieving that success may be. Satch Hoyt's installation presents this unwritten rule not as something self-evident; rather, he introduces it in all its ambiguity. That his boxer in the ring represents the black boxing tradition is convincingly commented on by the laws of *The DonKingDom*: the boxers themselves simply have to function.[2] We hit at the crumpled figure, a left hook, a 'jab' above the shoulder; the sculpture stands and does not defend itself. The most important thing is that the show – and the business – goes on. Indeed, it would seem as if these heroes only intended to become big in what they repeat over and over again in a muffled, staccato, mantra-like 'drum & bass' line: 'I am the greatest', declares Ali for the last time – and representatively refers to the hope of a self-fulfilling prophesy, which is fulfilled, if at all, only in the kingdom of Don King.

1 Satch Hoyt, *The DonKingDom* (project outline), p. 9.

2 Ibid.

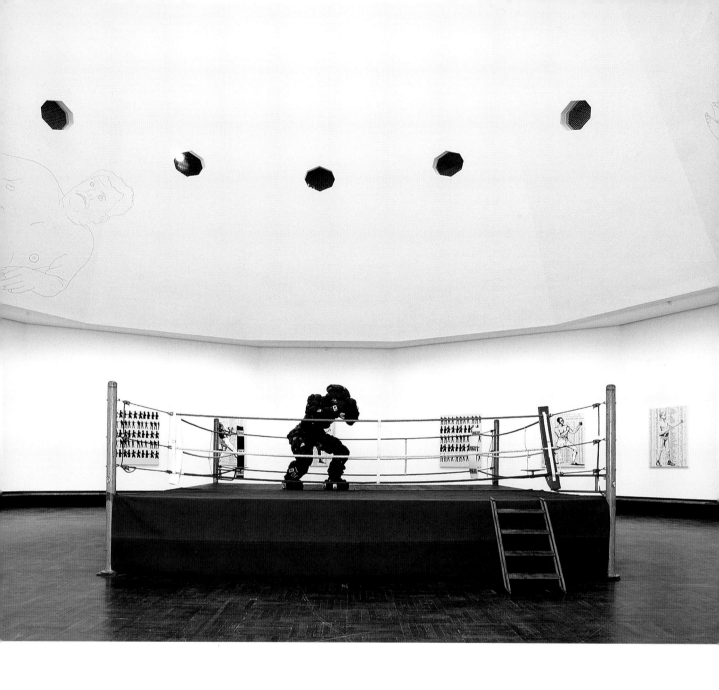

Satch Hoyt | **In the Corner** | Aus der Serie/from the series *The DonKingDom* | 2002 | Installation | verschiedene Materialien/installation | mixed media
Installationsansicht/installation view, Württembergischer Kunstverein Stuttgart

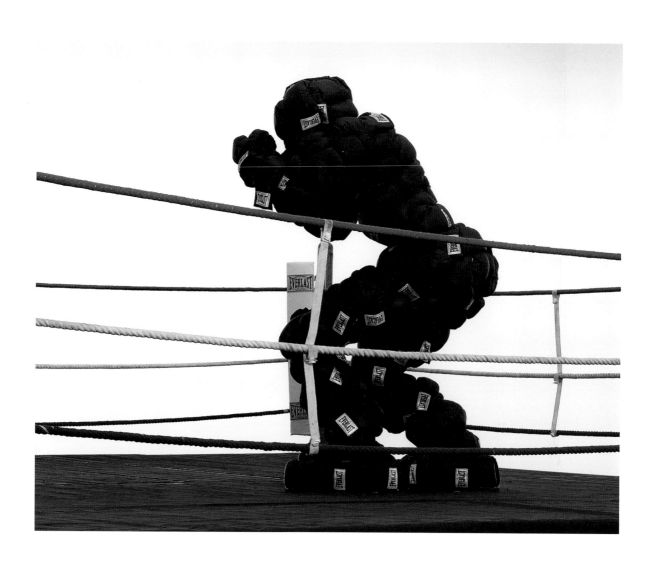

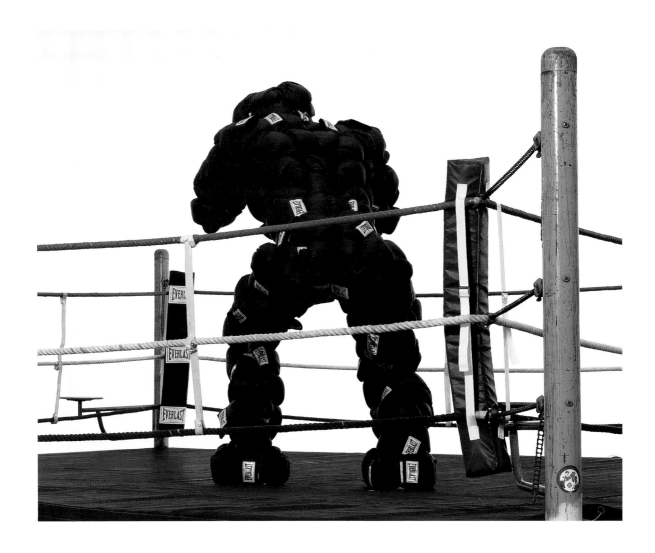

Satch Hoyt | **In the Corner** | Aus der Serie/from the series *The DonKingDom* | 2002 | Installation | verschiedene Materialien/installation | mixed media
Installationsansichten/installation views, Württembergischer Kunstverein Stuttgart

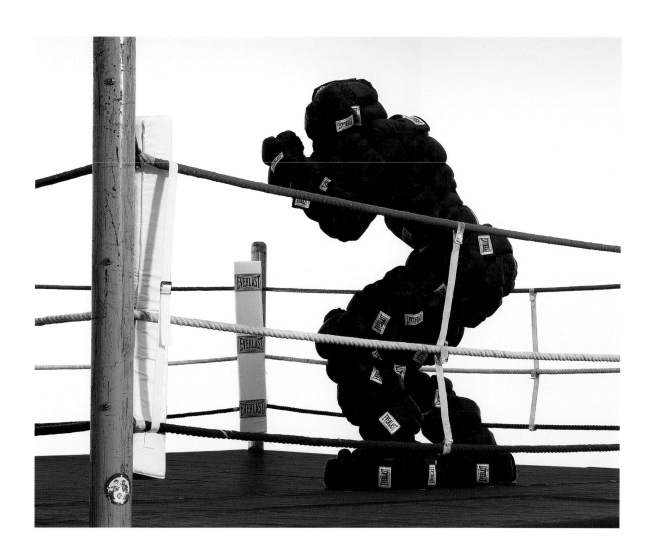

MICHAEL **JOSEPH**

Partners, 2002

Ralf Christofori

Michael Joseph gehört zu den wenigen zeitgenössischen Künstlern, die in der Auseinandersetzung mit dem Thema Sport ganz dezidiert auf Bilder verzichten. Gegenüber der Dominanz des Visuellen etabliert er Erfahrungsräume, die jenseits einer bloßen Sichtbarkeit besondere Formen der Aufmerksamkeit einfordern. In einer Performance etwa suchte er die unmerkliche Konfrontation mit fremden Personen in Fitness-Studios, indem er genau dieselben Übungen zu bewältigen versuchte wie diese. Der performative Aspekt dieser Arbeit vollzog sich gewissermaßen im Prozess selbst. Ob der Künstler mit seinen ausgesuchten Probanden mithalten konnte oder nicht – entscheidend war weniger die Motivation eines Wettstreites, sondern die einer »psychischen Erwiderung«, die sich für den Zeitraum dieser besonderen Konstellation einstellte.

Michael Josephs Klanginstallation *Partners* entstand aus diesem Projekt heraus. Diesmal widmet er sich den Geräuschen sportlicher Betätigung, wenn auch gerade nicht der tosenden Kulisse aufgepeitschter Fangruppen oder eines begeisterten Publikums. Joseph konzentriert sich wieder ganz auf den Einzelnen, und zwar in zweifacher Hinsicht. Sobald sich einzelne Besucher unter seinen trichterförmigen Parabol-Lautsprechern befinden, werden sie eingebunden in eine Art körperlicher Befindlichkeit, die gleichsam einen isolierten Raum markiert. Man hört, was alle anderen um einen herum nicht hören: Geräusche eines imaginären Gegenübers, das rhythmische Atmen eines Athleten, die gedämpften Geräusche einer Schwimmerin, die kaum vernehmlichen Laute während einer Yogaübung.

Man sieht sich eingebunden in den Erfahrungsraum einer fremden Person, wird hineinversetzt in eine imaginierte Präsenz, die dem Gehörten eine Atmosphäre, ein Körpergefühl abgewinnt, das durchaus visuelle und haptische Dimensionen erreichen kann. Dass das Hören unweigerlich Bilder erzeugt, davon handelt Josephs Anordnung nur am Rande. Weit mehr kommt in ihr ein Moment zum Tragen, das den Besucher einer unfreiwilligen persönlichen Konstellation überantwortet. Hatte Joseph in seiner Performance die Verbundenheit mit einem Gegenüber zunächst an sich selbst erprobt, so schafft nun die Klanginstallation Partners die »physische« Grundlage für eine »psychische Erwiderung« durch den Besucher.

So treffen zwei temporär isolierte Wesen aufeinander, treten in eine Beziehung. Man kann den Dialog erwidern oder sich ihm widersetzen. Man wird sich auf diese Situation einlassen oder wieder aus ihr heraustreten. Entscheidend ist nicht die eigentliche physische Reaktion, sondern eben jene »psychische Erwiderung«, von der bereits die Rede war. Im besten Falle ereignet sie sich als eine Form von Empathie, im Zuge derer sich die Besucher in den Bann ziehen oder vereinnahmen lassen – eine Empathie, die einzig auf der Basis akustischer Reize eine Befindlichkeit erwidert. Dass diese zum Ausdruck gebrachte Befindlichkeit eine betont körperliche ist, macht die Arbeit nur noch reizvoller.

Partners, 2002

Ralf Christofori

Michael Joseph is one of the few contemporary artists to have insistently eschewed images in his engagement with the subject of sport. To the dominance of the visual he opposes spaces of experience, and these demand particular forms of alertness that go beyond what is merely visible. In a performance piece, for example, he will endeavour to master the same exercises as someone else in a gym. In this way he will seek out and reveal the almost imperceptible confrontation that arises in such situations between individuals otherwise unknown to each other. The performative aspect of such a piece is in large measure exhausted by the process itself. Whether or not the artist is, on any given occasion, able to hold his own in his selected exercises, what matters is not so much the urge to compete physically as the need for the 'psychic response' that occurs during this particular situation.

Michael Joseph's sound installation *Partners* evolved within the context of the artist's performance project. On this occasion he explores the sounds of sporting activity – but he is far from being concerned with the roar of an excited crowd. Joseph once again focuses entirely on the isolated individual – in fact doubly so. As soon as the exhibition visitor stands under one of the artist's funnel-like parabolic loudspeakers, he or she is bound into a sense of the body's existing in a particular space, which is simultaneously demarcated as a form of isolation. The visitor can hear what those beyond this space cannot hear: the sounds made by an imaginary opponent, the rhythmic breathing of an athlete, the muffled sounds of a swimmer, the barely perceptible noises made during a yoga exercise.

The visitor sees him or herself incorporated within the space of another person's experience, transplanted into an imaginary presence, and the sounds experienced generate an atmosphere, a sense of the body that can attain a thoroughly visual and haptic character. But the fact that hearing inevitably generates images in the mind is secondary to Joseph's approach. Much more important is the element that provokes the visitor's sensation of being in a situation that he or she has not sought out. While Joseph, in his performance works, initially tried out for himself this form of connection with another person, the sound installation *Partners* now establishes the physical basis for a psychological response through the visitor.

Two temporarily isolated beings thus encounter each other, and enter into a relationship. The visitor can engage in dialogue or resist it. He or she can go along with this situation or withdraw from it. What matters is not the actual physical relationship but precisely the aforementioned psychic response. At best this comes about as a sort of empathy, as a result of which the visitor allows him or herself to be enchanted or taken in – an empathy that responds to a sense of being in a particular place that is itself based entirely on acoustic stimulation. The fact that this sense of 'being in a place' is an emphatically corporeal one makes this work even more fascinating.

Michael Joseph | **Partners** | 2002 | Soundinstallation/sound installation | Installationsansicht/installation view,
Württembergischer Kunstverein Stuttgart

ANTAL LAKNER

Ralf Christofori

INERS: The Power, 1998

»INERS is a tool, an instrument and a piece of sports equipment, an object of cultural criticism and a work of art, an entertaining workout machine, and anti-boredom advice. Unfortunately, it is impossible to pinpoint exactly what INERS is. You have to see yourself.«[1] In der Tat verschließen sich die Objekte Antal Lakners einer vordergründigen Benennung. Unter dem Label »INERS: The Power« entwickelte der ungarische Künstler in den vergangenen vier Jahren verschiedene Trainingsgeräte, die unterhaltsam, von augenzwinkernder Ironie und kritisch zugleich sind. Diese Geräte lassen nur einen einzigen Bewegungsablauf zu, und sie sind so konzipiert, dass die vorgegebenen Bewegungsabläufe handwerkliche Tätigkeiten simulieren. Es sind gewissermaßen Trockenübungen, die jenseits der bloß körperlichen Betätigung zu nichts führen.

Wallmaster (1998) etwa besteht aus einem zirka drei Meter hohen Metallgerüst, entlang dessen vertikaler Laufschienen eine blaue Walze bewegt werden kann. Über Seilwinden ist die Walze mit Gewichten verbunden, welche die Bewegung erheblich erschweren. Eine schwarz gummierte Bodenfläche schließlich markiert den Standpunkt des jeweiligen Benutzers, der diese Walze an einem langen Stab auf und ab bewegen soll. Der Aufbau entspricht exakt demjenigen eines Trainingsgerätes, wenngleich er in Funktion, Effizienz und Trainingsziel so gar nicht einleuchten mag. Simuliert wird hier das Streichen einer Wand, in gleichmäßigen Bahnen, immer an derselben Stelle. *Wallmaster – The Painting Bench*, so wirbt der Hersteller stolz, sei das klassische Modell der Firma, und er schildert die einleuchtenden Vorzüge des Produktes. »This machine enables you to practise using a paint roller without actually painting a wall. Consequently, neither will you get paint all over yourself, nor, in fact, use any paint at all! A single push is equal to painting about 0,8 square metres of wall surface. Its counterweight system makes it very easy to use. *Wallmaster* is the essential equipment for every home and professional gym. Maximum load: 10–25 kg. Recommended workout time: max. 6–8 hours. *Wallmaster* lets you build your arm muscles, triceps, leg muscles, and abdominal muscles.«[2]

In einem weiteren Modell der INERS-Produktpalette wird neben Armen und Beinen auch die Brustregion gestärkt: *Home Transporter* besteht aus einem gummierten Laufband, zwei polierte Metallrohre und ein an einem Gelenk fixierter blauer Zylinder bilden die funktionale Struktur eines Schubkarrens nach; die Wanne, in der ansonsten Altlasten oder Baumaterial befördert werden, ist ersetzt durch eine variable Verankerung, die man mit bis zu 50 Kilogramm Gewicht beladen kann. Laufgeschwindigkeit: drei Stundenkilometer, in regelmäßigen Abständen sollte eine Kippbewegung erfolgen. Als gänzlich »umweltfreundlich« erweist sich das Modell *Forest Master*, das sogar das Sägen in Zeiten allgemeinen Waldsterbens ethisch vertretbar macht. Der blaue Zylinder ersetzt hier einen kleinen Stamm, die Bewegung der Blattsäge verläuft innerhalb einer Metallvorrichtung, ein im Inneren des Zylinders befindliches Zahnrad erwirkt die nötige Kraftanstrengung.

Sämtliche der genannten Modelle entsprechen der gängigen Ästhetik von Trainingsgeräten, und sie verweisen auf die Absurdität tatsächlicher Fitnessstudios, in denen sich die Kundschaft reihenweise per Laufband, Rudergerät oder

Hometrainer dem eigentlichen Sinn solcher (Fort-)Bewe-
gungsabläufe entledigt. Lakner aber geht noch einen
Schritt weiter: Indem er nämlich den englischen Begriff
des »Work-out« unmittelbar an den zumindest im ökono-
mischen Primärsektor nach wie vor geltenden Begriff der
Arbeit zurückbindet, erhalten seine Geräte eine gleichsam
gesellschaftliche Relevanz. In der marxistischen Lesart
etwa könnte man diese Sportarbeitsgeräte als postindus-
trielle Substitute bezeichnen, die gewissermaßen den
Gipfel der Entfremdung bereits überschritten haben, um
die Produktionskräfte nur noch während der Freizeit per
Simulation spielen zu lassen. Umgekehrt hat Jean Bau-
drillard in einer geistreichen Argumentation gerade auf
die »Illusion der ›produktiven‹ Arbeit« hingewiesen, an
deren Stelle bereits während der industriellen Revolution
die verschiedenen Konturen der Reproduktion und Imi-
tation getreten seien. Gegenwärtig, so Baudrillards ab-
schließender Befund, sei »die ganze Produktionsordnung
[...] dabei, in die operationale Simulation umzuschlagen«.[3]
So scheint es nur konsequent, dass im Zuge einer »Fit-for-
Fun«-Euphorie die körperliche Arbeit ihren Sinn nur noch
im Selbstzweck körperlicher Be(s)tätigung sucht und fin-
det. Der Sport tritt an die Stelle nicht getaner Arbeit, wäh-
rend man die Ausübung eines körperlichen Zwecks – be-
ziehungsweise die Illusion darüber – an andere delegiert.
Wir lassen unser Haus streichen und stählen stattdessen
unseren eigenen Körper mit dem Wallmaster; wir bestellen
ein Fertighaus und bewegen abends auf dem Home Trans-
porter unsere steifen Glieder; wir kaufen Fertigholz im
Baumarkt und sägen am *Forest Master*, bis uns der Arm ab-
fällt. Was also könnte INERS sein? INERS ist ein Werkzeug,
ein Sportgerät, ein Artefakt. INERS ist ein Produkt – wenn
auch dieses Produkt weder massengefertigt noch weltweit
vertrieben wird. Bei den verschiedenen Modellen von
INERS handelt es sich um Prototypen, welche ihrerseits
das Produkt gesellschaftlich-kultureller Ideale sowie deren
Codierungen sind. Lakner greift diese Ideale und Codie-
rungen auf, um sie in ihren prägendsten Erscheinungs-
formen zu überhöhen oder ad absurdum zu führen. Wie
dies geschieht? – Sehen sie selbst, oder besser noch: Pro-
bieren Sie es aus!

1 Ágnes Berecz, »Man and Machine«, in: *Social Intercourse: Tamás
 Komoróczky, Antal Lakner*, AK zum Ungarischen Pavillon, Biennale
 di Venezia 2001, 49. Esposizione Internazionale d'Arte, S. 201.
2 Produktbeschreibung *Wallmaster – The Painting Bench*, zit. nach:
 ebd., S. 203.
3 Vgl. Jean Baudrillard, *Der symbolische Tausch und der Tod*,
 München 1991, hier insbes. S. 53 und S. 89.

INERS: The Power, 1998

Ralf Christofori

'INERS is a tool, an instrument and a piece of sports equipment, an object of cultural criticism and a work of art, an entertaining workout machine, and anti-boredom advice. Unfortunately, it is impossible to pinpoint exactly what INERS is. You have to see yourself.'[1] Indeed Antal Lakner's projects do not permit easy classification. Under the banner INERS: The Power, the Hungarian artist has over the years developed a range of training equipment that is at once entertaining, clever and critical. Each piece of equipment permits only a single sequence of movements, and these are designed in such a way that they simulate the prescribed sequence of movements of certain skilled activities. In some respects they are mock exercises that, beyond simple physical activity, lead nowhere.

Wallmaster (1998), for example, comprises a metal frame, about three metres high, with vertical running tracks along which a blue roller can be moved. By means of winches, the roller is connected to weights, which significantly impede movement. The user is supposed to stand on a black rubberized mat and move the roller up and down with a long rod. The structure corresponds exactly to that of a piece of training equipment, even though the function, efficiency and objective of the training is unclear. Rather, it is the painting of a wall that is simulated here – in even strokes, and always on the same place. According to the manufacturer's proud presentation, *Wallmaster – The Painting Bench* is the company's classic model. The clear advantages of the product are explained: 'This machine enables you to practise using a paint roller without actually painting a wall. Consequently, you will neither get paint all over yourself nor, in fact, use any paint at all! A single push is equal to painting about 0.8 square metres of wall surface. Its counterweight system makes it very easy to use. *Wallmaster* is the essential piece of equipment for every home and professional gym. Maximum load: 10 – 25 kg. Recommended workout time: max. 6 – 8 hours. *Wallmaster* lets you build your arm muscles, triceps, leg muscles, and abdominal muscles.'[2]

In another model from the INERS product range, the chest region is also strengthened alongside the arms and legs. *Home Transporter* comprises a rubberized treadmill, two polished metal tubes and a blue cylinder fixed to a joint, together forming the functional structure of a wheelbarrow; but the part of the wheelbarrow that normally transports waste or building material is here replaced by an anchor, which can take up to 50 kg in weight. Running speed is 3 km per hour; and at regular intervals a tipping movement should occur. A further model, the *Forest Master*, has proved itself to be extremely environmentally friendly: it manages to make sawing ethically defensible at a time when forests are dying out. Here, a blue cylinder is placed where one might expect a small log, and the movement of the saw takes place within a metal device. A cogwheel inside the cylinder generates the necessary degree of exertion.

In terms of aesthetics, all these models correspond to the appearance of current training equipment. They point to the absurdity of actual fitness studios, where large numbers of clients render meaningless the processes of moving on a treadmill, rowing machine or cross-trainer. Lakner goes one step further, however. In so far as he connects the

concept of 'work-out' directly with the concept of 'work' (at least in its primary economic sector), his equipment has a social relevance. In Marxist terms one might characterize these types of sports equipment as post-industrial substitutes which, in some respects, have gone beyond the peak of alienation so as to stimulate the play of the forces of production only during leisure-time simulation. Conversely, in an ingenious argument, Jean Baudrillard has pointed to the 'illusion of "productive" work', in place of which the various contours of reproduction and imitation have appeared during the Industrial Revolution. At present, according to Baudrillard's concluding analysis, 'here, the entire order of production [...] is transferred to operational simulation.'[3]
Thus, it is consistent that, in the context of today's 'Fit-for-Fun' euphoria, physical work finds its meaning only in the search for and discovery of physical confirmation as an end in itself. Sport appears at the place of work not yet done, whereas one delegates the exercise of a physical aim – or, rather, the illusion of it – to another. We have our house painted and steel our own body with the *Wallmaster*; we order a prefabricated house and in the evening move our stiff limbs on to the *Home Transporter*; we buy ready-made timber at the DIY store and saw on the *Forest Master*, until our arms drop off. So what could INERS be? INERS is a tool, a piece of sports equipment, an artefact. INERS is a product – even if this product is neither mass-produced nor distributed worldwide. The various INERS models are prototypes: they are themselves the product of socio-cultural ideals as well as their codification. Lakner takes up these ideals and codification, in order to intensify their most characteristic appearance or to lead them to their absurd conclusion. How does this happen? You have to see for yourself; or, even better, try it!

1 Ágnes Berecz, 'Man and Machine', in *Social Intercourse: Tamás Komoróczky, Antal Lakner* (exh. cat.), Hungarian Pavilion, Venice Biennale 2001, 49. Esposizione Internazionale d'Arte, p. 201.
2 Product description, *Wallmaster – The Painting Bench*, in ibid., p. 203.
3 Cf. Jean Baudrillard, *Der symbolische Tausch und der Tod*, Munich 1991, esp. p. 53 and p. 89.

Antal Lakner | **INERS – Wallmaster – The Painting Bench** | 1998 | Plakat/poster | 140 x 300 cm
Antal Lakner | **INERS – Home Transporter** | 1999 | Plakat/poster | 140 x 300 cm

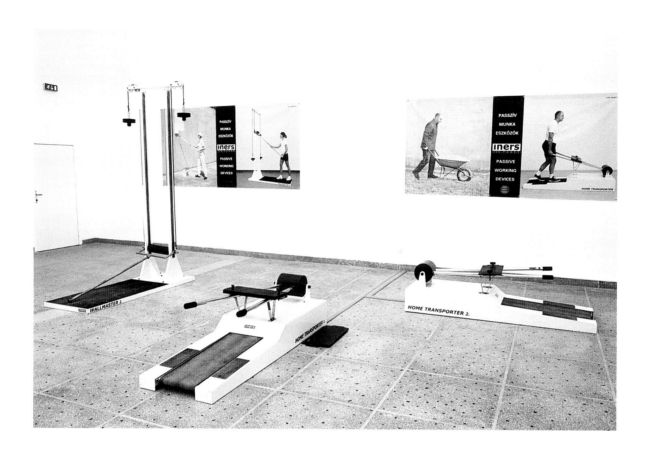

Antal Lakner | **INERS – The Power** | 2000 | Installationsansicht / installation view

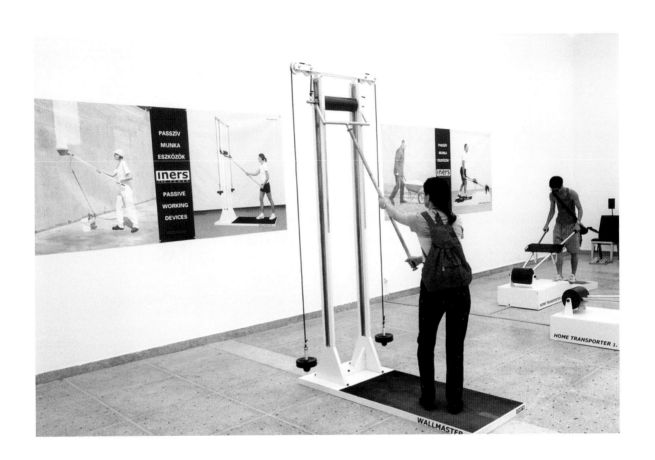

Antal Lakner | **INERS – Wallmaster – The Painting Bench** | 1998 | Metall, Gummi, Lack/metal, rubber, varnish | Installationsansicht/
installation view

JULIA LOKTEV

Press Shots, 2001

Rita E. Täuber

In Julia Loktevs Videoarbeit *Press Shots* scheinen Männer offensichtlich unter extremem Druck geraten zu sein. Bild für Bild zeigt sich die physiognomische Absorption körperlicher Bedrängnis, in der Lust und Schmerz kaum voneinander zu unterscheiden sind. Was sich aber zunächst wie eine psychologische Versuchsreihe mimischer Entgleisungen lesen lässt, stellt sich als natürliche Folge einer selbstauferlegten Kasteiung des Körpers dar.

Loktev platzierte ihre Kamera inmitten eines New Yorker Fitness-Studios, um sich dort, wo sich alles um den Körper dreht, ausschließlich auf das Gesicht zu konzentrieren. Ausnahmslos gilt dabei ihr Interesse Männern, die mit sklavischer Verbissenheit in der Smith-Maschine oder dem Butterfly an der Gestaltung ihres Körpers arbeiten. Immer mit derselben Kameraeinstellung, extrem nahsichtig und en face, ob Hispanos, Schwarze oder Weiße – die eindringlichen Momente entblößter körperlicher Grenzerfahrung gleichen sich. Denn Trainieren heißt Vergewaltigung, Folterung, Überwältigung des eigenen Leibes, heißt Wüten gegen das schwache Fleisch und gegen den sich in den Weg stellenden unwilligen Geist. Dabei bleibt die Sprache, respektive das Sprechen oder Sich-Äußern, das in der filmischen Arbeit Julia Loktevs ansonsten einen hohen Stellenwert einnimmt, ebenso ausgeblendet wie der Körper selbst. Das Ächzen, Keuchen und Stöhnen, das derart grenzgängerische Anstrengungen gewöhnlich begleitet, vollzieht sich allein im Kopf des Betrachters.

Diese lautlose Bildabfolge »leidgeprüfter« Physiognomien steht stellvertretend für die allgegenwärtige Präsenz und bedeutsame Rolle, die dem Körper in unserer modernen »Inszenierungsgesellschaft« zugewiesen wird. Denn obgleich dieser sich im Zuge einer digitalisierten Welt verflüchtigt hat, erscheint er als unumstößliches Fixum. Schon länger hat der Kult des Körpers den des Geistes abgelöst, sind Fitness und gesunde Lebensweise zu zentralen Werten geworden. Dass sich dabei mittlerweile auch die Männer mit den Zumutungen einer perfekten Körperrepräsentation konfrontiert sehen, ist jedoch eher neu.

Mit den Entwicklungen der modernen Lebens- und Arbeitswelt auf der einen und der schleichenden Transformation der Geschlechterordnung auf der anderen Seite geriet die Männlichkeit in eine offenbar selbst verursachte Krise: »Mit der Erfindung der Technik hat sich der Mann sukzessive selbst entmännlicht. Er hat Kraft, Stärke, Persönlichkeit, Autorität, Unverwechselbarkeit und Pioniergeist an immer effizientere Geräte und Instrumente delegiert.«[1]

Suchen die einen Auswege in konstruktiver Selbstkritik, finden die anderen im Fitness-Center zu einem neuen alten Selbstbild. Männermagazine und Ratgeber weisen den Weg, denn »Fitness«, so heißt es, »ist keine Domäne der Frauen mehr. Auch Männer wollen fit sein, denn mit Fitness verbinden wir außer körperlicher Leistungsfähigkeit und gutem Aussehen auch Gesundheit, Ausgeglichenheit und Erfolg.«[2]

Die gezielte Bearbeitung und Gestaltung des Körpers, seine Zurichtung auf ein ideales Maß hat also nicht mehr »nur« einen griechischen Athleten mit Waschbrettbauch und knackigem Po zum Ziel, der die Frauen in Entzücken versetzt und den Rivalen neidvolle Blässe ins Gesicht treibt. Als Mittel individueller Selbstvergewisserung und Medium der Selbstdarstellung gerät nun auch das wohlgeformte Äußere des Mannes zunehmend zu einem mehr oder minder verlässlichen Signum im Konkurrenzkampf um Anerkennung und Erfolg auf allen Ebenen.

Dass das Interesse Julia Loktevs in *Press Shots* aber gerade nicht dem konstruierten Körper, sondern der naturgegebenen Ausdrucksvielfalt des Gesichts gewidmet ist, lässt ein eigentümliches Paradox entstehen. Denn in dem Maß, wie diese Männer ihren Körper im Griff zu haben scheinen, geraten sie auch außer Kontrolle. Was somit auf einen allen gemeinsamen objektiven Nenner, ein künstlich erzeugtes stereotypes Ideal abzielt, entblößt Julia Loktev in den schmerzhaftesten Momenten äußerster Entgrenzung ein Maximum an Authentizität und damit individueller Differenz.

1 Walter Hollstein, *Nicht Herrscher, aber kräftig. Die Zukunft der Männer*, Hamburg 1988, S. 25.
2 *Body Fitneß für Männer. Mehr Power für Seele und Körper*, Köln o. J.: Rückencover.

Press Shots, 2001

Rita E. Täuber

In Julia Loktev's video piece *Press Shots*, men appear clearly under extreme pressure. In image after image we see evidence of the physiognomic absorption of physical distress, in which it is almost impossible to distinguish joy from pain. But what might at first be interpreted as a series of psychological experiments in mimicking derangement is soon revealed as a natural outcome of a self-inflicted castigation of the body.

Loktev set up her camera at the heart of a New York gym. Here, where everything is centred on the body, her aim was to concentrate exclusively on the face. Without exception, her interest is in the men who, with a servile doggedness, work on sculpting their bodies, on the 'Smith Machine' or the 'Butterfly'. With the camera always positioned in the same way, so that the subjects (Hispanic, Black or White) are viewed *en face* and in extreme close-up, the striking aspects of revealed bodily exertion come to resemble each other. Working out is shown to be a sort of violation, a torture, an overpowering of one's own body, a raging against the weak flesh and against the unwilling spirit that blocks the path to one's goal. Language (which, whether as speech or as expression, is an important aspect of Julia Loktev's other work with film) remains as sidelined as the body itself. The groaning, panting and moaning that usually accompany this sort of extreme exertion occur only in the mind of the spectator.

This series of soundless images of,'pain-proofed' physiognomies stands here for the ubiquitous presence and significance that the body has assumed in our contemporary 'staged society'. For, while it has in one sense vanished with the emergence of a digitalized world, it nonetheless appears in other respects incontestably here to stay. The cult of the body has long taken over from that of the spirit, and keeping fit and maintaining a healthy lifestyle have become key values. What is new, however, is that men, too, are now seeing themselves confronted with the expectation that they should possess and display a perfect body.

With, on the one hand, the recent developments in the way we approach leisure and work, and, on the other, the insidious transformation in gender relations, masculinity has entered into a seemingly self-generated crisis. As Walter Hollstein has observed: 'With the invention of technology, man has successively emasculated himself. He has delegated power, strength, personality, authority, uniqueness and the pioneering spirit to ever more efficient machines and instruments.'[1]

While some seek a way out through constructive self-criticism, others find their way to a new-old self-image at the gym. Men's magazines and other sources of advice point the way: 'Fitness', they say, 'is no longer exclusively women's territory. Men want to be fit too, for fitness is associated with physical ability and looking good, and health, a sense of balance and success'.[2]

Thus, the aim of the carefully targeted work-out and sculpting of the body, and its adjustment to match up to an ideal measure, is no longer 'only' to attain the physique of a Greek athlete with a flat-as-a-washboard stomach and a neat butt, a body guaranteed to provoke the admiration of women and turn rivals green with envy. As an expression of individual self-reliance and a medium of self-representation, the well-formed male exterior is now increasingly seen as a more or less dependable marker in the battle for recognition and success on all levels.

It is a somewhat curious paradox that the focus of Julia Loktev's interest in *Press Shots* is precisely not the constructed body but the god-given diversity of expression in the face. For, while these men appear to have their bodies under control, it is evident that, in another sense, they have lost control. By this means Julia Loktev reveals that within the struggle towards a universal objective denominator, an artificially generated stereotypical ideal, there is to be found, at the most painful moments of extreme exertion, a maximum of authenticity and thus of individual differentiation.

1 Walter Hollstein, *Nicht Herrscher, aber kräftig. Die Zukunft der Männer*, Hamburg 1988, p. 25.
2 *Body Fitness für Männer. Mehr Power für Seele und Körper*, Cologne n. d.; cited on back cover.

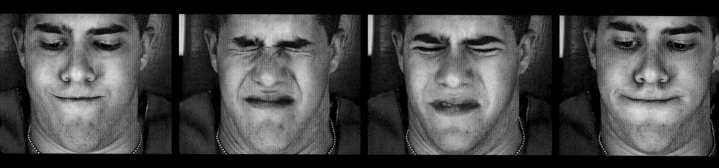

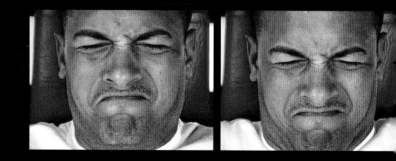

Julia Loktev | **Press Shots** | 2001 | Videoprojektion/video projection | Courtesy Galerie griedervonputtkamer, Berlin

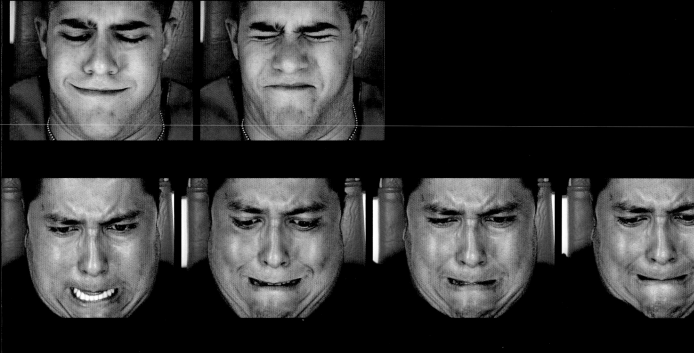
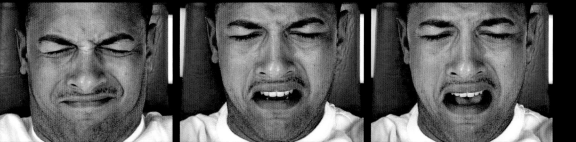

RUSSELL **MALTZ**

Reinhard Ermen

Ballpark XXX, 2002

Das Spielfeld ist grün, die Markierungen weiß. Russel Maltz nährt seine Arbeit mit Alltagserfahrungen und bewegt sich gleichzeitig im Rahmen einer autonomen Kunst. Damit kein Zweifel aufkommt, was gemeint ist, verweist der Serientitel eindeutig auf einen Kontext; das Betrachterauge geht im *Ballpark* spazieren, der sich durch die unmittelbare, auch ausgedehnte Gegenwart der unprätentiös gehandhabten Materialien als eine eigene Realität, als ein geradezu körperhaftes Gegenüber aufbaut. Doch das eben aktivierte Assoziationspotenzial wird in einem hochkonzentrierten Abstraktionsprozess, warum nicht: durch konsequente Formalisierung gleichsam kanalisiert. Hinzu kommt in vielen Arbeiten eine Anmutung des Ephemeren. In »stacks« organisiert, vielfach an die Wand gelehnt oder am Boden abgelegt, ja abgestellt, ist das eine Installation, die nicht für immer so dastehen will. Maltz intendiert beziehungsweise praktiziert eine lagerartige Situation, vorläufig wie ein Spiel oder eine Ausstellung.

Alles, was die Arbeit von Russel Maltz ausmacht, ist bereits angesprochen; der hochkonzentrierte Formalisierungsprozess, dessen Strategien ein Weiterdenken der konkreten Kunst meinen und eine Reflexion von Alltag, durch die tagtäglichen Realien des Hier und Jetzt, und das sind vor allen Dingen die Materialien, Glasscheiben, Verbundplatten, auch »Fundstücke«. Gearbeitet wird häufig vor Ort. Der Träger soll dabei nicht transzendiert werden, er bleibt, was er ist, mit all seinen natürlichen formalen Qualitäten. Die Verwundungen seiner Herkunft, wie Schnitte, gelegentlich auch Bruchkanten, werden nicht immer eliminiert. Russell

Maltz ist Maler! Die Malerei ist der Widerpart, den er wie einen breiten Streifen über den Träger zieht und ihn zum Bild macht. Maltz arbeitet mit Industriefarben, sieht man einmal von seinen empfindsamen Papierarbeiten ab, für die etwas andere Bedingungen gelten. Das unübersehbare »light orange« (orange lumière) war zeitweilig so etwas wie seine Lieblingsfarbe, wovon insbesondere das Projekt *Accu-Flo* zeugte: Das leuchtende Signalrot zog sich wie ein Ariadnefaden über alle nur denkbaren Träger und durch die Räume mehrerer Institutionen zwischen Berlin, Backnang, Otterndorf, Stuttgart, Ludwigshafen, Dortmund oder Basel, von 1994 bis 1999. Das Stapeln ist dabei konkrete Handlungsstrategie und überregionale Metapher zugleich. Das geschichtete Material (»stack«) wird zum akkumulierenden Gebilde, zum Sammelfeld expressiver, konkreter und assoziativer Energien. Bei Russell Maltz ist der »stack« Ergebnis und Ausdruck der sich ergebenden Schichtung, einschließlich der dabei akzeptierten, ja der gewollten Ungenauigkeiten.

Seit 1976/77 gibt es die *Ballpark*-Serie. Im Rahmen eines konzeptionell-konkreten Seriendenkens wird der grundsätzliche Kontrast von Grün und Weiß immer wieder aufs Neue dekliniert; ganz zu Anfang noch in Ölfarben. Das signalartige Gegensatzpaar nimmt zeichenhafte Züge an. Das Spiel meint den Ausgleich, das letzte und grundsätzlichste Kompositionsprinzip einer Kunst, die im eigentlichen Sinne nicht mehr »komponiert«. Wichtigste Orientierungshilfe ist die Horizontale, rechts und links von einer ideellen Mittellinie (oft genug der Punkt, an dem beide Farben sich begegnen) werden die optischen Gewichte platziert. Doch gibt es für *Ballpark* (und das gilt nicht nur für diese Serie) auch den Austrag von Grün gegen Weiß in einem Diskurs über Kreuz, wenn der Träger aus Glasscheiben besteht, deren Transparenz partiell ein offenes Schichten erlaubt. Das Auge folgt den gestaffelten Feldern durch die Trübungen einer matter werdenden Opazität. Die Mittelachse (die Rede ist von *Ballpark* IV, realisiert 1984 für die Gallery of Western Australia in Perth) springt von Glas zu Glas in der Tiefe, ein Feld fängt das andere auf. Es ergeben sich mehrere Horizontalen. Wenn das raue Drahtglas verwendet wird, erscheint die Transparenz wie vergittert, Assoziationen an Werkstatt und Industrie drängen sich nach vorn. Die Farbe schwebt. Das frei gelassene Glas vermittelt die Malerei leichter in den Raum.

Ballpark XXX, 2002

Reinhard Ermen

The sports field is green, the markings white. Russell Maltz approaches his work with the experience of the everyday and, at the same time, moves within the framework of an autonomous art. So that there is no doubt about what is meant, the title of the series clearly points to a context; the eye of the observer goes for a walk in the *Ballpark* which, through the direct and also extended presence of unpretentiously organized material builds on a physical counterpart. And yet, the newly activated associative potential is evenly channelled into a highly concentrated process of abstraction by a consistent formalization. Added to this, in many works we find the appearance of the ephemeral. Organized in 'stacks' leaned against the wall or laid on the floor, these installations are intended to be a process. Maltz presents a store-like situation; it is provisional, like a game or an exhibition.

Russell Maltz's work is distinguished by its highly concentrated formalization process, its strategies signifying a conceptual extension and reflection of the everyday. He does this by means of the day-to-day realities of the here and now, in particular materials – such as panes of glass, wooden plates and found objects. In most cases, work is carried out on site. The raw material is not modified in any way – it remains what it is, with all its natural and formal qualities. Faults, such as cuts or split edges, are often left as they are. Russell Maltz is a painter! The paint is the material counterpart, which is pulled over the material, like a broad strip and transforms it into a painting. As can be seen from Maltz's sensitive work on paper, he works with industrial colours, which are subject to different conditions. One of his favoured colours is an unmistakable light orange (orange lumière), as seen in the project *Accu-Flo*: from 1994 to 1999, the illuminated red signal, like an Ariadne leitmotif, appeared in every possible position and space at numerous institutions from Berlin to Backnang, Otterndorf, Stuttgart, Ludwigshafen, Dortmund and Basel. Thus, the stacking is both a concrete strategy of action and a trans-regional metaphor. The layered material becomes an accumulated structure for the collective field of expressive, concrete and associative energies. The 'stack' is the product and expression of the layering, and imprecision is acceptable – indeed, it is intentional.

The *Ballpark* series has existed since 1976/77. Within the framework of conceptually concrete serial thought, the fundamental contrast between green and white is repeatedly played through; at the very beginning, still in oil colours. The signal-like opposite pair assumes a symbolic character. The game signifies balance, the last and most essential compositional principle of an art that, in the real sense of the word, no longer 'composes'. The most important aid to orientation is the horizontal: the optical weight is placed to the right and left of an ideal centre line (frequently, the point at which both colours meet). There is also the contrast of green and white in a crossing discourse, if the 'plate' is comprised of panes of glass the transparency of which partially allows for open layers. The eye follows the layered fields through a clouded opacity, which becomes increasingly dense. In *Ballpark IV* (realized in 1984 for the Gallery of Western Australia in Perth) the middle axis jumps from glass to glass into the depths: one field catches the other. The result is a series of horizontals. When rough reinforced glass is used, the transparency is impeded and associations of workshops and industry are brought to the fore. The colour 'hovers' supported by stacks of wire glasses.

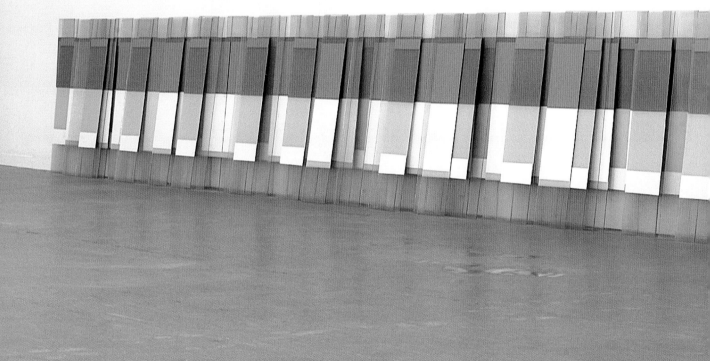

Russell Maltz | **Ballpark XXX** | 2002 | Glas, Emaillefarbe/glass, enamel | 40 x 185 cm (Glasplattenmaße/size of glass)
Courtesy Galerie Michael Sturm, Stuttgart | Installationsansicht/installation view, Württembergischer Kunstverein Stuttgart

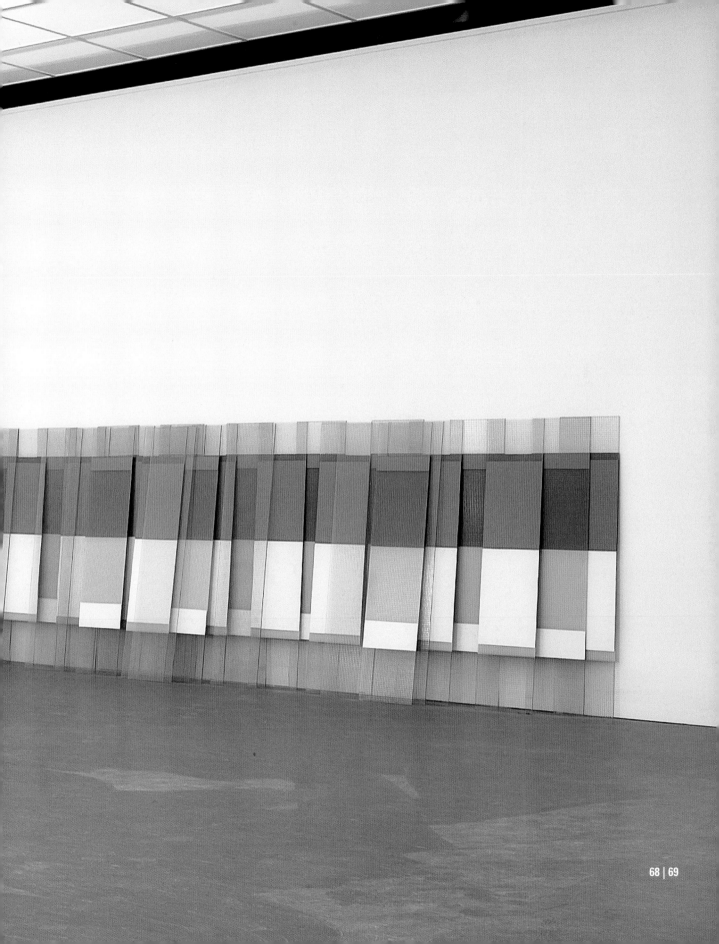

DIE SÜSSE

KUNST ZU VER-

Claudia Lüersen

LETZEN

»Adrian, ich verlange von dir nicht, dass du aufhörst, eine Frau zu sein, verlange auch von mir nicht, dass ich aufhöre ein Mann zu sein. Bitte.«

Rocky Balboa (Sylvester Stallone)[1]

»[…] nicht nur der Geschlechtsverkehr selbst ist harte Arbeit, sondern allein schon die Geschlechtlichkeit an sich.«

Andy Warhol[2]

Apropos Body Power: Für die Zurschaustellung der Dualität von Körperkraft und (Anziehungs-)Kraft des Körperlichen gibt es wohl keine geeignetere Bühne als den Boxring. Auch wenn es immer wieder boxende Athleten gibt, die Leichtigkeit, taktische Finessen und Eleganz ihres Sports betonen, wird das Publikum in erster Linie Zeuge dessen, was gezielt beschleunigte Körpermasse anrichten kann: die blutige Deformation des gegnerischen Körpers. Auch deshalb stellen die Faustkämpfe der »Super-Champions« im medialen Erregungsmassiv Sport die von keiner anderen Disziplin zu erreichenden Höhepunkte dar. Kein Sport hat mehr Mythen hervorgebracht, keiner ist männlicher. Bis zum Jahr Fünf vor der Jahrtausendwende ist das Boxen in Deutschland gar per definitionem eine »Zweikampfsportart von *männlichen* Partnern im Ring« (Offizielle Verbands-Wettkampfbestimmungen).

Doch was passiert eigentlich, wenn Frauen den Boxring betreten? Die Studie einer Autorin, die »habituelle Besucherin der Großkampftage im Madison Square Garden und mit der Boxhistorie von der Antike bis zu den modernen Gladiatoren vom Schlage eines Mike Tyson bestens vertraut«[3] ist, gibt Aufschluss: Joyce Carol Oates' Essay *Über Boxen*. Wer allerdings von Oates' Auseinandersetzung mit dem Boxkampf ein paradoxes, gebrochenes oder humorvolles Spiel mit männlichen Mega-Mythen, also die dekonstruktive Zersetzung durch den sprichwörtlichen weiblichen Blick erwartet, sieht sich enttäuscht. Die amerikanische Autorin blickt unverkennbar mit den Augen von »daddy's daughter« in den Ring, den sie als Kind schließlich an der Hand Ihres Vaters kennen gelernt hat. Oates ist Boxfan, ihr Essay strotzt vor Anekdoten und Zitaten rund um jenen Dreiminutentakt, in dem die »ideale Männlichkeit – ideal, weil unbewusst und selbstverständlich« (Oates, S. 57)[4] – sich entfaltet. In der lustvoll ausgebreiteten Materialfülle stellt Oates Zusammenhänge her, die zwar den Mythos nicht dekonstruieren, zur Analyse desselben jedoch überaus erhellende Einblicke liefern.

Hommage an die Unermüdlichkeit

Der Boxkampf, wie Oates ihn sieht, »spiegelt die kollektive menschliche Aggressivität, diesen sich durch die Geschichte ziehenden Wahnsinn, der ohne Ende ist« (Oates, S. 25). Der Faustkampf wird hier zur Metapher für das Leben als Existenzkampf schlechthin, er gerät zur Hommage an die Unermüdlichkeit: »Für die, die kämpfen …«, lautet die schlichte Widmung. Boxen ist für die Schriftstellerin kein Sport, denn es hat »grundsätzlich nichts Spielerisches, nichts Helles, nichts Gefälliges an sich« (Oates, S. 23). Diese proklamierte Enthebung der »sweet science of bruising« (die süße Kunst zu verletzen) aus dem sportlichen Kontext wirkt allerdings nicht ganz überzeugend. Sie widerspricht nicht nur dem legendären »Float like a butterfly, sting like a bee«, mit dem Muhammad Ali den Reiz seines Kampfstils zu charakterisieren pflegte, der sich gerade aus dem Kontrast zwischen spielerisch-tänzelnder Leichtigkeit und punktgenau zentrierter Schlagkraft speist. Auch die mythische Überhöhung einzelner Helden zu Projektionsleinwänden der männlichen Fantasie ist charakteristisch nicht nur für das Boxen, sondern für alle Varianten des Leistungssports, insbesondere für die Nationalsportarten. Den Legenden um Boxer wie Harry »die menschliche Windmühle« Greb oder Joe »der braune Bomber« Louis stehen jene um die Fußballhelden Matthias Sindelar, »der Papierene«, oder Pelé, »der schwarze Bomber«, in nichts nach. Überhaupt sind die kämpfenden Helden, von denen Joyce Carol Oates erzählt, einem Phänomen wie dem Fußballspieler Günther Netzer, der noch heute deutschen Intel-

lektuellen als Lieblingsmetapher für das Gute – also das Rebellische – im Mann dient,[5] viel näher als einem Boxer wie Henry Maske. Ex-Weltmeister Maske hat das Boxen stets mit dem Schachspiel verglichen, sich selbst als Strategen bezeichnet, der die davongetragenen Narben nicht als Trophäen schätzen mag[6] und sich folgerichtig als »Gentleman im Ring« vermarkten lässt. Der in der ehemaligen DDR aufgewachsene Maske ist aufgrund seiner spezifischen Biografie zum Zwangsprofi mutiert, entspricht jedoch viel mehr jenem Modell, nach dem auf Kuba die erfolgreichsten Boxamateure der Welt geformt werden. Es handelt sich um ein kollektives Modell, das Oates nun gerade nicht meint. Prototypisch wird ihre Vorstellung verkörpert in einem Boxer wie Mike Tyson: Er stammt »aus einer kaputten Familie in Brooklyn«,[7] er lispelt, beherbergt »in seinem muskulösen Hals die Stimme eines Kastraten«[8] und sitzt, bevor er sich zum zweiten Mal den Weltmeistertitel im Schwergewicht erkämpft, wegen Vergewaltigung im Gefängnis. Michael Gerard Tyson wird von ganz weit unten nach oben gemanagt von einem Mann, der sich wie kein Boxpromoter vor ihm als Zuhälter inszeniert: Don King. Der Ring das Bordell, der Körper die Ware, die Fans die Kunden und der Manager der Zuhälter. Es ist nicht schwer, eine allegorische Verbindung zwischen Boxen und Prostitution zu knüpfen.

Don Kings Reich

Der Künstler Satch Hoyt (vgl. S. 46) spinnt genau diesen Faden weiter: Im Zentrum seiner anspielungsreichen, interaktiven Installation *The DonKingDom* steht eine Skulptur, die von einer Schicht aus 150 roten Boxhandschuhen wie von überdimensionierten Blutergüssen bedeckt wird. Die Handschuhe stammen ausgerechnet vom Hersteller Everlast: Der Körper verschwindet, die Marke bleibt – der Boxsport ein korrumpiertes System, die Boxer reine Staffage. Ausdrücklich ist das Publikum eingeladen, die Helden eigenhändig zu demütigen. Den Besuchern werden Boxhandschuhe zur Verfügung gestellt, sie dürfen den Ring betreten und zuschlagen. So werden Ikonen künstlerisch trivialisiert.

Oates befasst sich nicht mit der korrupten Seite des Boxens, für sie ist der Faustkampf vor allem eine echte Chance für den sonst tellerwaschenden »isolato«, der sich als Profi in Handschuhen aus der Gosse hoch in den Ring boxen kann. Und weil sie mit dem Faustkampf den Amerikanischen Traum besingt, liest sich ihr Essay wie ein 122-Seiten-Song: »For somethin' that he never done/Put in a prison cell/But one time he coulda been/The champion of the world«, vertextete Bob Dylan das Leiden des Boxers Rubin Carter, genannt »Hurricane«. Diese Zeilen hätten auch von Oates stammen können, deren Botschaft sich schlicht zusammenfassen lässt: Boxen ist Rock'n'Roll – reine Männersache.

Boxer und Künstler im Trainingslager

Was nun reizt Künstler und Intellektuelle am archaischen Spektakel? Die Anziehung, die der Faustkampf etwa auf Jack London, Jonathan Swift, Marc Twain, Lord Byron, Ernest Hemingway, Norman Mailer oder auch Bertolt Brecht ausübt – Oates ist, wie es scheint, die einzige von diesem Sport faszinierte Schriftstellerin von Bedeutung –, erklärt die Autorin auf recht abenteuerliche Weise: Der Akt des Trainierens sei es, der Boxer und Künstler verbinde. Der Kampf im Ring sei vergleichbar mit der Veröffentlichung eines Buches. Diesen beiden Höhepunkten gehe eine »langwierige, mühsame, erschöpfende und oft zur Verzweiflung treibende Zeit der Vorbereitung« (Oates, S. 30) voraus. Fesselnd sei für Schriftsteller jene »Systematik, mit der man bei diesem Sport lernt, Schmerzen zu ertragen, um ein Ziel, ein Lebensziel, zu erreichen« (Oates, S. 31). Darüber hinaus handele es sich beim Boxen um ein stummes Schauspiel, das andere braucht, die es in Worte fassen. Hartes Training und Wortlosigkeit sind, das ist Oates entgegenzuhalten, wesentliche Komponenten aller Arten von Leistungssport. Die Radikalität, mit der eine erfolgreiche Turnerin oder Leichtathletin ihren Körper zu disziplinieren hat, steht der des Boxers in nichts nach. Was nun ist speziell am Faustkampf so inspirierend? Der Reiz liegt in der unverstellten Direktheit, mit der beim Boxen ge- und besiegt wird. Nirgendwo sonst hat der Sieg so direkt mit Unterwerfung, mit Knechtung des Gegners zu tun. Den körperlichen Triumph über den anderen begleitet dabei in einer Gesellschaft, in der Fortschritt immer »weg vom Hauen-ins-Gesicht bedeutet«,[9] eine zutiefst unkorrekte Note. Der Flirt mit dieser Unkorrektheit ist für die Intellektuellen auch in Deutschland spätestens seit der Weimarer Republik zur »Modernitäts-Pflicht« geworden.[10] Da es heute

besonders in bürgerlich-intellektuellen Kreisen wenig angesagt ist, sich zu identifizieren, zu siegen oder gar zu triumphieren, gelingt es trefflich, sich über das Bekenntnis, ein Fußball- oder Boxfan zu sein, mit einer angenehm politisch unkorrekten Note zu schmücken und sich als Über-Intellektueller mit einem Hang zum Trivialen zu profilieren. Und diese rebellische Profilierung »fühlt sich wirklich gut an« in einer Gesellschaft, in der Schlagen noch immer das Gegenteil von Denken bedeutet, weshalb der Intellektuelle einer »Ausgeschlossenheit aus der kodifizierten Welt des Boxens unterliegt, die fast so vollständig ist wie beispielsweise die der Frau« (Oates, S. 57).

Bertolt Brecht versuchte einst mit dem Wunsch nach einem Theaterpublikum, das dem von Boxkämpfen gleicht, sein gebildetes Stammpublikum zu brüskieren und sich auf die Seite der »richtigen Männer« und des Proletariats zu schlagen. Die Geste findet eine Verlängerung in dem Kinospot, mit dem Theaterintendant Leander Haußmann einst in Bochum ums gemeine Publikum geworben hat: Der von einem Bühnenakteur zitierte Klassiker »Nun steh' ich hier, ich armer ...« wird komplettiert durch einem Schnitt auf den laut »Tooor!« schreienden Fanblock des VfL Bochum.

Kein Glamour, nirgends

Für die Umkehrung dieser Versuchsanordnung hat sich die Künstlerin Ana Busto (vgl. S. 30) entschieden: Sie bringt das Boxen zum Kunstpublikum. 1999 organisiert sie im Rahmen ihrer Aktion *Night Fights* erstmals Amateurboxkämpfe in einer Kunstgalerie in Barcelona. Im Publikum treffen »echte« Boxfans, die ganz offensichtlich nicht an der künstlerischen Dimension des Projektes interessiert sind, auf jene, die in erster Linie genau diese Dimension anzieht. Oder spielt auch beim Kunstpublikum die Lust am Spektakel eine entscheidende Rolle? Die selbstreflexive

Frage »Warum bin ich hier?« wird künstlerisch provoziert durch Wandspiegel, mit denen Ana Busto zwei Jahre später ihre Installation ergänzt. An der »reinen« Intention der Kämpfenden will die Künstlerin jedenfalls keinen Zweifel aufkommen lassen: An den Wänden um den Boxring herum hängen stark vergrößerte Fotografien von Boxern außerhalb des Rings, oft Großaufnahmen von Gesichtern und Händen. Der Betrachter blickt in zerschundene, blutende Antlitze, auf bandagierte, von Schwielen bedeckte Hände. Kein Glamour, nirgends. Das Boxen der Amateure ist harte Arbeit, findet abseits des medialen Rampenlichts statt, und als Lohn winkt kein Reichtum, sondern bestenfalls Ehre und bescheidener Ruhm. Derartiges sportliches Tun hat ganz offensichtlich nichts mit dem Fetisch der Effizienz einer funktionierenden Leistungsgesellschaft zu tun. Das Boxen verlangt von den Amateuren nahezu bedingungslose Leidenschaft und Hingabe – und genau diese Eigenschaften machen die auf den Fotos fast versehrt wirkenden Boxer zu Außenseitern. Berechnung, so die unterschwellige Message der Installation, kommt erst dann ins Spiel, wenn die Athleten ins Profilager wechseln. Die Beschaffenheit dieses profitablen Systems wird von der Künstlerin gebündelt in dem einzigen großformatigen Bild in der Reihe. Darauf ist eine gepflegte Hand zu sehen: die des Boxpromoters und Managers Don King, der – goldberingt – ein Ringseil fest im Griff hat. Es ist sicher kein Zufall, dass neben Satch Hoyt auch Ana Busto Don King als Symbol für Geld- und Geltungssucht nutzt. Schließlich ist die King'sche Selbstinszenierung plakativ und im Vergleich zu seinen im Hintergrund agierenden Kollegen transparent und – »ehrlich«. King ist quasi der personifizierte (Kinder-)Traum vom goldenen Mercedes, mit dem der Underdog, wenn er »es« denn geschafft hat, vor der Wohnung seiner Mutter vorfährt.

Es ist nur konsequent, dass sich Busto beim weiteren Ausloten der unprofitablen Niederungen des Boxsports so weit wie möglich vom Profilager entfernt. Die Künstlerin ist nach Kuba gereist, in ein Land, in dem ausschließlich Amateure kämpfen. In ihrem 2001 erstmals ausgestellten Ensemble *La Escuela Cubana de Boxeo* (Die kubanische Schule des Boxens) spitzt sie ihre künstlerische Position zu. Wieder prangen großformatige Bilder, diesmal kubanischer Boxer, von den Wänden eines Raumes, in dessen Zentrum acht leere Schaukelstühle in einem Oval angeordnet sind. Die kommunikativ situierten Stühle symbolisie-

ren den Ort der Legendenbildung: das Gedächtnis und Gespräch derer, die einst dabei gewesen sind. Und dieser Ort steht gleichzeitig für den einzigen Lohn, den die Boxer erwarten können: von einem überschaubaren Publikum geachtet, eventuell bewundert zu werden. Gleichzeitig verweisen die Stühle auf den Preis, den die Faustkämpfer für diesen Lohn zu zahlen haben. Denn beim Betrachten der zerschundenen Gestalten an den Wänden drängt sich die Frage auf, ob sie jemals auf diesen Altersruhesitzen werden Platz nehmen können. Nicht zufällig stehen die Stühle leer und unbewegt da.

Mit der Faszination für körperliche Verausgabung, die nicht nach dem unmittelbaren Nutzen fragt, steht Busto nicht allein da. Schon Brecht, der einen Teil der Autobiografie des Mittelgewichtlers Paul Samson-Körner verfasst hat, bewundert wortreich die Leidenschaftlichkeit eines sportlichen Tuns jenseits der Gesundheitspflege: »Sport aus Hygiene hat etwas Abscheuliches. Ich weiß, daß der Dichter Hannes Küpper, dessen Arbeiten wirklich so anständig sind, daß sie niemand druckt, Rennfahrer ist, und das George Grosz, gegen den ja auch keine Klagen vorliegen, boxt, aber sie tun dies, wie ich genau weiß, weil es ihnen Spaß macht, und sie würden es auch tun, wenn es sie körperlich ruinieren würde.«[11] Interessant ist, dass Brecht neben dem Boxen das Rennfahren lobt. Beide Sportarten stehen schließlich wie keine andere für den Übergang von der »freien Unwirklichkeit«[12] des Spiels zu jenem Bereich der Wirklichkeit, in dem man sterben kann. Und genau auf diesen Bereich verweisen auch Ana Bustos leere Stühle. Der Reiz des Risikos ist also nicht nur für Brecht die Basis für das Erleben jener authentischen Körpererfahrung, die mit der intellektuellen Erfahrungsweise nicht kompatibel zu sein scheint.

Der Ring als archaischer Altar

Die paradoxe Sehnsucht nach ganzheitlicher Erfahrung in einer modernen arbeitsteiligen Gesellschaft forciert im frühen 20. Jahrhundert und auch danach einen modernen Kult um den Körper, der zum Garant für unmittelbares Erleben wird. Wenn vor allem das sportliche Treiben selbst authentische Subjekt-Erfahrung garantieren soll, was fasziniert dann ein Publikum – Intellektuelle und Künstler inklusive – an der Rezeption eines archaischen Rituals wie dem Faustkampf? Oates formuliert variantenreiche Antworten, sie verweist unter anderem auf die »mörderische Kindheit der menschlichen Rasse«, die beim Boxkampf zu erleben sei, und beschreibt den Ring als eine Art vorzivilisierten Altar, auf dem ein Ritus begangen wird, der denen gleicht, die zelebriert wurden, »ehe Gott als Liebe begriffen wurde« (Oates, S. 24). Michael Kohtes fasst den Oates'schen Fächer überaus elegant zusammen: Boxen hat zu tun mit »kollektiven Regressionsgelüsten, die der Faustkampf wie kein anderes Spektakel fokussiert und bestenfalls abventiliert. Was der Autorin das muskulös eskalierende Drama vor Augen führt, ist das Drama einer Zivilisation, die allem humanistischen Trainingseifer zum Trotz von ihrer Idealform nur träumen kann.«[13] Korrekterweise muss hier angemerkt werden, dass Joyce Carol Oates das Boxspektakel auch völlig anders interpretiert. Linear die Darlegungen zum Gladiatorenkampf fortsetzend, bedeutet der Kampf für sie auch ganz plakativ ein Drama zur Befriedigung eines »angeborenen Instinktes«: »[…] ein tödlicher Kampf, der sich mit persönlichem Mut verbindet, ist qualitativ etwas anderes als eine reine Instinkthandlung, und anderen zuzuschauen, wie sie miteinander kämpfen und sich töten, scheint ein angeborener Instinkt zu sein« (Oates, S. 43 f.). Oates geht hier noch wesentlich weiter als Norbert Bolz, der die Wünsche nach systematischer Außerkraftsetzung der Rationalität und emotionaler Identifikation, die er Fußballfans unterstellt, als ein unterdrücktes, geopfertes, aber zum Subjekt gehöriges Gefühl bezeichnet.[14] Das Vorhandensein dieses Gefühls begründet er mit Freuds Paradigma von der Größe der Verlustrechnung des Zivilisationsprozesses: kollektive Triebunterdrückung als Preis für die Erhaltung des zivilisierten Europäers. Es stellt sich jedoch die Frage, ob die beschriebenen geopferten Gefühle zwangsläufig dem Subjekt angehören und deshalb jeden wie auch immer gearteten Zivilisationsprozess problematisieren würden, oder ob sie als Folge von funktionalen Anpassungsmechanismen im arbeitsteiligen kapitalistischen System erst enstanden sind.

Oates ist eine Schriftstellerin, die das Phänomen Boxen nicht nur besingt – sie eignet es sich auch rezeptionsästhetisch an. Ihre Ergründung der Motivation eines Boxers liest sich wie eine idealistische Interpretation, also als genaues Gegenteil von Hoyts und Bustos Stigmatisierung des Profiboxens. Ums Geld geht es den Profis nach Oates zwar auch, aber eben nur unter anderem. Denn einerseits »setzen sich Boxer Verletzungen aus, um eine Schuld zu sühnen, in einer Art Dostojewskijschem Austausch von körperlichem Wohlbefinden gegen ein ruhiges Gewissen« (S. 29). Anderseits vermutet Oates, »daß sich Boxer gegenseitig bekämpfen, weil ihnen die wirklichen Gegner, auf die sich ihre Wut richtet, nicht zugänglich sind« (S. 67). Ähnlich anregend und eigenwillig liest sich Jan Phillip Reemtsmas Versuch, den Mythos Muhammad Ali anhand einer genauen Analyse seines Boxstils zu erklären. Die Faszination Alis, so der furiose Schlusspunkt der Ausführungen des Literaturwissenschaftlers, beruht auf seiner siegreichen Verkörperung dessen, was seine Fans im besten Falle einmal sein werden: ein postmodernes Einzelwesen, das seine Identität mit den gestellten Anforderungen wechseln kann.

Frauen in Handschuhen

Welche Rollen nun können Boxerinnen in einem Sport spielen, dessen Reiz so elementar auf der Huldigung all dessen beruht, was sich unter dem Etikett »Machismo« zusammenfassen lässt? Schließlich darf nicht vergessen werden, dass bei einem echten Kampf Weiblichkeit im Ring ausschließlich in Form von Nummerngirls geduldet wird und dass die Keuschheit des Boxers vor dem Kampf das wohl stabilste Element der Folklore des Boxens ist: »Statt seine Energien und Phantasien auf eine Frau zu konzentrieren, richtet er sie auf seinen Gegner. Wo ›Frau‹ war, muss ›Gegner‹ sein – frei nach Freud.« (Oates, S. 34)
Unverstellte Aggressivität gilt innerhalb der traditionellen Differenzierung der Geschlechter als verlässlicher Garant für Männlichkeit, hegende Fürsorge markiert Weiblichkeit. Eine Frau, die boxt, kann deshalb nicht ernst genommen werden, »sie ist eine Parodie, ein Witz, sie ist monströs. Stünde sie für eine Ideologie, wäre es die des Feminismus« (Oates, S. 74). Klar, wer schön sein will, muss zwar leiden, aber bitte nicht beim Boxen. Blumenkohlohren und gebrochene Nasenbeine sind konventioneller Schönheit unbestreitbar sehr, sehr abträglich. Boxende Frauen setzen sich freiwillig der Gefahr der Verunstaltung ihrer konsumierbaren Oberfläche aus und verhöhnen damit das existierende lückenlose Regime der Körperkontrolle, welches Frauen dazu verdonnert, dafür zu sorgen, dass der Alltag gefälligst keinerlei Spuren auf ihrem Körper hinterlässt. Frauenboxen – ein Schlag in die Magengrube aller René Wellers dieser Welt, die behaupten: »Eine Frau muß für den Mann gemacht sein, nicht für den Männersport.«[15]

Die Grenze zwischen »female« und »feel male«

Joyce Carol Oates zitiert den Psychologen Erik Erikson, für den die »Kontemplation von Ruinen eine spezifisch männliche Eigenart« ist, um das zu benennen, was die Boxfans vom Kampf erwarten: Nicht Grazie und Schönheit, sondern »das spektakuläre Zusammenstürzen der Blöcke, die sich so hoch aufgetürmt haben, wie es nur irgend ging« (Oates, S. 74). Dem traditionellen Rollenmodell »Frau« entspricht demgegenüber eine Identifikation mit dem Verlierer, dem Verletzten. Gerade weil das Boxen auch vor und nach Muhammad Ali die männlichsten Mega-Mythen hervorbringt, eignet es sich für Frauen wie keine zweite Sportart dazu, die starre Grenze zwischen »female« und »feel male« zu überschreiten. Frauen wie die rappende Boxerin im Vorspann zu Spike Lees Film *Do the Right Thing* ebenso wie die Popsängerin Björk, die sich für das Cover ihrer CD *Post* vom Visagisten zwei stilisierte Feilchen verpassen lässt, bauen den einst männlichen okkupierten »I-am-the-greatest«-Touch des Boxens geschickt in ihre Selbstinszenierung ein. Die Boxerin ist dabei nicht mehr monströse Parodie, sie führt vielmehr dekonstruierend die Stereotypie der männlichen Inszenierung vor. Ein Paradebeispiel für diese Strategie ist Caitlin Parkers Videoinszenierung *I Wish I Was Roy Jones Jr.* (vgl. S. 97). In dem 2001 fertig gestellten Einakter von drei Minuten – exakt die Dauer einer Boxrunde – spielt die Künstlerin nicht nur einen vielfachen Boxweltmeister im Halbschwergewicht, sie ersetzt ihn. Lakonisch, ohne eine Miene zu verziehen, tritt die schmächtige Künstlerin gegen einen männlichen Boxer an. Eine wackelige Handkamera gibt dem Schwarzweißvideo eine hektische Rhythmik und nur scheinbar dokumentarische Note – selbst ein Laie hätte den Film mit heutigem Standardequipment perfekter hingekriegt. Die Boxerin schlägt den Gegner k. o., weiterhin ohne sich aufzuregen oder auf die von großen Champions bekannte

Überwältigungsgestik zurückzugreifen. Selbst in klassischer Siegerpose, den Gürtel des Weltmeisters geschultert, bewahrt sie kühle Contenance. Kontrastiert wird diese fast unbeteiligte Haltung der Siegerin durch einen aufgeregten Sound, zusammengeschnitten aus Originalkommentaren der Kämpfe von Roy Jones Jr., Muhammad Ali – »the Greatest« ist mit weit aufgerissenen Augen für Sekunden auch immer wieder ins Video montiert – und dem Schreien und Jubel des Originalpublikums. Diese polare Anordnung verschafft der Akteurin einen doppelten Sieg: Sie schlägt nicht nur ihren Gegner, sie behält auch als einzige einen kühlen Kopf, geht das Drama rational und nicht emotional an. Und damit doppelt männlich. Ihr Gegner ist nicht einmal in der Lage, dem Blick der Boxerin in einer klassischen Eye-to-Eye-Situation standzuhalten: Er fällt aus der Rolle und versucht die Frau zu küssen, die doch eigentlich sein Gegner ist.

Caitlin Parker hat für ihre Aneignung das perfekte Vorbild gewählt: Roy Jones Jr. ist nicht nur ein Superstar im Ring, er ist auch Basketball-As, Musikproduzent mit eigenem Label, Entertainer und Schauspieler. Und der einzige wirklich bedeutende Profiboxer in den USA, der sich selbst promotet und managt. Ein Champion nicht nur im Ring, sondern auch im Leben, so die vollmundige Botschaft auf seiner Homepage.

Abschied von Underground-Schlampe und Maschinenfrau

Wer alles gut im Griff hat, scheint sich Grenzüberschreitungen eher leisten zu können. Denn auch bei der Selbstinszenierung der Popikone Madonna geht es spielerisch zu. Ihre öffentliche Identität hat in rasendem Tempo die Bandbreite zwischen Underground-Schlampe und Maschinenfrau durchlaufen. Von ihr lernen wir, uns von weiblichen Stereotypen zu verabschieden und nicht, uns an sie zu gewöhnen. Freilich werden derartige popkulturelle Erscheinungen, ebenso wie das Frauenboxen, in der Öffentlichkeit völlig anders aufbereitet. An den Reaktionen der Berichterstatter lässt sich deutlich ablesen, wie männlich das Boxen noch immer ist. Wenn überhaupt, reagiert man pikiert bis empört auf Frauen im Ring. So stellt sich die Wirklichkeit eben dar für Traditionalisten, denen im Hinterstübchen noch immer das Modell einer »weiblichen Natur« herumspukt, der – womöglich frauenbewegt – nur noch beim Ausschlüpfen geholfen werden muss. Einst waren es die verbiesterten unter den Feministinnen, zu denen freilich irgendwie fast alle gehörten, heute, in lockereren Zeiten, sind es eben die Boxerinnen, die sich partout nicht mit einer fixierten weiblichen Natur zufriedengeben wollen.

Schön wär's, wenn die männliche Kritik sich endlich auf ein weitaus lohnenderes, weil ihrer spezifischen Kompetenz eher entgegenkommendes Terrain beziehen würde: die Inszenierungsmodi des Profi-Kampfes der Geschlechtsgenossen. Über keinen anderen Sport werden schließlich so viele Filme gefertigt wie über das Boxen. Kein Wunder: Sind es denn letztlich nicht nur Kleinigkeiten, die das streng ritualisierte Drama im Ring vom klassischen Western-Showdown trennen? Muhammad Ali hat ebenso wie Gary Cooper ganz allein in die Augen der zu bekämpfenden »nogoodniks« zu schauen. Aber ebenso wie im Wildwestfilm sind beim Boxen auf Zelluloid alle Sieger Bleichgesichter: Hollywood schlägt, seit es schwarze Boxweltmeister gibt, weiß zurück. Nur weiße Mega-Stars wie Robert de Niro (*Wie*

ein wilder Stier), Paul Newman (*Für eine Handvoll Dreck*),
John Wayne (*Der Sieger*) oder Burt Lancaster (*Rächer der
Unterwelt*) sind gut genug, um auf Zelluloid zu siegen. Am
eindrucksvollsten wird die Wirklichkeit jedoch von Syl-
vester Stallone (*Rocky I–V*) korrigiert, der einen in der syn-
thetischen Welt Apollo Creed genannten Ali erst besiegt,
dann zu seinem Trainer macht und ihn so auf jenes Mittel-
maß reduziert, von dem sich Rocky – weiß und deshalb
amerikanischer – championmäßig so richtig schön abhe-
ben kann. Derartig konservative Gefühlswelten lassen
selbstverständlich keinen Raum für »männliche« Frauen,
»weibliche« Männer oder gar Androgynität.

Die Freude des Mannes auf seinen Friseur

Wer genau hinschaut, kann jedoch eine Trendwende aus-
machen. Es sind allerdings nicht die Kommentatoren, die
diese Aufweichung klassischer Geschlechterrollen voran-
treiben, sondern die Superstars aus der Welt des Sports
selbst. So scheinen ausgerechnet die beiden Spieler mit
dem unbestreitbar größten Pop-Appeal der eben beendeten
Fußballweltmeisterschaft wenig Lust auf die traditionelle
Rolle der kämpfenden Balltreter zu haben. David Beckham
freut sich ganz unverhohlen auf einer Pressekonferenz
darüber, dass seine Frau – selbst zu beschäftigt, um ihn zu
besuchen – seinen Friseur zur Weltmeisterschaft nach
Asien einfliegen lässt. Auf die süffisante Frage eines Jour-
nalisten, wann denn nun sein Haarstylist einträfe, antwor-
tet Beckham offenherzig: »Ich weiß nicht. Aber allein die
Tatsache, dass er kommt, macht mich schon glücklich.«
Und Ahn Jung-Hwan, Star der Weltmeisterschaft und
»Beckham Südkoreas«, ist ohnehin der Spieler, der einer
Frau unbestreitbar am ähnlichsten sieht – und diesen an-
drogynen Touch noch betont.
Und last but not least bricht selbst ein boxender Superstar
wie Roy Jones Jr. mit jener von René Weller vorexerzierten
kategorischen Ablehnung des Frauenboxens. Der Champ,
der sich wie Basketball-Superhero Dennis Rodman gerne
mal mit weiblichen Accessoires ablichten lässt, antwortet
auf die Frage, was er von boxenden Frauen halte: »More
women should consider it.«[16]

1 Zit. nach Jan Philipp Reemtsma, *Mehr als ein Champion. Über den
 Stil des Boxers Muhammad Ali*, Reinbek bei Hamburg 1997, S. 95.

2 Zit. nach Klaus Theweleit, *Buch der Könige*, Bd. 2: *Recording Angels'
 Mysteries*, Basel und Frankfurt a. M. 1994, S. 458 f.

3 Michael Kohtes, »Zartgefühl im ausgeleuchteten Quadrat«, in: *Die
 Zeit, Literaturbeilage*, Nr. 49, 1. Dezember 1995, S. 13.

4 Alle Seitenangaben beziehen sich auf den Essay von Joyce Carol
 Oates, *Über Boxen*, Zürich 1988.

5 Demonstriert anschaulich in Helmut Böttigers Biografie *Günther
 Netzer. Manager und Rebell*, Frankfurt a. M. 1994.

6 Vgl. André Müller, »Ich jubel nicht, wenn der andere blutet.
 Interview mit Boxweltmeister Henry Maske«, in: *Die Zeit*, Nr. 34,
 19. August 1994, S. 39.

7 Jürgen Kalwa, »Mike Tysons Frauen: Alles Schlampen außer Mutti«,
 in: *Das Zeit-Magazin*, Nr. 12, März 1996, S. 8.

8 Ebd.

9 Vgl. Reemtsma 1997 (Anm. 1), S. 19.

10 Vgl. Hans Ulrich Gumbrecht, »Dabeisein ist alles.« *Über die
 Geschichte von Medien, Sport, Publikum*, Siegen 1988, S. 10 ff..

11 Vgl. Bertolt Brecht, »Sport und geistiges Schaffen«, S. 123.

12 Roger Callois definiert das Spiel unter anderem als »eine fiktive
 Bestätigung, die von einem spezifischen Bewußtsein einer zweiten
 Wirklichkeit oder einer in bezug auf das gewöhnliche Leben freien
 Unwirklichkeit begleitet wird« (Klaus Kreimeier, *Lob des
 Fernsehens*, München und Wien 1995, S. 292).

13 Kohtes 1995 (Anm. 3), S. 13.

14 Vgl. Christoph Biermann, *Wenn du am Spieltag beerdigt wirst,
 kann ich leider nicht kommen. Die Welt der Fußballfans*, Köln 1995,
 S. 192 f.

15 Zit. nach *Emma*, März/April 1995.

16 Vgl. www.royjonesjr.com: RJJ Email Questions, 4. Mai 2001.

THE SWEET

SCIENCE

Claudia Lüersen

OF BRUISING

'Adrian, I don't ask you to stop being a woman, so don't ask me to stop being a man. Please.'[1]

Rocky Balboa (Sylvester Stallone)

'... not only is sexual intercourse hard work, sexuality itself is.'[2]

Andy Warhol

Apropos body power: for demonstrating the duality of physical force and the (attractive) power of the physical there is probably no stage better suited than that of the boxing ring. Even though many boxers emphasize the legerity, tactical finesse and elegance of their sport, the audience is primarily witness to what deliberate accelerated body masses can accomplish: the bloody deformation of the opponent's body. For the same reason, the fist fights of 'Super-champions' are the peaks within the massif of excitement that sports represent for the media, reaching heights that no other discipline can achieve. No sport has produced more myths; none is more masculine. Until five years before the millennium, boxing in Germany was, by its very definition, a 'sport with two *male* partners competing in a ring' (according to the official rules of the boxing association; emphasis added).

But what happens, then, when women enter the boxing ring? A study by an author who is a 'habitual visitor to the great competitions in Madison Square Garden and well acquainted with the history of boxing from antiquity to the modern gladiators like Mike Tyson'[3] gives us some idea: Joyce Carol Oates's book *On Boxing*.[4] Anyone expecting Oates's engagement with boxing to be a paradoxical, broken or humorous play with masculine megamyths – that is, a deconstructive undermining by means of the proverbial feminine gaze – will be disappointed. The American writer is unmistakably seeing the ring through the eyes of 'daddy's daughter' – and indeed she first got to know that ring while holding her father's hand. Oates is a boxing fan, and her essay bursts with anecdotes and quotations at the three-minute pace at which the 'ideal (because unthinking, unforced) masculinity' (Oates, p. 54) plays out. In the rich materials she spread before us with relish, Oates establishes connections that may not deconstruct the boxing myth but certainly provide illuminating insights for an analysis of it.

Homage to Persistence

Boxing, as Oates sees it, 'is the very image ... of mankind's collective aggression; its ongoing historical madness' (Oates, p. 21). Fist fighting is a metaphor here for life as a struggle for existence, pure and simple, a homage to persistence: 'For the contenders ...' reads the simple dedication. For this writer, boxing is not a sport since there is 'nothing fundamentally playful about it; nothing that seems to belong to the daylight, to pleasure.' (Oates, p. 18). This announcement that the 'Sweet Science of Bruising' will be lifted out of the context of sports is not entirely persuasive, however. And not only because it contradicts the legendary 'Float like a butterfly, sting like a bee' with which Muhammad Ali liked to characterize the appeal of his boxing style, playing off the contrast between playful, dancing legerity and pinpoint accuracy of punching. The mythical elevation of individual heroes into projection screens for male fantasies, too, is characteristic not only of boxing but of all variants of competitive sports, especially national sports. The legends surrounding boxers like Harry 'the Human Windmill' Greb or Joe 'the Brown Bomber' Louis are matched by those surrounding the soccer heroes Matthias 'the Wooden' Sindelair or Pelé, the Black Bomber. In general, the battling heroes whose stories Joyce Carol Oates relates are much closer to a soccer player like Günther Netzer, who even today is a favourite metaphor among German intellectuals for the Good – that is to say, the

Rebellious – in mankind,[5] than to a boxer like Henry Maske. The former World Champion Maske always compared boxing to chess, considered himself a strategist who didn't like to think of the scars he bore as trophies,[6] and consequently sold himself as the 'Gentleman of the Ring'. Maske, who grew up in the former German Democratic Republic, mutated into a professional by necessity, owing to the specifics of his biography, but really corresponded much more to the model that produced the world's most successful amateur boxers in Cuba. This is a collective model, precisely not the one to which Oates refers. This ideal finds its prototype embodied in a boxer like Mike Tyson, who comes from 'a broken family in Brooklyn',[7] who lisps, who conceals 'in his muscular throat the voice of a castrato',[8] and who sat in prison for rape twice before winning the World Heavyweight Championship for the second time. Michael Gerard Tyson was managed from way down to the top by a man who, like no boxing promoter before him, presented himself as a pimp: Don King. The ring is a bordello, the body a product, the fans the customers, and the manager the pimp. It is not difficult to make an allegorical connection between boxing and prostitution.

Don King's Empire

The artist Satch Hoyt (see p. 47) has spun this very thread: in the centre of his allusion-filled, interactive installation *The DonKingDom* stands an interactive sculpture that is covered with a layer of 150 red boxing gloves – as if covered in oversized, bleeding wounds. The gloves are, of course, made by Everlast: the body disappears, but the brand remains – boxing as corrupt system, the boxers as mere window dressing. The viewers are expressly invited to humiliate the heroes with their own hands: the visitors are given gloves, and they can enter the ring to punch away. In this way, art trivializes icons. Oates does not address the corrupt side of boxing; for her, fist fighting is a true opportunity for the *isolato*, who would otherwise be washing dishes, to box his way out of the gutter as a professional man in gloves. Because she sings the praises of fist fighting as the American dream, her essay reads like a 118-page song: 'For somethin' that he never done / Put in a prison cell, but one time he coulda been / The champion of the world', as Bob Dylan described the sufferings of the boxer Rubin 'Hurricane' Carter. Those lines could be by Oates, as well, whose message can be simply summed up as: Boxing is rock 'n' roll – a man's world.

Boxer and Artists in the Training Camp

What draws artists and intellectuals to the archaic spectacle? The appeal that fist fighting has had for such colleagues as Jack London, Jonathan Swift, Mark Twain, Lord Byron, Ernest Hemingway, Norman Mailer and even Bertolt Brecht – Oates is, it seems, the only important female writer who shares this fascination – is one the author explains in a quite daring way. The act of training is what united the boxer with the artist. The battle in the ring is comparable to the publication of a book, since both high points are preceded by a 'protracted, arduous, grueling, and frequently despairing period of preparation' (Oates, p. 26). It is, moreover, a silent drama that needs others to put it into words. Hard training and a lack of words are, one could reply to Oates, essential components of all competitive sports. The extent to which a successful female gymnast or track-and-field athlete has to discipline her body is no less radical than that of the boxer. So what is so particularly inspiring about fist fighting? The appeal lies in the unmitigated directness with which winning and losing come in boxing. Nowhere else is victory so directly associated with conquering, enslaving the opponent. The physical triumph over the Other is accompanied, in a society in which progress always means 'move away from a punch in the face',[9] by a profoundly false note. For intellectuals in Germany, at least since the time of the Weimar Republic, this flirtation with incorrectness became the 'requirement of modernity'.[10] Because these days – especially in bourgeois-intellectual circles – it is considered inappropriate to identify oneself, to win or to triumph, it works perfectly to use an admission that one is a soccer or boxing fan as a way to strike a politically incorrect note and distinguish oneself as a super-intellectual with a penchant for the trivial. And this rebellious label 'feels right' in a society in which punching is still considered the opposite of thinking, which is why the intellectual is subject to an 'exclusion

very nearly as complete as, say, the exclusion of a woman from boxing's codified world' (Oates, p. 54). Bertolt Brecht once tried, by expressing a wish for a theatre public more like that at boxing matches, to snub his usual educated audience in favour of real men and the proletariat. The gesture was taken up again in a film ad that the artistic director Leander Haussmann once used in Bochum to appeal to a common audience: the classic line from Goethe's *Faust*: 'Nun steh' ich hier, ich armer ...', read by an actor, is completed by a cut to a group of fans of the soccer team VfL Bochum shouting a loud 'Tooor!' [The *Tor* (fool) in the line from *Faust* – 'Here I stand, a poor fool' is replaced by a crowd cheering *Tor* (goal). *Trans.*]

No Glamour, Nowhere

The artist Ana Busto (see. p. 31) chose to reverse this experiment: she brings boxing to the arts audience. In 2000, as part of her action *Night Fights*, she organized for the first time amateur fights in an art gallery in Barcelona. The public combined 'genuine' boxing fans, who were clearly uninterested in the artistic aspects of the project, with those who were attracted primarily to just that. Or does the thrill of the spectacle perhaps play a decisive role for the art public as well? The self-reflective question 'Why am I here' is provoked artistically by the wall mirrors that Ana Busto added to her installation two years later. The artist has no wish to raise doubts about the 'pure' intentions of the fighters, however: the walls around the boxing ring are hung with greatly enlarged photographs of boxers outside the ring, often details of faces and hands. The viewer looks into pulped, bloodied faces, at bandaged, callused hands. No glamour, nowhere. Amateur boxing is hard work; it takes place outside of the footlights of the media, and the rewards are not wealth but at best honour and modest fame. That sort of sporting activity clearly has nothing to do with the fetish of efficiency in a functioning service economy. Boxing demands of amateurs almost unconditional passion and devotion – and it is precisely these qualities that turn the boxers, who look almost damaged in the photographs, into outsiders. The subliminal message of the installation is that calculation only comes into play when the athletes move into the professional camp. The features of this profitable system are bundled by the artist into the only large-format image in the series, which shows a well-cared-for hand, that of the boxing promoter and manager Don King, wearing a gold ring and holding the rope of a boxing ring. It is surely no coincidence that both Satch Hoyt and Ana Busto use Don King as a symbol for money and greed. After all, King's self-presentation is showy and transparent and 'honest' in comparison to his colleagues who work in the background. King is the personified (childlike) dream of the golden Mercedes in which the underdog, when he has made 'it', drives past his mother's apartment.

It is merely logical that Busto moved as far as possible from the professional camp when exploring further the unprofitable depths of the sport of boxing. The artist travelled to Cuba, to a country where only amateurs fight. In her ensemble *La escuela cubana de boxeo* [The Cuban School of Boxing], first exhibited in 2001, she sharpened her artistic positions. Once again, large-format images, this time of Cuban boxers, are hung resplendent on the walls of a room in whose centre eight empty rocking chairs are arranged in an oval. The chairs, arranged as if for communication, symbolize the place where legends are formed: the memories and conversations of those who once participated. At the same time, the place stands for the only reward the boxer can expect: to be respected by a small public, perhaps even admired. The chairs also point to the price that the boxers pay for this reward. Looking at the damaged forms on the wall, the question arises whether they will ever be able to take their places in these chairs in retirement. It is no coincidence that the chairs are empty and motionless.

Busto is not alone in her fascination with physical expenditure that does not seek immediate utility. Even Brecht, who wrote part of the middleweight Paul Samson-Körner's autobiography, described profusely his admiration for the passion of athletic activity irrespective of reasons of health: 'Practising sports for the sake of hygiene is somehow repulsive. I know that the poet Hannes Küpper, whose works are so respectable that no one will print them, is a race driver and that George Grosz, about whom no one can complain either, is a boxer, but they do this, as I know very well, because they enjoy it, and they would do it even if it destroyed them physically.'[11] It is interesting that Brecht praises car racing as well as boxing. These two sports represent, like no others, the transition from the 'free irreality'[12] of play to that realm of reality that lies where one can die. And it is precisely that realm to which Ana Busto's empty chairs point. It is not just Brecht for whom the attraction of risk represents the experience of that authentic physical experience that seems incompatible with an intellectual approach to experience.

The Ring as an Archaic Altar

The paradoxical desire for integrated experience in a modern society based on the division of labour necessarily led, in the early 20th century and even later, to a modern cult of the body that became the guarantor of immediate experience. When athletic activity was the primary guarantee for authentic experience of the subject, what is so fascinating for the public – including intellectuals and artists – about the reception of an archaic ritual like fist fighting? Oates gives various answers. Among other things, she points to the 'murderous infancy of the race' (Oates, p. 20) that is experienced at a boxing match and describes the ring as kind of archaic altar on which a rite is performed like the one celebrated 'before God was love' (Oates, p. 21). Michael Kohtes neatly summarized Oates's categories: boxing is concerned with 'collective regressive cravings that focus on fist fighting like no other spectacle and are at best pressure valves. What the author places before us as a muscularly escalating drama is the drama of a civilization that, despite all the enthusiasm for humanistic training, can only dream of its ideal form.'[13] It should be noted here, for the sake of accuracy, that Joyce Carol Oates also interprets the spectacle of boxing in an entirely different way. Following the lines of her descriptions of gladiatorial combat, fighting is for her quite strikingly a drama that satisfies an 'inborn instinct': 'though the instinct to fight and to kill is surely qualified by one's personal courage, the instinct to watch others fight and kill is evidently inborn' (Oates, pp. 41–42). Oates goes much further here than Norbert Bolz, who characterizes the desires he attributes to soccer fans systematically to undermine rationality and instead to identify emotionally, as a feeling that has been suppressed and sacrificed but still belongs to the subject.[14] He explains the presence of this feeling with reference to Freud's paradigm of the value of the loss calculation in the process of becoming civilized: the collective repression of drives as the price for achieving the civilized European. The question arises, however, whether the sacrificed feelings that are described necessarily belong to the subject, and thus would be problematic for any form of civilizing process, or whether they only developed as a consequence of the functional adaptation mechanisms in a capitalist society based on the division of labour.

As a writer, Oates not only sings the praises of boxing, she also appropriates it in terms of the aesthetics of reception. Her exploration of a boxer's motivation can be read as an idealistic interpretation, that is, as the precise opposite of Hoyt's or Busto's stigmatization of the professional boxer. For Oates, money is also a consideration for the professional boxer, but only as one thing *among others*. On the one hand, she asserts that 'boxers … invite injury as a means of assuaging guilt, in a Dostoyevskian exchange of physical well-being for peace of mind' (Oates, p. 25). On the other, Oates suspects 'that boxers fight one another because the legitimate objects of their anger are not accessible to them' (Oates, p. 63). Jan Phillip Reemtsma's attempt to explain the myth of Muhammad Ali by means of a precise analysis of his boxing style comes across as similarly stimulating and wilful. Ali's fascination, this literary scholar concludes, is based on Ali's successful embodiment of what his fans would most like to be: a postmodern individual that can exchange its identity with the tasks set for it.

Women in Gloves

What role can female boxers now play in a sport whose appeal is so fundamentally based on a homage to everything that can be gathered under the label *machismo?* It cannot be forgotten, after all, that femininity is tolerated in a real match only in the form of score girls and that the boxer's celibacy before the match is probably the most frequently occurring element in the folklore of boxing: 'Instead of focusing his energies and fantasies upon a woman, the boxer focuses them upon an opponent. Where Woman has been, Opponent must be.' (Oates, p. 30)

In the traditional differentiation of the sexes, undisguised aggressiveness is a reliable guarantee of masculinity; [loving] concern marks femininity. A woman who boxes thus cannot be taken seriously: 'The female boxer violates this stereotype and cannot be taken seriously – she is parody, she is cartoon, she is monstrous. Had she an ideology, she is likely to be a feminist.' (Oates, p. 73). Anyone who wants to be beautiful must suffer, but, please, not in boxing. Cauliflower ears and broken noses are very, very difficult to reconcile with traditional beauty. Boxing women freely subject themselves to the risk of marring their consumable surface and thus mock the existing, absolute regime of body control that demands that women see to it that everyday life leaves no traces on their bodies. Female boxing is a punch to the stomach of all the René Wellers of the world who assert that a 'woman must be made for a man, not for male sports.'[15]

The Line between 'Female' and 'Feel Male'

Joyce Carol Oates quotes the psychologist Erik Erikson, for whom 'the contemplation of ruins is a masculine speciality' (Oates, p. 73), to specify what boxing fans expect of a match: not grace and beauty but 'the blocks piled as high as they can possibly be piled, then brought spectacularly down' (Oates, p. 73). Part of the traditional role of the woman, by contrast, is identification with the loser, with the injured. Precisely because boxing, both before and after Muhammad Ali, produces the most masculine megamyths, it is better suited than any other sport to women who wish to overstep the rigid boundary between 'female' and 'feel male'. Women like the rapping boxer in the credits to Spike Lee's film *Do the Right Thing* or the pop singer Björk, who had the make-up artist give her two stylized black eyes for the cover of her CD *Post*, cleverly build the formerly masculine 'I am the greatest' aspect of boxing into their presentations of themselves. The female boxer is thus not longer a monstrous parody; instead, she reflects the stereotype of male self-presentation in a way that deconstructs it. A classic example of this strategy is Caitlin Parker's video *I Wish I Was Roy Jones Jr.* (see p. 98). In this three-minute-long one-act video from 2001 – exactly the length of a round of boxing – the artist not only plays a middleweight boxing champion, she replaces him. Laconically, the slightly built artist confronts a male boxer without being bent out of shape. A wobbly hand-held camera gives the black-and-white video a hectic rhythm and an illusory documentary touch – even an amateur could have done a better job with the film using the equipment that is standard today. The female boxer knocks her opponent out, without raising a sweat or falling back on the gestures of dominance familiar from the great champions. Even in the classical pose of the victor – with the championship belt slung over her shoulder – she preserves a cool countenance. The victor's almost indifferent attitude is contrasted with a keyed-up soundtrack taken from original commentaries on matches with Roy Jones Jr., Muhammad Ali – 'the Greatest', with eyes wide open, is repeatedly cut into the video for a few seconds – and the screams and cheers of the original audiences. This polar arrangement gives the actress a double victory: not only does she beat her opponent, she also retains a cool head, approaching the drama in a rational way, not an emotional one. Thus she is doubly masculine. Her opponent is not even able to meet the female boxer's gaze in the classical eye-to-eye position: he falls out of his role and tries to kiss the woman who is his opponent. Caitlin Parker chose the perfect model. Roy Jones Jr. is not only a superstar in the ring, he is also a basketball ace, a music producer with his own label, an entertainer, and an actor. He is also the only important professional boxer in the United States who promotes and manages himself. He is a champion not only in the ring but in life – such is the brash message of his website home page.

Farewell to the Underground Tramp and the Machine Woman

Those who have everything under control seem to be more able to transgress borders. It happens playfully even in the way the pop icon Madonna presents herself. Her public identity has run at breakneck pace from underground tramp to machine woman. From her we learn to say farewell to female stereotypes rather than to grow used to them. Admittedly, such phenomena of pop culture, and female boxers as well, are often received totally differently by the public. From the reactions of the reporters it is still clear how masculine boxing still is. If women in the ring get any reaction at all, it is likely to be one of pique or outrage. That is how reality appears for those traditional men whose closets are still haunted by a model of 'feminine nature', who only need a woman's help when being born. Once it was only the most beastly of the feminists – a category to which all of them belonged, admittedly – whereas today, in more relaxed times, it is the female boxers who are unwilling to content themselves with a fixed conception of the nature of women.

It would be nice if male critics could finally take on a terrain that would be far more rewarding, since it corresponds to their specific competence: the ways in which the professional matches of their gender comrades are presented. After all, boxing has had more films made about it than about any other sport. And it is no wonder: isn't it the case that the highly ritualized drama in the ring is distinguished from the classical Western showdown by mere details? Didn't Muhammad Ali all alone stare into the eyes of boxing nogoodniks, just as Gary Cooper did? But just as in Wild West films, all the victors in boxing on film are pale-faces: ever since there have been Black boxing champions, Hollywood has been punching back with White. Only White megastars like Robert de Niro (*Raging Bull*), Paul Newman (*Somebody up there likes me*), John Wayne (*The Quiet Man*) and Burt Lancaster (*The Killers*) are good enough to triumph on celluloid. Reality is made most impressive by Sylvester Stallone (*Rocky* I – IV), who first defeats an Ali, called Apollo Creed in this synthetic world, only to make him his trainer and thus reduce him to the mediocre level against which Rocky – White and thus American – can stand out properly as a champion. These kind of conservative emotional worlds naturally have no room for 'masculine' women, 'feminine' men, or even for androgyny.

The Joy a Man Derives from his Hair Stylist

Anyone who examines the situation closely, however, will spot a shifting trend. It is not the commentators who drive this loosening of the classical gender roles but rather the superstars of the sports world themselves. For example, in the recently ended World Cup it was precisely the two players who indisputably had the greatest pop appeal who seemed to have the least interest in the traditional role of the battling kicker. David Beckham was visibly pleased that his wife, who was too busy to visit him herself, had his hair stylist flown to Asia for the World Cup. In reply to a journalist's question about when his stylist would arrive, Beckham replied candidly, 'I don't know. But just the fact that he is coming makes me happy.' And Ahn Jung-Hwan, the star of the World Cup and 'South Korea's Beckham', was the player who most clearly resembled his wife – and he emphasized this androgynous touch himself. Last but not least, even a superstar of boxing like Roy Jones Jr. can break with René Weller's earlier categorical dismissal of women's boxing. The champ – who, like basketball superhero Dennis Rodman, enjoys being photographed in women's clothing – replied to a question about his views on women in boxing: 'More women should consider it.'[16]

1 Cited in Jan Phillip Reemtsma, *Mehr als ein Champion: Über den Stil des Boxers Muhammad Ali*, Reinbek, p. 95.

2 Cited in Klaus Theweleit, *Recording Angels' Mysteries*, vol. 2 of *Buch der Könige*, Basel 1994, pp. 458–59.

3 Michael Kohtes, 'Zartgefühl im ausgeleuchteten Quadrat', *Die Zeit*, *Literaturbeilage*, no. 49 (1 December 1995), p. 13.

4 Joyce Carol Oates, *On Boxing*, Garden City, N.Y. 1987.

5 This is clearly demonstrated in Helmut Böttiger's biography *Günther Netzer: Manager und Rebell*, Frankfurt am Main 1994.

6 Cf. André Müller's interview with Henry Maske, 'Ich jubel nicht, wenn der andere blutet: Interview mit Boxweltmeister Henry Maske', *Die Zeit*, no. 34 (19 August 1994), p. 39.

7 Jürgen Kalwa, 'Mike Tysons Frauen: Alles Schlampen außer Mutti', *Das Zeit-Magazin*, no. 12 (15 March 1996), p. 8.

8 Ibid.

9 Cf. Reemtsma 1995 (note 1), p. 19.

10 Cf. Hans Ulrich Gumbrecht, *'Dabeisein ist alles': Über die Geschichte von Medien, Sport, Publikum*, Siegen 1988, p. 10ff.

11 Cf. Bertolt Brecht, 'Sport und geistiges Schaffen', p. 123.

12 Roger Callois defines the game as, among other things, 'a fictive confirmation that is accompanied by a specific consciousness of a second reality or of an irreality that is free from ordinary life.' See Klaus Kreimeier, *Lob des Fernsehens*, Munich 1995, p. 292.

13 Kohtes 1995 (note 3), p. 13.

14 Cf. Christoph Biermann, *Wenn du am Spieltag beerdigt wirst, kann ich leider nicht kommen: Die Welt der Fußballfans*, Cologne 1995, p. 192f.

15 Cited in *Emma* (March/April 1995).

16 Cf. www.royjonesjr.com: RJJ e-mail questions, 4 May 2001.

MATTHEW McCASLIN

Surfing – Non-Stop Wave, 1997

Reinhard Ermen

Ohne elektrischen Strom läuft gar nichts mehr. Das ist hier so wie im restlichen Leben. Dass Matthew McCaslin sich zeitweilig durch Arbeiten als Elektroinstallateur über Wasser gehalten hat, erklärt manches und schadet dem Ernst der Sache in keinem Augenblick. An einer Kunsthochschule lernt man so etwas nicht. Ein Maler, der nebenbei zur Finanzierung seines Lebensunterhalts als Anstreicher arbeitet, ist dagegen eine durchaus komische Figur. Die »anderen Universitäten« sind eine Voraussetzung für den geradezu virtuosen Umgang McCaslins mit seinen bevorzugten Materialien: Steckdosen, Verteilerköpfe, Baulampen, Kabel in schlichten Kunststoffummantelungen, aber auch in respekteinflößenden Sicherheitsarmierungen aus Metall, Spiegelbirnen, die das Licht zurück auf die Wand beziehungsweise die schönen, schlichten Porzellanfassungen werfen, Uhren, immer wieder Uhren, Monitore und weiteres Hilfsgerät. Wer über McCaslin schreibt, kommt gar nicht umhin, den verschlungenen Kabelwegen wortreich zu folgen, was vielen Texten, insbesondere den Ausstellungskritiken, gelegentlich eine seltsame Uniformität verleiht. Auch dieser Text kann sich der Lust an der Beschreibung nicht ganz entziehen, das faszinierende Ornament der Schaltkreise produziert darüber hinaus Metaphern. Die Tatsache, dass die »Installationen« auf tragende Wände, den sicheren Boden oder andere stützende Leitern und Gerüste angewiesen sind, lässt sie wie technische Gewächse erscheinen, wie Ranken, Schlingpflanzen, ja, warum nicht: wie Parasiten im White Cube.

»Dir glaub' ich nicht mit dem Ohr/Dir glaub' ich nur mit dem Aug«, heißt es in Richard Wagners *Siegfried*, und diesen Apell an das offensichtlich vor unseren Augen liegende meint man auch in den Installationen Matthew McCaslins zu spüren. Alles ist einsehbar, nichts wird verschwiegen oder verdeckt. Jede Verbindung der Raumzeichnung macht einen Sinn! Die Elektrizität ist – wie jeder, der schon mal in eine Steckdose gefasst hat, weiß – eine gefährliche, aber letztendlich naive Kraft. Hier gibt es keine digitalen Tricks. Der Strom fließt analog, ein entmaterialisierendes Umrechnen in Nullen und Einsen, was dem zeitweiligen Verschwinden entspricht, gibt es nicht. McCaslin macht keine abstrakte Kunst. Zu sehen und mit allen Sinnen erfassbar sind im übertragenen Sinne integrierte Schaltkreise, keine Medienkunst (trotz der häufig verwendeten Monitore) und auch keine »Information Art«. Diese Lampe leuchtet, dieser Monitor flimmert, weil er am Strom-

kreis angeschlossen ist, und womöglich geht es weniger darum, eine Lampe zum Leuchten zu bringen, obwohl die Modulation von Licht und Schatten einen besonderen Reiz der Arbeit ausmacht; das Licht und andere Signale bezeugen, dass die Energie da ist. Eben: »Dir glaub' ich nur mit dem Aug'.« Wo der »Saft« herkommt, lässt sich sehend nachvollziehen, auch wenn die Kabel sich schon mal zur einem unübersichtlichen Gewirr verknoten. Doch solche gordischen Knoten sind durchlässig für den kreisenden Strom. Trotzdem entzieht sich die Arbeit beziehungsweise die Conditio sine qua non der sinnerfüllten Wege an einem Punkt dem Betrachterauge: Hinter der Steckdose beginnt das energetische Unterbewusstsein des Offensichtlichen. Die Ikonografie ist nicht nur durch die zeichnerische Lineatur der Wege gegeben. Schon die Lampen in ihren behelfsmäßigen Gehäusen deuten andere Kontexte an, welche die Uhren zu einer noch allgemeineren Bedeutung öffnen. Aus dem anderen (sozialen) Unterbewusstsein, das die Arbeiten von McCaslin auch speist, taucht die Frage nach der Zeit auf, zum Beispiel der Arbeitszeit (schließlich sind wir auf der »Site«, auf dem Arbeitsplatz, der Baustelle), doch im ornamentalen Gewirr, wo die Uhren zu Tränen mutieren können (*Tears of Corvette Summer*, 1995) arbeiten die Zeiger gegeneinander. Unser Zeitempfinden zerbricht. Die Uhr wird zum kinetischen Versatzstück, zum Allgemeinplatz, was auch für die Bilder der Monitore gilt. Ein grandioser Allerweltssonnenuntergang (*Alaska*, 1995, auch in den *Tears of Corvette Summer* wird er zitiert) glänzt für sich und eine falsche Romantik, grasende Kühe treten gegen Autos an. Das Aufblühen einer Knospe ist in extremem Zeitraffer gewaltsam forciert, ein Naturwunder wird vor unseren Augen abgespult. In *Surfs up* (1997) ist das bewegte Versatzstück ein Wellenreiter, der im schaumgekrönten Blau seine Endlosschleife zieht. Funsport. Zwei der Monitore sind kopfüber, also punktsymmetrisch gegeneinander getürmt, als sei das eine bewegte Spielkarte. Die elektrische Uhr läuft mit, doch ihre Kreise meinen etwas ganz anderes.

Surfing – Non-Stop Wave, 1997

Reinhard Ermen

Without electric current, nothing works anymore. This is as in the rest of life. That Matthew McCaslin occasionally kept his head above water by working as an electrician explains much about his work, and doesn't detract from its seriousness in the slightest. You don't learn such things at art school. A painter who earns money on the side by doing house decorating is, by contrast, a thoroughly comic figure. The other 'universities' are a presupposition for McCaslin's almost virtuoso handling of his favoured materials: wall sockets; distribution switches; construction lamps; cables in simple plastic coatings or in imposing metal safety sheathings; mirrored light bulbs that reflect light on the wall or on their handsome, simple porcelain sockets; clocks – always clocks; plus monitors and additional auxiliary equipment. Whoever writes about McCaslin cannot help but volubly follow his intricate paths of cables, a fact that can give many texts on his work – particularly essays in exhibition catalogues – a strange uniformity. (This introduction, too, cannot quite resist the pleasure of description; moreover, the fascinating ornament of the electric circuit produces ready metaphors.) The fact that these 'installations' are dependent on supporting walls, secure ground or ladders and scaffolding makes them appear to be technical growths, like tendrils, climbing plants, even – why not? – parasites in a white cube.

'My ears don't believe you,/Only my eyes believe you': those words from Richard Wagner's *Siegfried* – an appeal to what obviously lies before our eyes – apply equally to Matthew McCaslin's installations. Everything is observable; nothing is concealed or covered up. Each specification of space makes sense. Electricity is a dangerous force (as anyone who has put their finger in a wall socket knows), but ultimately a very basic one. There are no digital tricks here. The current flows in an analogue fashion: there is no dematerializing conversion into zeros and ones that might correspond to occasional disappearance. McCaslin does not make abstract art: integrated circuits are to be seen and – in the metaphorical sense – seized by all the senses. Neither is it media art (despite the frequently used monitors) or 'information art'. This lamp shines, that monitor flickers, because it is plugged into the electric circuit. Possibly it is less the matter of making a lamp shine (although the modulation of light and shadow does constitute a particular appeal of the work) and more the fact that the light and other signals testify that energy is there.

'Only my eyes believe you.' The source of the 'juice' can be visibly followed, even if the cables knot themselves into a confusing tangle. The circulating current can travel through such Gordian knots. Even so, the work, or the *conditio sine qua non* of the meaningful way, becomes withdrawn from the spectator's eye at some point. Behind the wall socket begins the energetic unconsciousness of the obvious.

The iconography is manifest not only in the draughtsman-like use of line. The lamps, in their improvised casings, suggest other contexts; and the clocks offer up a still more general meaning. Out of the other (social) unconsciousness, which also feeds McCaslin's work, there emerge questions about time. We may be in working time (after all, we are at a 'site' at the work place, at the construction site), yet in an ornamental tangle, where the clocks can mutate into tears (*Tears of Corvette Summer*, 1995), the hands work against one another. Our experience of time cracks. The clock becomes a kinetic set-piece, a commonplace; and this also holds for the pictures on the monitor. A grandiose sunset (*Alaska*, 1995; also referenced in *Tears*) shines for itself and gives a false romanticism; grazing cows enter the lists against cars. The blossoming of a bud is violently forced in very fast motion: a wonder of nature is torched before our eyes. In *Surfs up* (1997), the moving set-piece is the wave-rider who cuts an endless loop in the foam-crowned blue. Fun sport. Two monitors stand on their heads, leaning against one another like playing cards with moving images. The electric clock runs along with them, yet its circles mean something quite different.

Matthew McCaslin | **Tribal Time** | 1992/96 | Elektrokabel, Steckdosen, Glühlampe/electrical hardware, light bulb | Courtesy Kunstmuseum
St. Gallen | Leihgabe aus Privatbesitz/loan from private collection | Installationsansicht/installation view, Württembergischer Kunstverein Stuttgart

Matthew McCaslin | **Surfing – Non-Stop Wave** | 1997 | Videoinstallation/video installation | Kunstmuseum St. Gallen | Leihgabe aus Privatbesitz/ loan from private collection | Installationsansicht/installation view, Württembergischer Kunstverein Stuttgart

FLORIAN MERKEL

Soziale Anmut, 2002

Tobias Wall

»Die Beziehung des Künstlers zum Sport sagt etwas über seine Beziehung zum Leben überhaupt aus.«[1]

»Vor allem die jüngere Malergeneration neigt zur indirekten, verfremdeten Bildaussage, wobei vielfältige Kunstgriffe, wie das bewußte Zitieren von Motiven, die Übernahme ikonographischer Muster, die Adaption und Mischung unterschiedlichster Stilelemente vergangener Kunstepochen verwendet werden.«[2]

Auf dem Briefpapier von Florian Merkel steht »Diplomfotografiker«, ein Begriff, der nicht nur darauf hinweist, dass der Künstler von Haus aus Fotograf ist und in der DDR ausgebildet wurde,[3] sondern in dem auch die zwei künstlerischen Gestaltungsaspekte auftauchen, die Merkels Konzept für das Kuppelbild im Württembergischen Kunstverein Stuttgart ausmachen: Es handelt sich um großformatige Zeichnungen, die sich von Fotografien herleiten. Mit dieser Arbeit führt Merkel eine Werkreihe monumentaler Zeichnungen fort, die er 1997 mit den Entwürfen zum griechischen Penthesilea-Mythos begonnen hat und dessen letzter Höhepunkt im Frühjahr 2002 die zeichnerische Treppenhaus-Gestaltung im Haus der Kunst in München war.
Merkel teilt die Kuppel des Württembergischen Kunstvereins in übereinander geordnete Abschnitte und bevölkert sie mit verschiedenartigen sporttreibenden Gestalten. Er stellt seine Figuren nicht vollplastisch dar, sondern in feinen farbigen Umrisszeichnungen mit sehr reduzierter Binnenstruktur, die wie vergrößerte Nachkonturierungen

fotografischer Abbildungen anmuten. Bei den dargestellten Figuren, die sich im Bild mehrfach wiederholen, handelt es sich um Durchschnittstypen, die sich – teils nackt, teils in Turnkleidung – in sportlichen Ertüchtigungen ergehen: Sie beugen oder strecken sich oder liegen auch nur ruhend neben dem Szenario, wobei die meisten ganz auf sich konzentriert erscheinen. Andere haben sich zu gemeinsamen Sportübungen zusammengefunden, bewegen sich kollektiv, stehen auf- und übereinander oder helfen einander. Es scheint jedoch, dass auch die Menschen in diesen Gruppen vereinzelt und ohne Kontakt untereinander sind, ein kühles Nebeneinander, Berührung ohne Kraftübertragung (»Auf dem Weg nach oben ist jeder allein«). Die Aktionen der Figuren werden nach oben hin bewegter. Während die Figuren in den unteren Segmenten größtenteils auf dem Boden liegen und in ihren Ertüchtigungen horizontal, ja sogar nach unten orientiert sind, richten sich die Gestalten darüber in ihren Bewegungen immer weiter auf, um schließlich im oberen Wandabschnitt, zum Teil in gemeinsamer Anstrengung, an den Öffnungen der Lichter vorbei, noch weiter nach oben zu streben. Dort haben sich einige Menschen bereits aus den niederen sportlichen Mühen freigekämpft und richten den Blick aufrecht und nackt, wie in Erwartung höherer Weihen, zum höchsten Punkt der Kuppel.
Merkel knüpft mit seiner Wandzeichnung an die lange Tradition der idealisierenden Figurenkompositionen und damit an eines der wohl ältesten Motive der Kunstgeschichte an. Ausgehend von der griechischen Vasenmalerei und von Reliefs führte die Kunst das Streben des Menschen nach Vollendung immer wieder in der Form mehr oder weniger monumentaler Darstellungen von Sporthelden und ihren Taten vor.
Der Künstler greift in seiner Arbeit für den Württembergischen Kunstverein bewusst zentrale Aspekte dieses klassischen Darstellungstypus auf: das Thema der Idealisierung im Sport, die öffentlichkeitswirksame Ausstellungssituation und die Theatralik eines idealisierenden Monumentalwerkes. Seine Intention als Künstler jedoch entfernt sich grundlegend von seinen historischen Vorbildern. Zwar

inszeniert Merkel ein fulminantes Deckenbild, er lässt aber gleichzeitig den theatralischen Zauber seiner eigenen pathetisch historisierenden Bilddramaturgie an ihrem Höhepunkt auffliegen.

Auch wenn er die ästhetische Wirkung des dramatisch historisierenden Rahmens auskostet, rückt in seiner Arbeit die Kehrseite der Idealisierung ins Blickfeld: die Gleichschaltung und Reduzierung des Individuellen. Beim Versuch, sich selbst in der Ausrichtung am Ideal zu erhöhen, riskiert das Individuum seine eigene Neutralisierung. Zwar entwindet es sich der Schwerkraft der Mittelmäßigkeit, wird jedoch gleichzeitig als Individualpersönlichkeit uninteressant. Der Mensch verliert im Aufstieg zum Idealen seinen bergenden Untergrund, wird immer verlorener und heimatloser.

Diesem Aspekt der »Entleerung durch Verklärung« entspricht Merkels Darstellung seiner multiplen Gestalten als Umrisszeichnungen, die die individuellen Gesichtszüge der einzelnen Personen auf verschlossene Masken reduzieren. Seine Gestalten erscheinen im wahrsten Sinne des Wortes entleert, ausgegossen und aller inneren Lebendigkeit entledigt, wie in ihrer aller äußersten Hülle gefangen. Das Streben nach Vollkommenheit, das stets in der Aura des Sports mitschwingt, das heißt die Suche des Menschen nach einem entrückten Ideal, erweist sich in Merkels Wandbild letztlich als ein Kampf des Individuums gegen sich selbst, ein Kampf, aus dem es neutralisiert, unheldenhaft und gebeugt hervorgeht. Selbstvollendung als Selbstzerstörung.

1 Willi Sitte, ehem. Präsident des Verbandes Bildender Künstler der DDR, in einem Interview mit Wolfgang Schrader, in: Peter Kühnst, *Sport und Kunst. Sporting Art in der DDR*, Köln 1985, S. 2.

2 Hartmut Zimmermann (Hrsg.), *DDR-Handbuch*, Bd. 1, Köln 1985, zum Stichwort »Bildende Kunst«, S. 232.

3 »Diplomfotografiker« war der Ausdruck in der DDR für einen akademisch ausgebildeten Fotografen, entsprechend dem westdeutschen Fotodesigner.

Soziale Anmut, 2002

Tobias Wall

'The artist's relationship to sport tells us a lot about his relationship to life as a whole.'[1]

'It is above all the younger generation of painters that tends towards indirect, alienating forms of pictorial expression, making use of numerous artistic devices such as the deliberate citing of motifs, the adoption of iconographic patterns and the adaptation and combination of different stylistic elements from the art of the past'.[2]

Florian Merkel's letterhead reads *Diplomfotografiker* [Academically Qualified Photographer], a term that not only informs us that the artist is a photographer and was trained in the German Democratic Republic (the old East Germany),[3] but which also anticipates the two principle aspects of the approach Merkel has adopted in devising his concept for the decoration of the cupola of the Württembergischer Kunstverein in Stuttgart. Merkel's scheme consists of large-scale drawings, which are derived from photographs. This work continues a series on which Merkel embarked in 1997 (with his sketches inspired by the Ancient Greek myth of Penthesilea) and which attained its most recent highpoint in the spring of 2002 (with the graphic decoration of the staircase in the Haus der Kunst in Munich).

Merkel has divided the surface of the cupola into overlapping segments, each of which is peopled with figures engaged in various types of sports-related exercise. The figures are not rendered as fully three-dimensional; rather, the artist has used delicate coloured outlines with minimal indications of internal structure. The results resemble enlarged tracings of photographic images. The figures represent recurring types rather than unique individuals. Some are naked, some are wearing gymnasts' outfits; they are shown bending or stretching, or even simply resting, flat out, after their exertions – but all appear to be completely self-absorbed. Some figures have joined forces to perform group exercises, engaging in coordinated or collective activity, standing on one another's shoulders or in some way assisting each other. Yet even in these groups, the individuals appear to be isolated and enjoy no real contact with each other. It is, rather, a case of cool proximity: they touch each other but their touch conveys no strength. ('On the way to the top each one is alone.')

Higher up, the figures' movements become more energetic. While those in the lower segments are involved in exercises in which their bodies are aligned with the ground, and their movements are largely horizontal or even pointing downwards, the upper figures show an increasing tendency to move in an upward direction in order, finally, in the uppermost section of the cupola (and partly in a communal effort) to strive even further upwards beyond the skylights. There, a few individuals have freed themselves from the struggles that engage those below and, standing naked and upright, direct their gaze (as if in expectation of admission into a superior order of being) at the highest point in the cupola.

In his mural scheme Merkel joins a long tradition of artists engaged in idealized figure-painting and, moreover, in the depiction of what is probably one of the oldest motifs in the history of art. From a starting-point in the Ancient Greek tradition of vase painting and architectural sculptural relief, art has repeatedly presented humankind striving for perfection in the form of renderings – whether large or small in scale – of sporting heroes and their deeds. In his work for the Württembergischer Kunstverein Merkel consciously adopts central aspects of the 'classical' tradition:

the theme of idealism in sport, the scale and ostensible public accessibility of the setting, and the inevitably theatrical aspect of an idealizing large-scale work. His aims as an artist are, however, fundamentally distinct from those of his historical models. While it is true that Merkel offers us a brilliant scheme of decoration for the cupola, he nonetheless simultaneously undermines the theatrical magic of his own bombastically historicizing pictorial drama at its high point.

Even if Merkel clearly savours to the full the aesthetic impact of the dramatically historicizing setting, what comes to the fore in his work is quite the reverse of idealization: he shows us the homogenization and reduction of the individual. In the attempt to raise himself to match up to an ideal, the individual risks his own neutralization. While it is true that he may succeed in evading the gravitational pull of mediocrity, by the same token he becomes uninteresting as an individual personality. The individual, in his ascent to the ideal, loses his salutary grounding in the earth, and becomes increasingly lost and homeless. It is this aspect of 'deflation through transfiguration' that Merkel conveys in presenting numerous figures as outline drawings, so that the features of each face are reduced to those of a closed mask. His figures appear empty in the truest sense of the word: they have been relieved of their inner vitality, and it is as if all that there is left for the artist to record is their outermost shell.

The striving for perfection, which has always hovered about sport, humanity's search for an unearthly ideal, is ultimately revealed in Merkel's scheme as a battle of the individual with himself, a battle from which he emerges neutralized, unheroic and bowed. For Merkel, self-perfection is a form of self-destruction.

1 Willi Sitte, former President of the Federation of Artists of the German Democratic Republic, in an interview with Wolfgang Schrader, in Peter Kühnst, *Sport und Kunst. Sporting Art in der DDR*, Cologne 1985, p. 2.

2 Entry on *Bildende Kunst* [Fine Art] in Hartmut Zimmermann, ed., *DDR Handbuch*, vol. I, Cologne 1985, p. 232.

3 *Diplomfotografiker* was the term used in the German Democratic Republic for an academically trained photographer, the equivalent of what in the German Federal Republic [West Germany] was termed a *Fotodesigner*.

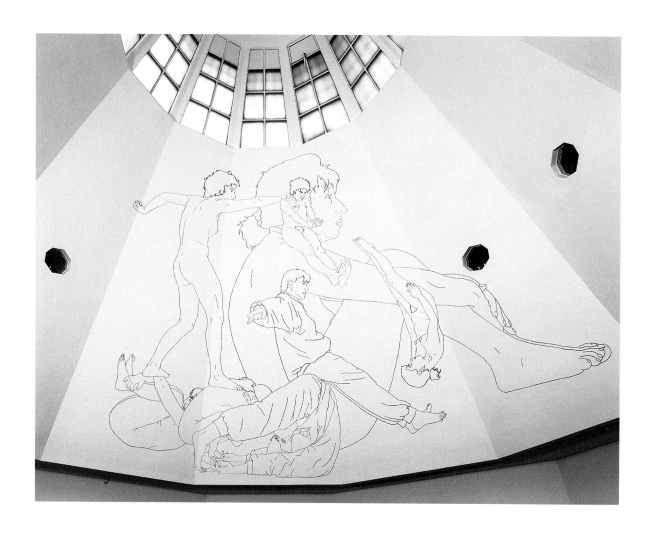

Florian Merkel | **Soziale Anmut** | 2002 | Wandmalerei/wall painting | Courtesy Galerie Wohnmaschine, Berlin | Installationsansichten / installation views, Württembergischer Kunstverein Stuttgart

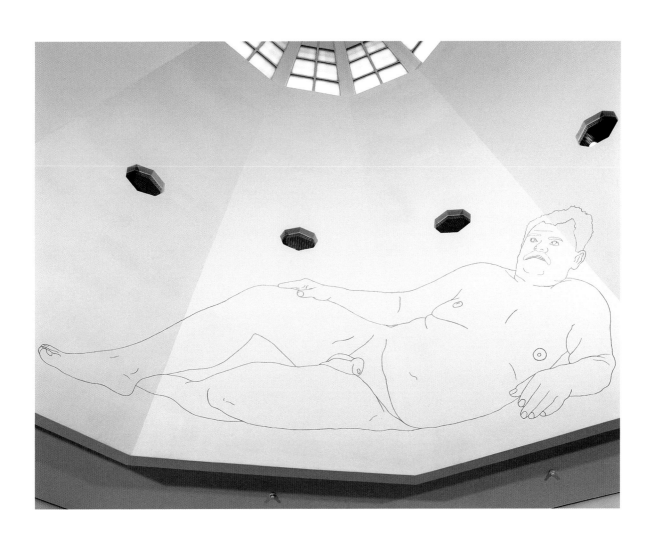

Florian Merkel | **Soziale Anmut** | 2002 | Computergrafik/digital drawing | Courtesy Galerie Wohnmaschine, Berlin

CAITLIN PARKER

I Wish I Was Roy Jones Jr., 2001

Rita E. Täuber

»How do you feel about women boxing?«
Roy Jones: »More women should consider it.«[1]

33 Jahre – 74 Kilogramm – IBF-, WBA-, WBC-Weltmeister im Halbschwergewicht – 45 Siege – eine Niederlage – 36 K.o.-Siege: Das ist das derzeitige Profil und die beeindruckende Kampfbilanz des amerikanischen Boxprofis Roy Jones Jr. Ein Superstar, der nebenbei professioneller Basketball-spieler ist, Musicals produziert, rappt, schauspielert, der sich gemeinsam mit Muhammad Ali für Erziehungsideale einsetzt und ein Frauen-Footballteam vor dem finanziellen Ruin rettet. Diesen »nice guy«, diesen Ausnahmeathleten, »der zehntausend Mal mehr ein Mensch als ein Boxer ist«[2], wählt Caitlin Parker als imaginären Protagonisten für eine Boxkampfparodie der besonderen Art.

Wie ihre Malerei, die sich auf Standbilder selbst inszenier-ter und selbst produzierter Videoarbeiten und Kurzfilme bezieht, handelt es sich auch hier um eine vergleichbar hybride Mischung, in der Dokumentation und Pseudodoku-mentation – Authentizität und Fiktion – sinnstiftend durchdrungen sind.

Unter dem Pseudonym »Roy Jones Jr.« steigt Caitlin Parker selbst in das magische Quadrat des Boxrings. »I am pretty, I am a bad man«, einer der legendären Einheizerslogans Muhammad Alis – des wohl brillantesten Ringstrategen –, gilt ihr, der schmächtig wirkenden, stupsnasigen weißen Frau, die siegesgewiss den Weltmeistergürtel schultert und in der Folge ihren hochgewachsenen, athletischen Heraus-forderer durch einen mehrfachen Knockdown in die Seile treibt. Die spartanische Inszenierung ohne die obligatori-schen Ring- und Punktrichter und ein aufgeheiztes Publi-kum kommt jedoch durch die Ausdruckslosigkeit seiner Akteure eher einer lapidaren Trockenübung gleich. Wären da nicht die authentischen wortstarken Kommentare der Ringberichterstatter, die den gestellten Kampfszenen pointiert und konterkarierend unterlegt sind. Damit ist man dabei, wie der amtierende Profi-Boxweltmeister Roy Jones Jr. im Jahr 1995 vor 12 000 Fans im Atlantic City Con-vention Center seinen Titel gegen Vinny Pazienza, den »Pazmanian Devil«, in nur sechs Runden und durch drei Knockdowns erfolgreich verteidigt.

Die boxende Caitlin Parker reiht sich mit dieser burlesken Inszenierung in die traditionsreiche Geschichte ein, die Kunst und Boxen und damit Künstler und Boxer seit den sportbegeisterten zwanziger Jahren verbindet. Ob Georges Braque, Jean Cocteau, George Grosz, Bertolt Brecht, George Bernard Shaw, Ernest Hemingway, Barnett Newman oder Josef Beuys, der auf der Documenta von 1972 mit einem seiner Schüler für »Direkte Demokratie« kämpft, all diese Männer zeigen sich vom physischen und psychischen Dra-ma des Faustkampfes ebenso fasziniert wie inspiriert.

So selten aber, wie Frauen in dieser hochgradig männlich geprägten Welt eine Rolle spielten, so selten beschäftigten sich Künstlerinnen mit diesem legitimen Akt der Tabuver-letzung. So verewigt beispielsweise Renée Sintenis den ge-stählten Körper Max Schmelings in Stein, und Marie Jo Lafontaine macht 1981 in ihrer Videoarbeit *Round around the Ring* das Boxduell zweier Schwergewichtsmeister zu einem ästhetischen Seherlebnis mit erotischer Verfüh-rungskraft.

Von alldem ist das betont leidenschaftslos inszenierte und dazu wenig schweißtreibende Box-Schauspiel Caitlin Par-kers weit entfernt. Vielmehr scheint hier der von Künstlern und Intellektuellen immer wieder beschriebene und be-schworene Vergleich, in dem das Boxen als ausdrucksstar-ke Parabel menschlicher Existenz, als Spiegel individueller und kollektiver menschlicher Aggressivität und Sinnbild der Antagonismen der Welt verstanden wird, gerade durch die gottgegebene Ungleichheit der Akteure ironisch auf die Spitze getrieben.

Mann und Frau als Gegner im Ring verleiten Caitlin Parker nicht zu den gewöhnlich damit verbundenen Schlussfol-gerungen. Auch wenn sich für Sekunden in diesem anson-sten emotionslos geradlinigen Schlagabtausch ein span-nungsgeladenes Moment der Verführung aufbaut, kann dies kaum darüber hinwegtäuschen, dass es sich hier we-niger um eine Neuauflage als vielmehr um einen amüsier-ten Abgesang auf den ewigen Kampf der Geschlechter han-delt.

Caitlin Parker bemächtigt sich wohl weniger als Frau denn als Künstlerin der Kräfte und Kampfstrategien eines drei-fachen Box-Weltmeisters. Ob diesem Akt der Verwandlung allerdings solcherart Parallelen zwischen Künstler und Boxer zugrunde liegen, die nach Joyce Carol Oates in der-selben »fanatische[n] Unterwerfung der eigenen Persön-lichkeit unter ein selbstgewähltes Schicksal« liegen, bleibt angesichts der fehlenden Dramatik offen.[3] Einzig der Titel dieser Arbeit, *I Wish I Was Roy Jones Jr.*, offenbart das Be-kenntnis, dass Boxern und Künstlern das Ringen um Ruhm und Scheitern gemeinsam ist. Und Boxen und Kunst braucht – wie der ehemalige Amateurboxer und Ausstel-lungsmacher Jan Hoet bemerkte – starke Promotoren.

1 Zit. nach der Website von Roy Jones Jr.: www.royjonesjr.com.

2 Ebd.

3 Zit. nach: Joyce Carol Oates, *Über Boxen*, Zürich 1988, S. 30.

I Wish I Was Roy Jones Jr., 2001

Rita E. Täuber

'How do you feel about women boxing?'
Roy Jones: 'More women should consider it.'[1]

Thirty-three years old – seventy-four kilos – IBF, WBA and WBC Light-Heavyweight World Champion – forty-five wins – one defeat – thirty-six knock-outs: this is the current record and the impressive results table of the professional American boxer Roy Jones Jr. A superstar of boxing, who is also a professional basketball player, who produces musicals, who raps and acts, who (like Muhammad Ali) has spoken up for the value of education, and who has saved a women's football team from financial ruin. And it is this 'nice guy', this exceptional athlete, 'who is 10,000 times more a human being than a boxer',[2] that Caitlin Parker has chosen as the imaginary protagonist for a special kind of parody of the boxing match.

As in her work as a painter, which derives from film stills taken from the video pieces and short films that she has directed and produced herself, she is here again concerned with a comparatively hybrid art form, in which meaning is achieved through the interpenetration of documentary and pseudo-documentary, authenticity and fiction.

Adopting the pseudonym Roy Jones Jr., Caitlin Parker herself steps into the magic square of the boxing ring. 'I am pretty, I am a bad man', one of the legendary slogans that featured in the warm-up routines of Muhammad Ali – probably the ring's most brilliant strategist – holds good for her too, the short, frail-looking, snub-nosed White woman, who, confident of victory, assumes the World Champion's sash and goes on to drive her tall, athletic challenger on to the ropes in a series of knock-outs. The spartan setting, without the obligatory scoreboard and excited crowd, gives the impression of a mere dry-run, especially on account of the lack of expression in both protagonists. What does make a difference are the authentically wordy commentaries of the ringside reporter, which both point up elements in the artificial confrontation and simultaneously undermine them. These commentaries tell us that it is 1995, the year in which the reigning professional Boxing World Champion Roy Jones Jr. successfully defended his title against Vinny Pazienza, the 'Pazmanian Devil', in only six rounds and with three knock-outs, in front of 12,000 fans at the Atlantic City Convention Center.

With this burlesque enactment, Caitlin Parker takes her place in a rich tradition of connections between art and boxing, and between artists/writers and boxers, that dates from the 1920s, a period of enormous enthusiasm for sport. Be it Georges Braque, Jean Cocteau, George Grosz, Bertolt Brecht, George Bernard Shaw, Ernest Hemingway, Barnett Newman or Joseph Beuys (who at the 1972 Documenta exhibition in Kassel boxed with one of his students for 'direct democracy'), each of these men proved to be as inspired as he was fascinated by the physical and psychic drama of the boxing match.

But just as women have played – and continue to play – a fairly insignificant role in this insistently masculine world, so it is only rarely that women artists have embarked on such a legitimate act of taboo-breaking. Renée Sintenis, for example, immortalized the steely body of Max Schmeling in stone, and Marie Jo Lafontaine, in her video piece of 1981, *Round around the Ring*, made the boxing duel of two heavyweights into a simultaneously seductive and aesthetic visual experience.

Caitlin Parker's very passionately directed yet relatively unstrenuous boxing drama is, however, far removed from these earlier works. Here, it is rather a case of the comparison that is repeatedly described and invoked by artists and intellectuals, in which boxing is understood as a strongly expressive parable of human existence, as a mirror of both individual and collective male aggression, and as a symbol of the antagonisms of the world – notions that here receive ironic emphasis precisely through the god-given inequality of the protagonists.

Yet man and woman as opponents in the boxing ring do not prompt Caitlin Parker to the conclusions usually reached in such circumstances. Even if, from time to time in the course of this otherwise unemotional and straightforward exchange of blows, there emerges an exciting element of seduction, this can hardly deceive us as to what we are watching: not so much a new version of the eternal battle of the sexes as an amused attempt to go through the motions of this confrontation. Nonetheless, the implications of the intentional lack of expression in the setting are to some degree countered by the notion informing this piece. It is not so much as a woman than as an artist that Caitlin Parker claims for herself the strengths and the fighting strategies of a three-times Boxing World Champion. On account of the lack of any real drama, it remains an open question as to how far this successful metamorphosis is dependent on the essential validity of the parallels between artist and boxer, parallels that Joyce Carol Oates has described as epitomized by the same 'fantastic subjection of one's own personality to a self-determined fate'.[3] Only in the title of Caitlin Parker's work, *I Wish I Was Roy Jones Jr.*, is there evidence of the admission that boxers and artists share the struggle for fame and the failure of that struggle. And, as the former amateur boxer and exhibition organizer Jan Hoet once remarked, both boxing and art need strong backers.

1 Cited at www.royjonesjr.com.

2 Ibid.

3 Joyce Carol Oates, *On Boxing*, Garden City, N.Y., 1987.

Caitlin Parker | *I Wish I Was Roy Jones Jr.* | 2001 | Videoprojektion/video projection

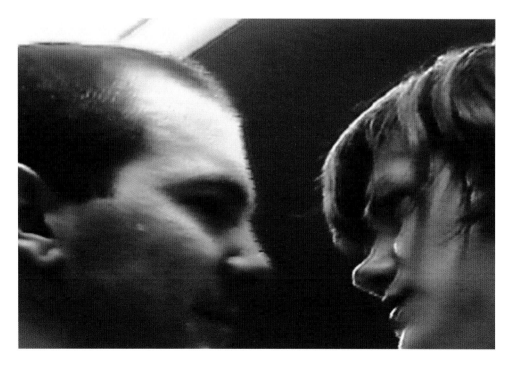

Caitlin Parker | **I Wish I Was Roy Jones Jr.** | 2001 | Videoprojektion/video projection

JOÃO PENALVA

Ralf Christofori

The Prize Song, 2001

Zwei Ringe hängen vor einem tiefschwarzen Hintergrund, Hände greifen nach ihnen, gepudert und bandagiert, in der extremen Nahaufnahme bleibt der Rest des Körpers unsichtbar. Plötzlich schnellt er nach oben, ein roter Turnanzug bekleidet Beine und Oberkörper, die Kamera bleibt dicht an den dynamischen Bewegungen. Ein kurzes Verharren in der ausbalancierten Position, die starken Oberarme – von Muskeln und Venen durchzogen – werden für einen Moment sichtbar. Der Schwung verwischt die Orientierung wieder, katapultiert den Turner in eine neuerliche Pose, um darin wiederum für einige Sekunden zu verharren. Diese Bilder sind suggestiv, sie präsentieren den männlichen Athleten und dessen Körperbeherrschung wie eine Art bildhaften Torso. Schwerer noch wiegt der Klang zu den Bildern: Das Reiben der Lederriemen setzt immer dann ein, wenn das Bild einen der stark beanspruchten Körperteile fokussiert, das Schlagen der Seile und der Haken lässt die geturnte Kür wie eine Tortur erscheinen. Am Ende des dynamischen Abgangs verschwindet der Körper aus dem Bild, die hölzernen Ringe schlagen aneinander, ihr lautloses Ausschwingen beendet die Videosequenz. Kein Applaus. Keine Verneigung vor dem Athleten. Der knapp dreiminütige Loop beginnt von neuem.

Ursprünglich als Teil einer umfassenden Installation im Rahmen der letztjährigen Biennale von Venedig gezeigt, entfaltet João Penalvas Videoarbeit *The Prize Song* auch als eigenständiges Werk einen vielschichtigen Resonanzraum, der das Motiv des Künstlers, sein Werk und dessen Ort unweigerlich in einen »kompetitiven Kontext« stellt.[1] Eingeleitet durch einen Auszug aus dem Libretto von Wagners *Meistersingern von Nürnberg*, gemahnt die Trias von Text, Bild und Klang an eine kodifizierte Form von Meisterschaft, die einer allgemeinen Logik nicht entbehrt: An deren Anfang steht die »Freiung«, jener Akt, der im Grunde einem Schwur gleicht, die Regeln und Anforderungen dieser Disziplin zu respektieren; es folgt der Wettstreit, an dessen Ende schließlich der »Meisterpreis« erworben beziehungsweise verliehen wird. Die »Leges Tabulaturae« der *Meistersinger* stehen dabei stellvertretend für eine Norm, die zur Maßgabe eines jeden gereicht, der es innerhalb der jeweiligen Disziplin zur Meisterschaft bringen möchte.[2]

Die les-, hör- und sichtbare Motivik von Penalvas Arbeit folgt einem zutiefst allegorischen Impuls, der sich von Anfang bis Ende des konzentrierten Stückes wie eine Ellipse um dessen zentrale Botschaft spannt. Die rhetorische Figur jedoch löst sich nicht etwa in die Bestandteile einer rein wahrnehmenden Konstellation auf, sondern sie verweist gleichsam auf die kulturelle Codierung, die sich an den fragwürdigen Prämissen einer solchen zur Meisterschaft gebrachten Körperbeherrschung aufzeigen lässt. In den Zwischenräumen von Text, Bild und Klang seziert Penalva die Ambiguität der perfekten Haltung, die Anmut des Körpers, die Disziplinierung des Willens und der Kraft: Die Schwerkraft reißt an den Gliedmaßen des Turners, die zur Schau gestellte Figur verharrt in schweißtreibenden Schwebezuständen, um letztlich in einem dumpfen Aufprall wieder am Boden anzukommen. Die Meisterschaft wird so zur ebenso physischen wie psychischen Zerreißprobe, das Zurschaustellen der Körperbeherrschung zur Tortur für die Betrachter.

In der Kür des Athleten wiederfahren uns so jene Paradoxa von »kompulsiver Schönheit« (»compulsive beauty«) und »konvulsiver Identität« (»convulsive identity«),[3] deren Anziehungskraft sich nicht nur aus den Wahrnehmungserfahrungen der Betrachter speist, sondern ebenso aus den Konventionen eines erwünschten oder sanktionierten Genusses. Die Regeln des Wettstreits erzeugen den Zwang, während sich die Identität des Wettkämpfers krampfhaft in dem Bestreben eines möglichst perfekten Vortrags seines Könnens windet. Wer den *Prize Song* João Penalvas genießt, wird es auf seine Weise tun. Psychisch wie physisch. Er oder sie wird sich an den Maßgaben eines imaginären Preisgerichts orientieren, sich in die Lage des Turners versetzen oder den beschriebenen allegorischen Impuls in andere kulturelle oder identitätsstiftende Gefilde ableiten. Ganz sicher aber wird man sich dieser Arbeit nicht entziehen können.

1 Pedro Lapa, »Sense and Subversion«, in: João Penalva. *R.*, AK Biennale di Venezia, Portugiesischer Pavillon, 2001, S. 35.

2 Penalvas Text zitiert jene Passage aus Wagners *Meistersingern von Nürnberg* (1. Akt, 3. Szene), in der Kothner, einer der Meistersänger, die »Leges Tabulaturae« verliest, die in diesem Falle für den Bewerber Walther von Stolzing und dessen angestrebte »Freiung« als bindend vorgetragen werden.

3 Vgl. Hal Foster, *Compulsive Beauty*, Cambridge und London 1993; darin insbesondere Kap. 2 und 3 sowie S. 102.

The Prize Song, 2001

Ralf Christofori

Two rings hang in front of a deep black background; hands, powdered and bandaged, reach up to them, but the rest of the body is invisible in the extreme close-up of the shot. Suddenly the body jerks up, a red leotard clothing legs and torso, and the camera remains trained on the dynamic movements. A brief pause in a position of balance, the strong upper arms – threaded by muscles and veins – are visible for a moment. Then the momentum again effaces the orientation, catapulting the gymnast into a new pose, before pausing once again for a few seconds. These images tell us something: they present the male athlete and his control over his own body as a sort of graphic torso. Even more emphatic is the sound accompanying the images: the rubbing of the leather straps always starts up when the image is focused on one of the heavily strained body parts; and the whiplash effect of the ropes and the presence of the hooks gives the voluntary gymnastics performance the air of a process of torture. After the dynamic finish the body disappears from the picture, the wooden rings clack against each other; and it is their noiseless swinging that ends the video sequence. No applause. No bows from the athlete. The film loop of barely three minutes begins again. Originally shown as part of an extensive installation at a recent Venice Biennale, João Penalva's video piece *The Prize Song* subsequently evolved as an independent work, the many-layered resonance of which locates the themes of the artist, his work and the place that his work occupies in a 'competitive context'.[1] Introduced by an excerpt from the libretto for Richard Wagner's *Die Meistersinger von Nürnberg*, the triad of text, image and sound alludes to a codified form of mastery that cannot dispense with a general logic: at its beginning there stands the 'liberation', the act that essentially resembles an oath to respect the rules and standards of this discipline; there follows the contest; and at the end of this the 'master prize' is eventually won or awarded. The *Leges Tabulaturae* of the *Meistersinger* stand in for a norm that provides a measure for everyone who would like to achieve mastery in his own discipline.[2]

The legible, audible and visible motifs of Penalva's work follow an extremely deep allegorical impulse, which runs throughout the concentrated piece like an ellipse around its central message. The rhetorical figure, however, does not, as it were, dissolve into the component parts of a purely perceptual combination; rather, it refers to the cultural codification that is revealed in the questionable premise of such control over the body brought to mastery. In the interstices of text, image and sound Penalva dissects the ambiguity of perfect poise, the body's beauty, the disciplining of will and strength. Gravity tears at the limbs of the gymnast, the exposed figure halts in sweat-inducing floating states, in order ultimately to come to rest once again with a dull thud. Mastery is, then, a gruelling ordeal, as physical as it is psychological; and, for the observer, the display of the control of the body is a form of torture.

In the voluntary exercises of the athlete, then, we encounter yet again those paradoxes of 'compulsive beauty' and 'convulsive identity',[3] the attraction of which is not only dependent on the viewer's experiences of perception, but equally on the convention of a desired or sanctioned pleasure. The rules of the competition generate the compulsion, while the identity of the competitor is entwined awkwardly with the striving for as perfect as possible a demonstration of his abilities. Whoever enjoys João Penalva's *Prize Song* will do so in these terms – both psychologically and physically. He or she will take his or her bearings from the terms established by an imaginary Prize Jury: to place him or herself simultaneously in the place of the gymnast, or to derive the described allegorical impulse in other cultural or identity-establishing fields. What is quite certain, however, is that it is not possible to evade this piece.

1 Pedro Lapa, 'Sense and Subversion', in *João Penalva – R.* (exh. cat.), Portuguese Pavilion, Venice Biennale 2001, p. 35.

2 Penalva's text cites the passage from Wagner's *Die Meistersinger von Nürnberg* (Act I, Scene 3), in which Kothner, one of the master singers, reads out the *Leges Tabulaturae*, which in this case are presented as binding on the applicant Walter von Stolzing and the 'liberation' he desires.

3 Cf. Hal Foster, *Compulsive Beauty*, Cambridge, Mass./London 1993, esp. chapters 2 and 3, also p. 102.

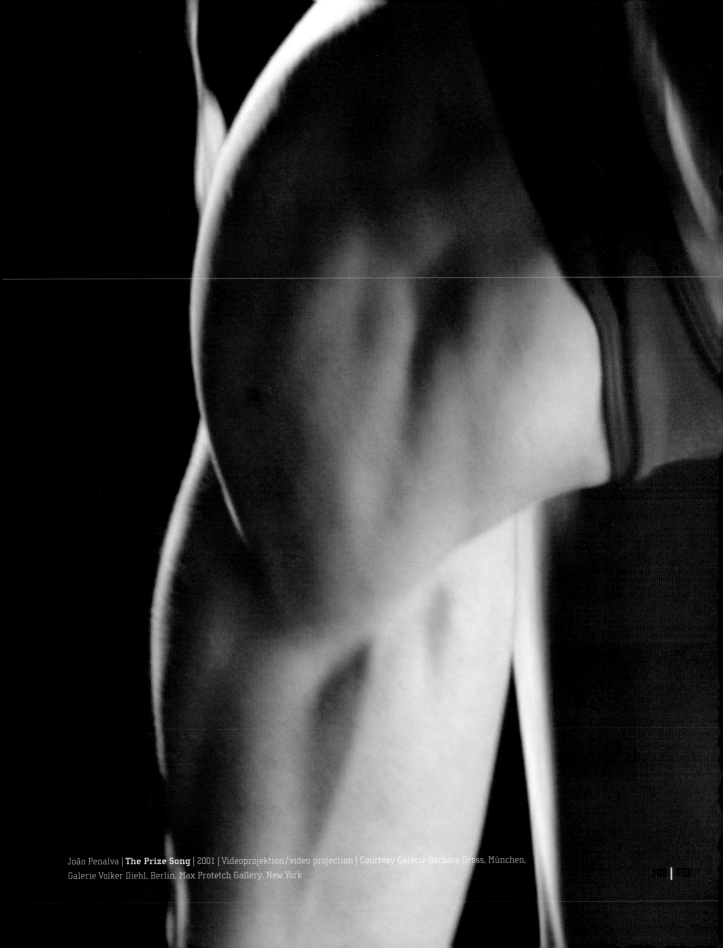

João Penalva | **The Prize Song** | 2001 | Videoprojektion / video projection | Courtesy Galerie Barbara Gross, München,
Galerie Volker Diehl, Berlin, Max Protetch Gallery, New York

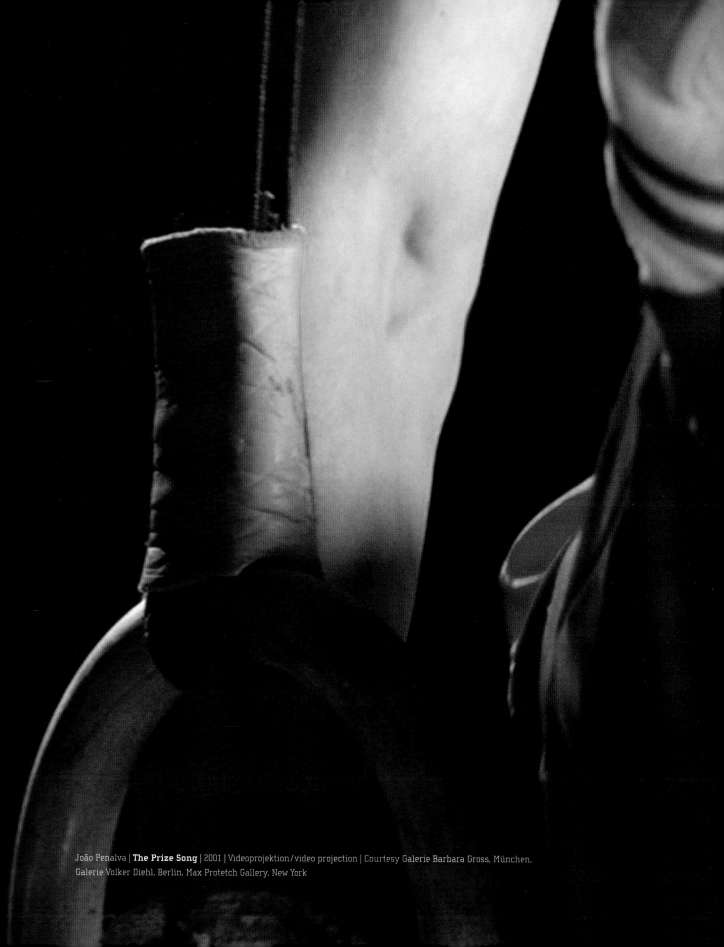

João Penalva | **The Prize Song** | 2001 | Videoprojektion/video projection | Courtesy Galerie Barbara Gross, München, Galerie Volker Diehl, Berlin, Max Protetch Gallery, New York

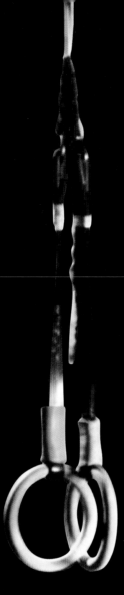

DOROTHEA SCHULZ
FELICIA ZELLER

Tobias Wall

»Geh«, »Nach vorn«, »Gib ab«, 2002

»[…] daß der Mensch endlich kurz daß der Mensch in Kürze endlich trotz der Fortschritte der Ernährung und der Abschaffung des Stuhlgangs im Begriff ist abzumagern und zugleich parallel verlaufend man weiß nicht warum trotz der Blüte der Leibesübungen der Praxis der Sportarten wie wie wie Tennis Fußball Rennen zu Fuß und mit dem Fahrrad Schwimmen Reiten Fliegen Siegen Tennis Kegeln Kunstlauf auf Eis und Asphalt […]«

Samuel Beckett, *Warten auf Godot*

Tableaux, so nennen Dorothea Schulz und Felicia Zeller ihre neuesten gemeinsamen Arbeiten, die sie erstmals im Württembergischen Kunstverein Stuttgart vorstellen. Es handelt sich um eine Zusammenführung von Bildkunst und Textkunst auf dem Computer, die sich konsequent aus der bisherigen Arbeit von Dorothea Schulz entwickelt hat. Für Schulz' Werk sind Texte, vor allem aber die gesprochene Sprache, seit langem ein wichtiger Bezugspunkt, etwa bei ihren gezeichneten Jahrbüchern oder dem Projekt *Apprendre le Français/Französisch lernen*, bei dem sie ihre Erfahrung mit einer ihr unbekannten Sprache in unzähligen Zeichnungen umsetzt und davon ausgehend Objeke und Interieurs entwickelt.[1]

Die Träger der *Tableaux* sind Computermonitore. Diese zeigen vor farbigem Hintergrund merkwürdige Strichfiguren, sich überschneidende einzelne Geschöpfe oder amorphe Figurenhaufen, die ineinander fließen beziehungsweise auseinander herauswachsen, wobei nicht auszumachen ist, ob es sich um menschliche Individuen, männliche oder weibliche Personen, um Tiere oder degenerierte Comicfiguren handelt. Es sind dieselben eigenartig neutralen Kreaturen, die in verschiedenartigster Ausführung das gesamte Schaffen von Dorothea Schulz bevölkern und welche die Künstlerin schlicht »Wesen« nennt. Die Bilder sind mit Sprachsequenzen unterlegt. Man vernimmt eigenartige Textloops, bei denen zum Beispiel ein Sprecher, begleitet von stimmungsvollem Pianospiel, von seinen »knirschenden, knackenden Knöcheln« erzählt oder ein Sport-

reporter unzusammenhängende Berichtcollagen wiederholt. Die Zeichnungen auf dem Bildschirm sind nicht statisch: Da und dort scheinen kleine Bewegungen der Figuren dazu einzuladen, näher zu treten und mit den *Tableaux* Kontakt aufzunehmen. Und wirklich: Es gibt einen Cursor, mit dem man das Bild aktivieren kann. Gerät er auf eines der Wesen, beginnt es sich zu regen: Eine der Figuren beginnt mit den Beinen zu strampeln, eine andere steht auf oder legt sich nieder, und jedes der angeklickten Wesen stößt bei seiner Aktion einen eigenartigen Laut aus, mal ein Seufzen, mal ein Husten. Per Doppelklick lassen sie sich sogar noch weiter in Bewegung versetzen: Einige verlassen ihren Ort und platzieren sich in neuer Haltung in einer anderen Ecke des *Tableau* (sie können durch Anklicken wieder zur Umkehr veranlasst werden), andere laufen kurz aufhüstelnd einfach los oder kugeln quer über den Bildschirm, um dann von selbst wieder in ihre ursprüngliche Position zurückzukehren, wieder andere hantieren mit absonderlichen Gerätschaften (Sportgeräten?). Die fremdartigen Sätze, die das sonderbare Treiben auf dem Bildschirm begleiten, bleiben ungeachtet der Veränderungen des Bildes unbeirrt immer die gleichen.

Zwar setzt sich der Text, der eines der *Tableaux* begleitet, aus Teilen einer Sportreportage zusammen, eine direkte Verbindung zu einem konkreten sportlichen Ereignis wird allerdings nicht hergestellt. Es scheint weder einen unmittelbaren Zusammenhang zwischen Text und Bild noch zwischen dem *Tableau* und Sport zu geben.

Was, so könnte man fragen, suchen diese *Tableaux* in einer Ausstellung, die sich das Thema Sport gewählt hat und die überdies »Body Power/Power Play« betitelt ist? Die Arbeiten scheinen auf den ersten Blick fremdartig im Kontext des Sport. Sport? Was ist das überhaupt ... Sport?

Erwachsene Menschen bringen sich an den Rand der totalen Erschöpfung, sie setzen sich schmerzhaften Anstrengungen aus, verrenken sich, bekämpfen und schlagen einander... wofür? Welches Ziel rechtfertigt diesen Wahnsinn, diese Verschwendung von Emotion und Kraft? Und jeder will dabei sein, die totale Emotion ..., und das alles für zielloses Stoßen Rennen, Zappeln ... Mühsal nach Regeln, aber ohne Sinn? Absurd.

Es ist gerade dieser absurde Zug des Unterfangens Sport, der in den *Tableaux* von Dorothea Schulz und Felicia Zeller in ein hintergründiges und verschlungenes Spiel eingearbeitet wird.

Die Figuren, die sich auf den Bildschirmen regen, sich recken, hüpfen, laufen und kugeln, sind das Gegenteil von Sportlerhelden: Es sind verwachsene Kopffüßler, Rübenmännchen mit Schlappmütze oder Hypochonder, die sich wehleidig den Bauch halten und mit den Beinen ausschlagen. Entsprechend sind die Laute, die sie von sich geben, wenig heroisch: ein Hüsteln, ein Quieken, ein Seufzen. Ihre Bewegungsabläufe sind sinn- und zusammenhangslos, ohne Halt im Raum, sie erinnern an die absurden Körperverrenkungen von Beckett-Figuren: maximaler körperlicher Einsatz bei minimalem Ergebnis, ja sogar ganz ohne Resultat, denn ein Ziel ihrer Bewegungen ist nicht erkennbar. Die komischen Wesen kehren nach Verrichtung ihrer Bewegungen immer wieder an den Anfangsort ihrer hoffnungslosen Mühen zurück. Sisyphos statt Adonis.

Entsprechend verwinkelt und verworren entwickelt sich das Verhältnis der Betrachter zu dem Ereignis auf dem Bildschirm. Es erscheint wie eine Art Sportzuschauerpersiflage, denn zunächst versetzen Schulz und Zeller die Betrachter mit ihren interaktiven *Tableaux* in eine Position, von denen Sportbegeisterte immer träumen, wenn sie vor dem Bildschirm sitzen: Sie können aktiv teilnehmen und dem Geschehen genau den Verlauf geben, der ihnen gefällt (»Mensch, gib doch ab!«). Im Falle der *Tableaux* zeigt sich allerdings schnell, dass die Betrachter, obwohl sie in der Lage sind, die Akteure zu aktivieren und deaktivieren, we-

niger Eingriffsmöglichkeiten auf die Figuren und deren Bewegungsabläufe haben als zunächst angenommen. Auf dem Bildschirm finden Veränderungen statt, die sie gar nicht ausgelöst haben, und manches Anklicken, das gerade noch ein Wesen hatte hüpfen oder zucken lassen, bleibt folgenlos. Die Interaktivität, mit der das Bild gelockt hat, erweist sich als verschraubte Hermetik, die lediglich durch einige Bewegungsrelais Lebendigkeit vortäuscht. Jegliche Versuche, in die Bewegungsabläufe und Figurenkombinationen einen eindeutigen Sinn, eine Geschichte oder einen geregelten Spielablauf hineinzulegen, bleiben ergebnislos. Dorothea Schulz und Felicia Zeller erschaffen mit ihren *Tableaux* einen virtuellen Raum, in dem sie ihre Wesen in ein Eigenleben entlassen, das sich nicht nur dem direkten Zugriff, sondern auch jeglicher ordnungssuchender Rationalität widersetzt. Nicht die Betrachter spielen mit den Wesen, die Wesen spielen mit dem Publikum. Die obskuren Kreaturen fordern die Spieler immer wieder und immer weiter zur Aktion heraus, ziehen sie auf das Feld ihres regellosen Treibens, um sie schließlich wieder an den Spielfeldrand und damit auf ihre machtlose Zuschauerposition zurückzuschicken.

1 Dorothea Schulz, *Apprendre le Français/Französisch lernen*, Valence 2001.

'Geh', 'Nach vorn', 'Gib ab', 2002

Tobias Wall

'[...] that man in short that man in brief in spite of the strides of alimentation and defecation wastes and pines wastes and pines and concurrently simultaneously what is more for reasons unknown in spite of the strides of physical culture and the practice of sports such as tennis football running cycling swimming flying floating riding gliding conating camogie skating tennis of all sorts [...]'

Samuel Beckett, *Waiting for Godot*

'Tableaux' is the term that Dorothea Schulz and Felicia Zeller use to describe their most recent joint project, exhibited for the first time at the Württembergischer Kunstverein in Stuttgart. It deals with a synthesis of pictorial art and text art using the computer as medium, in keeping with the development of Dorothea Schulz's work to date. Texts – particularly the spoken language – have been an important point of reference for the artist, as in her signed diaries, for example, or the project *Apprendre le Français/Learning French*, in which she converts her experience of unknown languages into numerous characters and then proceeds to develop objects and interiors referring to them.

The 'plates' of the tableaux are computer monitors. Against a coloured background, they depict rather peculiar cartoon characters, overlapping single creations or amorphous heaps of figures that flow into or grow out of one another. It is impossible to determine whether they are meant to be human beings, males or females, animals or degenerate comic figures. They belong to the same family of unique neutral creatures that, in extremely diverse ways, populate Dorothea Schulz's entire creative output and which the artist simply calls 'beings'.

The pictures are set to language sequences. One hears strange text loops in which, for example, a speaker relates a story accompanied by atmospheric piano playing and 'crunching, crackling knuckles', or disconnected excerpts from a sports reporter's commentary are repeated to form a collage. The symbols on the screen are not static: here and there, small movements of the figures appear to invite the observer to come closer and to make contact with the tableaux. And yes – there is a cursor, which one can use to activate the picture. If one touches one of these beings, it begins to move: one of the figures starts to thrash about with its legs, another stands up or lies down, and each of

the beings that is clicked on emits a strange noise as it moves – sometimes a sigh, sometimes a cough. With a double click they can be set further in motion: a number of them leave their places and move to a new position in another corner of the tableau (by a click they can be made to return to their original starting place); others simply begin to walk and emit a short cough or roll right across the screen, so as to return to their original start position; while yet others fiddle with peculiar objects (work-out equipment perhaps?). While the picture changes, the strange sentences that accompany the odd activity on the screen remain the same. For example, the text that accompanies one of the tableaux is composed of parts of a sports report, but there is no actual sporting event on the screen. It would appear that there is no direct connection between text and picture, nor between tableau and sport.

What, then, one may well ask oneself, do these tableaux have to do with an exhibition that has sport as its theme and which is entitled 'Body Power/Power Play'? At first glance the work would appear to have little or nothing in common with sport. Sport? What is it anyway?

Adults push themselves to the outer limits of physical exhaustion, they subject themselves to painful exertion, contort themselves, fight and beat each other – why? What kind of aim could possibly justify this madness, this waste of emotion and energy? And everyone wants to be there – it is total emotion. And all this is in aid of some aimless pushing, running, fidgeting – trials and tribulations according to rules and yet without any meaning. Absurd.

It is precisely this absurd feature of the business of sport that is incorporated into the tableaux of Dorothea Schulz and Felicia Zeller in an enigmatic game. The figures that move on the screen, that stretch, hop, run and roll are the antithesis of sports heroes: wishy-washy cephalopods, pumpkin-men with floppy caps or hypochondriacs, holding their bellies in pain and kicking out with their legs. The sounds corresponding to these gestures are somewhat less heroic: a cough, a squeak, a sigh. Their movements are without meaning and disconnected, without poise and support in space. They are reminiscent of the absurd bodily movements of Beckett's figures: with maximum physical exertion and minimum result, indeed, entirely without result, as the movements have no recognizable aim. These strange beings always return to the starting point of their hopeless efforts after going through their motions. Sisyphus instead of Adonis.

Correspondingly convoluted and muddled, the relationship between viewer and event unfolds on the screen. It appears to be a sort of satire on the typical sports audience since, with their interactive tableaux, Schulz and Zeller place their audience in a position that sports fans always dream of when sitting in front of their screens. Finally they can actively participate and influence events in whichever way they choose ('Pass the ball, man!'). However, with the tableaux it is quickly determined that the observers, even though they are in a position to activate and deactivate the actors, have less scope for influencing a figure's actions and the course of their movements than initially supposed. Changes occur on the screen which they may not have initiated, and some clicks that should have induced a hop or a twitch fail to do so. The interactivity with which the picture had initially lured the observer turns out to be a hermetic form of madness, which merely feigns vitality by means of relays of movements. All attempts to introduce a clear meaning to the movements and the combinations of figures, to create a story or a regular game course, are without result.

With their tableaux Dorothea Schulz and Felicia Zeller have created a virtual space in which they provide their beings with an independent life that resists not only direct access but also all forms of rationality-seeking order. It is not the viewers that play with the beings but rather the beings that play with the public. The obscure creatures increasingly demand further action of the players, and draw them into the field of their irregular activities – all so as to finally send them back to the periphery of the sports field and, thereby, return them to their powerless position as audience.

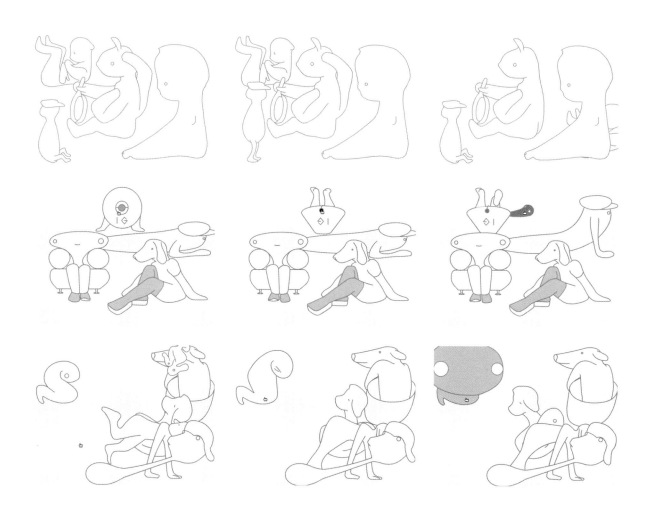

Dorothea Schulz/Felicia Zeller | **Geh** | **Nach vorn** | **Gib ab** | 2002 | Tableau (Computerinstallation)/tableau (computer installation)

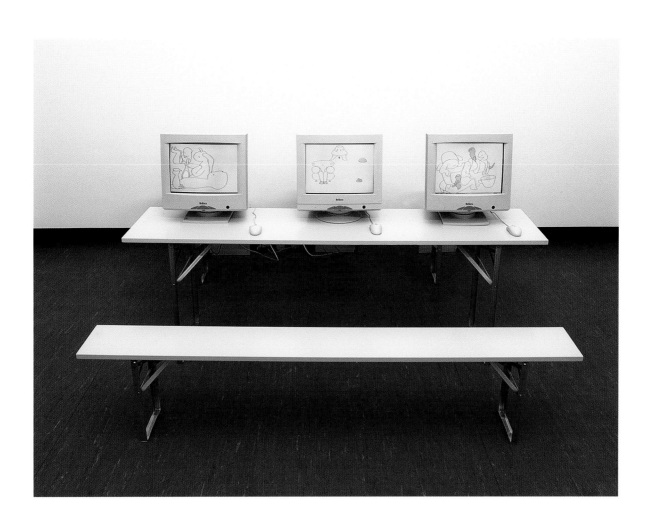

Dorothea Schulz/Felicia Zeller | **Geh** | **Nach vorn** | **Gib ab** | 2002 | Tableau (Computerinstallation)/tableau (computer installation) |
Installationsansicht/installation view, Württembergischer Kunstverein Stuttgart

KAREN SHAW

Tobias Wall

Sport's Wear , 2002

»Art making is lonely and often frustrating, so I like to amuse myself and get as much pleasure out of the experience as possible.«[1]

<div align="right">Karen Shaw</div>

Mit *Sport's Wear* stellt Karen Shaw eine Werkserie vor, die in ihrem bisherigen Schaffen keine unmittelbaren Vorläufer hat. Bekannt wurde die Künstlerin in den siebziger Jahren mit ihren konzeptuellen Wort- und Zahlenspielen, den so genannten *Summations* oder *Summantics*. Die Grundlage der *Summantics* besteht in der Zuordnung der Buchstaben des englischen Alphabets zu ihrer jeweiligen Positionszahl (a = 1, b = 2 und so weiter). Worte erhalten Zahlenwerte, und Zahlen stehen für Worte. (Der Name der Künstlerin ergibt zum Beispiel in der Quersumme der Positionsnummern seiner Buchstaben den Wert 100, 100 wiederum kann als Quersumme dem Wort »telephone« zugeordnet werden). Auf diese Weise ergibt sich ein unendliches kreatives Feld, das die Künstlerin bis in die Gegenwart in unterschiedlichsten Bereichen weiterentwickelte. So ermittelte sie zum Beispiel die Quersumme von Werken der Weltliteratur oder des Matthäus-Evangeliums, suchte aber auch Begriffe, die den Preisen von reduzierten Supermarktartikeln entsprechen.

Ein unmittelbarer Zusammenhang der hier vorgestellten Arbeit zum bisherigen Werk Shaws scheint auf den ersten Blick nicht zu bestehen. Bei *Sport's Wear* löst Karen Shaw Sportkleidung auf. Sie verwendet hierfür typisch amerikanische Sporttrikots in satten Farben, die kontrastreich mit großen Zahlen und Buchstaben bedruckt sind. Von den Schultern bis zur Brust zeigen die Shirts noch ihre kompakte sportliche Pracht, im unteren Drittel jedoch wird das dichte Gewebe allmählich lockerer und löst sich immer weiter in einzelne Fäden auf, um schließlich in ein fein gesponnenes Netz überzugehen. Das robuste Sporthemd verwandelt sich in ein zartes, unendlich langes, durchsichtiges Kleid. Obwohl *Sport's Wear* mit den *Summantics* in ihrer komplexen Wort- und Zahlenkombinatorik direkt nichts zu tun hat, sind die Wurzeln für diese Werkgruppe eindeutig in Shaws früherem Werk zu suchen. Seit den siebziger Jahren taucht bei ihren Arbeiten immer wieder Sportkleidung auf. Die Künstlerin arbeitet mit den großen Nummern auf den Shirts von Footballspielern und ordnet ihnen nach dem Prinzip der Summantics Begriffe zu, die – weil zufallsgeboren – keinerlei Rücksicht auf die heroischen Posen der Supersportler nehmen. Ein Spieler mit der Nummer 29 erhält das Wort »calm« (ruhig), Nummer 88 wird mit »chilly« (frostig, kühl) betitelt, Nummer 63 bekommt den Begriff »skies« (Himmel) zugeordnet. Aus diesen zufälligen Zuordnungen ergeben sich absurde Konstellationen, die Assoziationen wecken, durch die eingefahrene Wahrnehmungsmuster in neo-dadaistischer Manier konterkariert werden.

Karen Shaw liebt es, »paradoxe Situationen zu visualisieren, um sich über Langweiligkeit und Einseitigkeit festgefahrener Denkweisen lustig zu machen«, wie Jean Sellem es formuliert.[2]

Diese Umlenkung der Wahrnehmungsgewohnheiten bezweckt Shaw auch mit ihren Sports-Wear-Shirts. Doch während sie dies bei ihren *Summantics* nach alter Dada-Manier dem Zufall überlässt, bezieht sie mit ihren Sportshirts eine klare Stellung. Sie hat ein konkretes Angriffsziel: den männlichen Machismo, der viele, gerade amerikanische Sportarten wie Basketball oder Football prägt. Die Künstlerin verwandelt die mythosbeladenen Wettkampftrikots von Sportlern – Sinnbilder für typisch männliche Tugenden wie Kampfgeist, Kameradschaft und Siegeswillen –, in lange durchsichtige Gewänder, also in Frauenkleidung, die nicht nur für ganz andere Eigenschaften stehen, sondern die auf dem Spielfeld auch völlig unbrauchbar wären. In diesen Gewändern würde der Wettkampf zum Tuntenballett, das Spielfeld zum skurrilen Amateurlaufsteg.

Eine verbissen feministische Kulturkritik liegt Shaws Arbeit allerdings nicht zugrunde. Für sie zählt vor allem die kreative, ironische Seite ihrer Kunst: »Künstlerische Arbeiten, die mich zum Lachen bringen, gefallen mir, vor allem dann, wenn ich selbst daran arbeite.«[3]

Wie bei ihren *Summantics* ist auch bei *Sport's Wear* Karen Shaws Antrieb die Lust am Spiel, am Experimentieren mit dem Gewohnten. Ihr Ziel ist es, die Wahrnehmung zu wecken, indem sie das Selbstverständliche – mit einem Augenzwinkern – unverständlich macht.

1 Zit. nach einem Interview von Jean Sellem mit Karin Shaw, in: *Heterogénesis*, Nr. 33, Oktober 2000, S. 23.

2 Ebd., S. 29.

3 Ebd.

Sport's Wear, 2002

Tobias Wall

'Art making is lonely and often frustrating, so I like to amuse myself and get as much pleasure out of the experience as possible.'[1]

Karen Shaw

With *Sport's Wear*, Karen Shaw exhibits in Stuttgart a series of works that has no direct precedent in her earlier output. The artist achieved recognition in the 1970s for her conceptual word and number games, the *Summations* or *Summantics*. The *Summantics* were based on the arrangement of the letters of the English alphabet according to their respective positions within a numerical sequence (A = 1, B = 2, and so on). By this means, words acquired numerical values and numbers stood for words. (The artist's name, for example, expressed as the sum of the position numbers of its letters, comes out as 100, in other words 'Karen Shaw = 100', while 100 as a cross-sum in its own right could in turn be assigned to the word 'telephone', and so on.) In this way there arose endless scope for creativity, which the artist has continued to exploit in a diverse range of applications. She has established, for example, the cross-sum of masterpieces of world literature and of the Gospel according to Saint Matthew, and has also sought out concepts to match the prices of reduced items in a supermarket.

At first glance, there appears to be no direct connection between the piece exhibited here and these 'classic' examples of Karen Shaw's work. In the present work, the artist unravels 'Shaw Sportswear'. To this end, she uses typically American sports sweaters in deep colours, which are printed with large, boldly contrasting numbers and letters. Across the shoulders and over the chest the sweaters still evince their compact sporty splendour, but in their lower third or so the dense weave becomes gradually looser, eventually fraying, and ending as a finely spun net of individual threads. The robust sports shirt thus metamorphoses into a delicate, infinitely long, transparent dress. Although *Sport's Wear* has no direct connection with the complex combination of words and numbers in the *Summantics*, its roots are nonetheless to be found in Karen

Shaw's earlier work. Since the 1970s Shaw has repeatedly engaged with the theme of sportswear. She has worked with the large numbers printed on the shirts of footballers, allocating them, according to the principle informing the *Summantics*, to concepts that – because generated randomly – take no account of the sports superstars' heroic poses. A player who wears number 29 is allotted the word 'calm', number 88 is subtitled 'chilly', while 63 acquires the notion of 'skies'. This process gives rise to absurd combinations, which in turn provoke webs of association, by means of which the familiar patterns of perception are undermined, in the spirit of Neo-Dada. As Jean Sellem has observed: 'Karen Shaw loves to visualize paradoxical situations or things, in order to ridicule the boring or totalitarian one-dimensional and static way of thinking.'[2]

Shaw also aims at this re-routing of the patterns of perception with her sportswear. Yet while her *Summantics* – in the best tradition of Dada – left this process to chance, with her sports shirts she clearly adopts a particular ideological position. Here she has a specific target: the *machismo* that imbues many sports, and especially those that are essentially American: basketball or American football. She transforms the myth-laden competitive shirts – these symbols of traditional male virtues such as combativeness, comradeship and determination to win – into long transparent gowns, that is to say into women's clothing, which not only stands for entirely different qualities but which would be entirely useless on the playing field. In these gowns the competition becomes an effeminate ballet, and the playing field a grotesque amateur catwalk.

One should not, however, assume that an embittered feminist cultural critique is implicit in Shaw's work. What matters to her is, above all, the creative, ironic side of her art. As she has herself confessed: 'Works that make me laugh have great appeal to me, especially in the making [...]'.[3]

As in the case of *Summantics* so it is in *Sport's Wear.* Karen Shaw's motivating principle is a delight in play, in experimenting with the habitual. Her goal is to awaken perceptions – albeit always with an artful wink of her eye – through making the self-evident incomprehensible.

1 Karen Shaw interviewed by Jean Sellem, in *Heterogénesis*, no. 33, October 2000, p. 23.

2 Ibid., p. 29

3 Ibid.

Karen Shaw | **Basketball Gowns** | 2002 | Tuschezeichnungen auf Farbkopie | Kunststofffolie/colour xerox, Mylar and ink | c. 28 x 21 cm

Karen Shaw | **Sport's Wear** | 2002 | Sporttrikots / sports t-shirts | Installationsansicht / installation view,
Württembergischer Kunstverein Stuttgart

GRAZIA TODERI

Il decollo, 1998

Ralf Christofori

»Masse ist der *Durchschnittsmensch*. So verwandelt sich, was vorher nur Anzahl war – die Menge –, in eine Beschaffenheit: die allen gemeine Beschaffenheit nämlich; das sozial Ungeprägte; der Mensch, insofern er sich nicht von anderen Menschen abhebt, sondern einen generellen Typus in sich wiederholt.«[1] Für den spanischen Philosophen José Ortega y Gasset ist der Massenmensch ein sich selbst aufgebendes Ich. Er gehorcht einer übergeordneten Macht, einem Ideal, welches die Massenpsychologie als eine Art »Ich-Ideal« zu beschreiben pflegt. In der Masse reagiert dieser Mensch nur noch, er befolgt die Regeln der Allgemeinheit, reproduziert die Muster zumindest temporär Gleichgesinnter und ist nur mehr als Teil eines größeren »Ornaments der Masse« beobachtbar. Siegfried Kracauer hat in seinem gleichnamigen Buch darauf hingewiesen, der Mensch könne dieses Ornament wohl dann am besten beobachten, wenn er sich hinaufschwingt in die Perspektive einer Luftaufnahme, um so den Blick aus dieser Masse heraus und gleichsam auf sie zu werfen.[2]

Grazia Toderis Videoarbeit *Il decollo* versetzt den Betrachter in genau diese Position. Die Kamera ist von oben auf ein nächtlich erleuchtetes Stadion gerichtet, sie kreist über dem Oval, das auf den ersten Blick wie eine Raumstation inmitten winziger Sternensysteme erstrahlt. Das Tribünendach bildet einen äußeren Ring, helle Punkte markieren die Flutlichter; im Stadionrund sind Menschenmassen auf den Tribünen erkennbar, Massen, die offensichtlich ein Spiel auf dem grünen Rasen verfolgen; sie konzentrieren sich auf das, was sich im Schein der zusätzlichen Lichtkegel abspielt: ein Fußballspiel. In Toderis bewegten Bildern scheint der Mensch tatsächlich in der Masse aufgegangen zu sein, sichtbar nur als wabernde Fläche sowie hörbar durch den Chor einer aufwallenden und wieder abklingenden Begeisterung.

Es wäre unangemessen, diese Menschenmasse im Sinne Ortega y Gassets (und auch Kracauers) nur als ein reaktives, ausgeliefertes Medium zu beschreiben. Das Publikum folgt hier nicht der Demagogie eines Führers oder Verführers, sondern einem kleinen Ball, einem »magical flying object«, um den sich buchstäblich alles dreht.[3] Darüber hinaus befördert Toderis Auseinandersetzung mit dem Publikum gerade jenes Eigenleben an die Bildoberfläche, dessen Beweggründe anderer Natur sind. Ausgehend von der Annahme einer sozialen Topografie beobachtet sie die Dynamik solcher Gruppen, und zwar direkt am Rande des eigentlichen Geschehens: die Besucher in den Logen der Mailänder Scala, die Fans im San-Siro-Stadion, das Rund der Arena von Verona. »The ring of the stadium is a perfect ancient space for entertainment«, so Toderi. »Enclosed by a wall, like a medieval city, but open to the sky. A community is thus created inside and gathers round the metaphor of play, while the rules are completely transposed from reality and re-invented.«[4]

Grazia Toderi findet und erfindet Bilder dieser Räume, die für die Dauer des Spiels selbst den Charakter eines metaphorischen Ortes tragen. Jeder Ort bildet dabei einen abgeschlossenen kollektiven Erfahrungsraum. Erhaben kreist das Stadion um ein Zentrum, scheinbar schwerelos hält sich das Ornament der Masse selbst am Leben und bildet eigenwillige Formationen. Immer wieder driftet diese Raumstation ab, entfernt sich mehr und mehr von der Realität, um nach dem Spiel genau dort wieder anzukommen – wenn das magische fliegende Objekt vom Rasen verschwunden ist, die Lichter langsam ausgehen und die Menschenmassen das Stadion verlassen haben werden.

1 José Ortega y Gasset, *Der Aufstand der Massen*, Stuttgart 1989, S. 8.

2 Vgl. Siegfried Kracauer, *Das Ornament der Masse*, Frankfurt a. M. 1963.

3 Grazia Toderi, »Take Off«, in: *La Biennale di Venezia*, *48. Exposizione Internationale d'Arte*, AK Venedig 1999, S. 202.

4 Ebd.

Il decollo, 1998

Ralf Christofori

'The crowd is a manifestation of *the average*. What was once only a number – the many – is thereby transformed into a quality: the quality, that is to say, that all have in common; the socially unexceptional; man in as far as he is not distinguished from other individuals, but simply repeats in himself a general type.'[1] For the Spanish philosopher José Ortega y Gasset, man in the crowd is a case of individuality relinquishing itself. He obeys a higher power, an ideal which mass psychology has tended to describe as a sort of 'ideal I'. In the crowd this individual merely reacts, he follows the rules of the community as a whole, reproduces the pattern of the at least temporarily like-minded, and is observable as part of a greater 'mass ornament'. In his book of that name, Siegfried Kracauer referred to the fact that this 'ornament' is best observed by the individual if he adopts an aerial perspective, in order both to look beyond the crowd and simultaneously at it.[2]

Grazia Toderi's video piece *Il decollo* [Take Off] transplants the spectator into precisely such a position. The camera is directed, from above, on to a stadium illuminated at night. It circles above the oval, which initially appears like a space station gleaming in the midst of a diminutive galaxy. The roof that covers the stands creates an outer ring, bright points signal the floodlights; within the stadium one can make out crowds of people on the stands, crowds that are evidently watching a game being played on the grass pitch; their attention is focused on what is taking place in the brilliance of the additional cone of light: a football match. In Toderi's lively images the individual appears to be literally absorbed into the crowd, visible only as a unit interlocking with others and audible through the chorus of a surging and then fading enthusiasm.

It would be out of proportion to describe this crowd of people, in Ortega y Gasset's sense (and also Kracauer's), as a merely reactive, surrendering medium. The public is here not following the demagogic ravings of a leader or a seducer, but, rather, a little ball, a 'magical flying object', as Toderi has herself described it, around which literally everything turns.[3] In addition to this, Toderi's engagement with the public demands precisely that autonomy of the picture surface, the motivation of which is of a different kind. Starting with the assumption of a social topography, she observes the dynamic of such groups, focusing indeed on someone or something just to the edge of what is ostensibly happening: the opera lovers in the boxes at La Scala in Milan, the football fans at the San Siro Stadium, the oval of the Roman Arena at Verona. According to Toderi, 'The ring of the stadium is a perfect ancient space for entertainment. Enclosed by a wall, like a medieval city, but open to the sky. A community is thus created inside and gathers round the metaphor of play, while the rules are completely transposed from reality and re-invented.'[4]

Grazia Toderi finds and invents images of this space – a space which, for the duration of the game, even assumes the character of a metaphorical place. Every place, in fact, creates a discrete collective space of experience. Majestic, the stadium circles around a centre, seemingly weightless, the 'mass ornament' is self-generating and gives rise to autonomous forms. Repeatedly, this space station drifts off, distances itself increasingly from reality, in order, after the match, to return – when the magical flying object has left the pitch, the lights have gone out, and the crowd has left the stadium.

1 Cf. José Ortega y Gassett, *La rebelión de las masas*, 1929. English translation: *The Revolt of the Masses*, New York and London 1964.

2 Cf. Siegfried Kracauer, *Das Ornament der Masse*, Frankfurt am Main 1963. English translation: *The Mass Ornament*, Cambridge, Mass. 1995.

3 Grazia Toderi, 'Take Off', in *La Biennale di Venezia, 48. Exposizione Internazionale d'Arte* (exh. cat.), Venice 1999, p. 202.

4 Ibid.

Grazia Toderi | **Il decollo** | 1998 | Videoprojektion/video projection | Courtesy Castello di Rivoli Museo d'Arte Contemporanea Rivoli-Torino

Grazia Toderi | **Eclissi** | 1998 | Videoprojektion/video projection | Courtesy Galleria Giò Marconi, Mailand/Milan

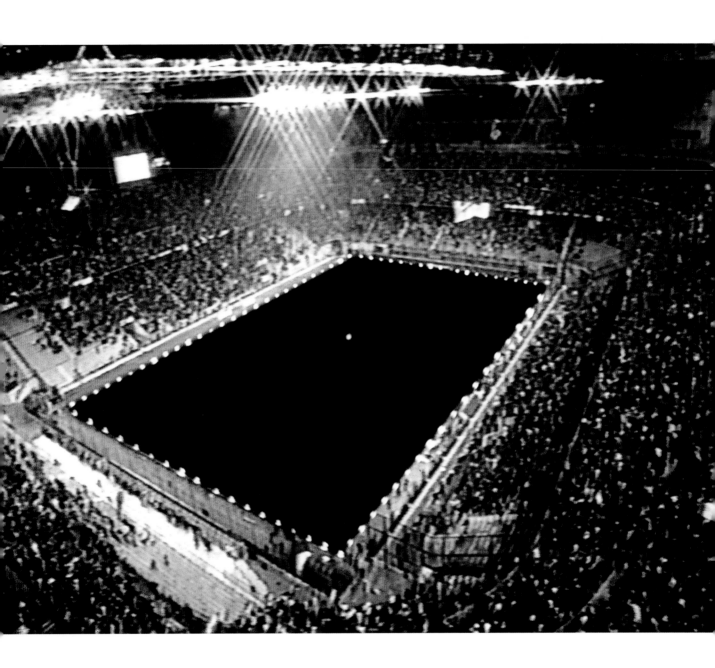

URI TZAIG

Infinity – ∞, 1998

Tobias Wall

Lassen Sie sich Zeit! Mit einem kurzen Blick ist es bei der Videoarbeit *Infinity – ∞* nicht getan. Lassen Sie sich Zeit! Ist es ein Ballspiel oder ist es Tanz, was uns der israelische Künstler Uri Tzaig hier zeigt?

In einer düsteren Halle auf einem grell erleuchteten Feld, dessen Grenzen durch helle Bänder markiert sind, spielen zehn Menschen in hellroten Overalls ein fremdartiges Handballspiel. Über dem Spielfeld ist eine Digitaluhr eingeblendet, die zehn Minuten läuft, um danach die gleiche Zeit wieder zurückzuzählen. Es lässt sich nicht genau ausmachen, wer hier gegen wen spielt, da es keine unterscheidbaren Mannschaften gibt: Die Spieler differieren in ihrer Kleidung lediglich durch große kreisrunde Punkte, die in unterschiedlicher Zahl auf den roten Anzügen haften. Zwar wird um den Ball gekämpft, die Regeln jedoch, nach denen dies geschieht, bleiben im Dunkeln; zuweilen scheint es sogar, dass Spieler, die gerade noch um den Ball stritten, in einem folgenden Spielzug gegen einen neuen Gegner zueinander halten. Ebenso wenig wird das Ziel des Ballspiels klar, und sogar das Spielfeld funktioniert nicht als fester, reglementierender Rahmen, da es durch die frei hängenden Begrenzungsbänder flexibel ist. Im Verlauf des Spieles ist keine Dramaturgie erkennbar: Das Video zeigt weder einen Spielbeginn, von dem das Geschehen ausgeht, noch ein Ende, auf das es sich zuspitzt. Das Spiel ist, wie auch der Titel »Infinity – ∞« nahe legt, »unendlich«. Durch ihre Ziel- und Regellosigkeit erscheinen die Aktionen der leuchtend rot gekleideten Spieler eher tänzerisch als kämpferisch, statt einer sportlichen Spannung entsteht ein beinahe meditativer Bewegungsfluss.

Uri Tzaig führt in *Infinity – ∞* keine reale Spielsituation vor. Zwar setzt er Elemente eines sportlichen Wettstreites ein (Spielfeld, Spieler, Ball) – ein Spiel als Sportereignis, das heißt mit Anfang, Ende, Höhen und Tiefen, Gewinnern und Verlierern entwickelt sich jedoch nicht. Tzaig präsentiert keinen Wettkampf, sondern das Spiel als Ausdruck grundsätzlicher Verhältnisstrukturen und sozialer Regelwerke.

Seit Mitte der neunziger Jahre beschäftigt sich der Künstler in Videos, Installationen, aber auch Texten mit dem Phänomen des Spiels und seinen Gesetzmäßigkeiten. Er entwirft unter Verwendung von Spielelementen Experimentierfelder, auf denen er die soziale Befindlichkeit des Menschen untersucht. Ihn interessiert, wie sich das Individuum innerhalb eines strukturierten Verhaltenskontextes als »Mit-Mensch« positioniert, also wie sich im Spiel die menschliche Identität im Spiegelspiel von Introspektion und Miteinander konstituiert.

Ausgangspunkt von Tzaigs Arbeiten ist die Bewegung des menschlichen Körpers im Raum, die in der Spielsituation ritualisiert, das heißt sowohl auf den anderen Menschen als auch auf ein gemeinsames Regelwerk ausgerichtet wird. Diese Regeln des ritualisierten Miteinanders sind jedoch nicht unantastbar. Im Gegenteil: Sie werden bei Tzaigs Spielen bewusst in Frage gestellt beziehungsweise offen gelassen. Den Künstler interessieren gerade die »Herstellung und Veränderung von Regeln und Ordnungsprinzipien«.[1] Er ist der Überzeugung, dass die Strukturen zwischenmenschlichen Verhaltens sich umso deutlicher zeigen, wenn vorgegebene Regeln gebrochen und wieder neu zusammengesetzt werden.

Uri Tzaig entwirft Szenarien, in denen die Beteiligten – Spieler und Tänzer ebenso wie die Zuschauer – ihre Teilhabe am sozialen Zusammenwirken, ihr Verhältnis zu sich selbst und zum Kollektiv innerhalb des Spielrituals aktiv durchleben.

Dementsprechend wäre es falsch, *Infinity – ∞* lediglich als Bild oder Metapher für derartige kulturelle Grundstrukturen zu lesen. Der Künstler führt in seinen Videos nie etwas von vornherein Festgelegtes vor. Die Arbeit zeigt Bewegungen und Austausch zwischen Menschen ohne einen festgelegten Sinn oder eine epische Struktur, wie sie beispielsweise ein geregeltes Spiel mit sich bringen würde. In seiner Endlosschleife gerät das Ereignis bei *Infinity – ∞* vielmehr in einen freien Fluss, bei dem der Betrachter seinen Status des distanziert erkennenden Gegenüber mehr und mehr einbüßt. Tzaig führt uns aus der Position des »passiven Zeugen«, des ästhetisch Wahrnehmenden heraus; er will, dass seine Arbeiten von jedem Einzelnen als »reale Erfahrung« wahrgenommen werden.[2]

»Vielleicht« so Uri Tzaig, »möchte ich wie bei der Hypnose dem Betrachter ermöglichen, seine eigenen Lesegewohnheiten aufzunehmen«,[3] um ihm so zu helfen, »seine eigene Geschichte zu lesen«.[4] Dies ist auch der Grund, warum Tzaigs Arbeit dem Betrachter Zeit abverlangt; dem kurzen Blick kann sich *Infinity* nicht erschließen.

1 Uri Tzaig im Interview mit Kurjakovic, in: *Kunst-Bulletin*, Nr. 7/8, 1999, S. 17.
2 Ebd., S. 19.
3 Ebd., S. 18.
4 Ebd., S. 19.

Infinity – ∞, 1998

Tobias Wall

'Take your time! You can't get to grips with the video piece *Infinity –∞* in just a quick glace. Take your time!'[1]

Is it a ball game or is it a dance that the Israeli artist Uri Tzaig is showing us here?

In a gloomy hall on a harshly lit sports field, its perimeters marked by bright ribbons, ten men dressed in bright red outfits are playing an unfamiliar handball game. On the screen a digital clock is intercut above the playing field: it runs for ten minutes and then counts the same period of time backwards. It is not possible to make out exactly who is playing against whom because there are no clearly demarcated teams: the players are only distinguished one from the other by means of the large dots, varying in number, attached to their clothing. Clearly, this contest involves the ball; yet the rules that govern it remain obscure; now and again it even seems that players who at one moment were fighting for the ball will subsequently team up against a new opponent. Equally unclear is the ultimate objective of this ball game. Nor does the playing field in itself seem to provide the framework for any sort of rules: with its perimeter marked only by the suspended ribbons, it seems the epitome of flexibility. Nor, in the course of the game, is any great drama detectable. The video shows neither the beginning of the game (so we might see how it gets underway) nor its end (so we might grasp what it has all been leading up to). As the title of this work suggests, the game is 'endless'. On account of this apparent lack of objective or regulation, the actions of the players in their glowing red outfits resemble those of dancers rather than competitors; and in place of the excitement generated by sport we find a fluidity of movement that is almost conducive to a state of meditation.

In *Infinity –∞* Uri Tzaig is, of course, not showing us a real game. While it is true that he incorporates elements associated with competitive sports (a playing field, players, a ball), these do not produce a game as a sports event – a game, that is to say, with a beginning and an end, with emotional highs and lows, and with winners and losers. What Tzaig shows us here is not a contest, but a game as an expression of the fundamental structures of relationship and the implementation of social rules.

Since the mid-1990s, Uri Tzaig, both in his videos and installations and also in his writing, has been concerned with the phenomenon of games and the rules that govern them. Employing elements associated with games, he devises experimental playing fields on which he investigates the human sense of belonging to a society. He is interested in how the individual positions him or herself, within a structured context of relationships, as a 'fellow human being'; that is to say in how, in a game, human identity may be seen to establish itself in the mutually reflecting play of introspection and a sense of togetherness. The starting point of Tzaig's works is the movement of the human body in space, a movement ritualized in the situation of the game, and ritualized both in relation to the other players and in relation to the framework provided by the rules of the game. Yet, as Tzaig shows us, these rules of ritualized togetherness are not inviolable. On the contrary: in Tzaig's games they are consciously called into question or, alternatively, left open to a variety of interpretations. For what interests Tzaig is precisely the 'establishment and alteration of rules and principles of arrangement'.[1] He is convinced that the structures of inter-human systems of behaviour can be all the more clearly revealed when the pre-established rules are broken and then re-established from scratch.

Uri Tzaig devises scenarios in which the participants – players and dancers, but also spectators – actively live out their own share in social collaboration, their relationship to themselves and to the collective, within the ritual of play.

It would, accordingly, be wrong to read *Infinity –∞* merely as an image or a metaphor of fundamental cultural structures. The artist in his video pieces never presents us with something that is firmly established from the start. His work shows movements and exchange between individuals without a firmly established meaning or an epic structure, such as would certainly be entailed by a match of some sort played out according to a firm set of rules. In the case of the endless film loop of *Infinity –∞*, the action shown is very soon perceived as a free flow of movement and the spectator increasingly loses his or her status as a distanced, discerning counterpart. Tzaig draws us out of the position of the 'passive witness', that is to say out of a merely aesthetic mode of perception; he wants his work to be perceived by every individual as a 'real experience'.[2]

Uri Tzaig has himself said of his work: 'Perhaps I'd like to enable the spectator, as if he/she were hypnotized, to comprehend his/her own reading habits',[3] in order to help the spectator 'to read his own history'.[4] This is also the reason why Uri Tzaig's work demands that as spectators we take our time; *Infinity –∞* cannot reveal itself to the brief glance.

1 Uri Tzaig, in an interview with Kurjakovic, *Kunst-Bulletin*, vii/viii (1999), p. 17.
2 Ibid., p. 19.
3 Ibid., p. 18.
4 Ibid., p. 19.

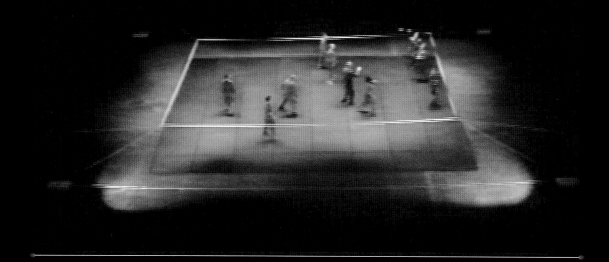

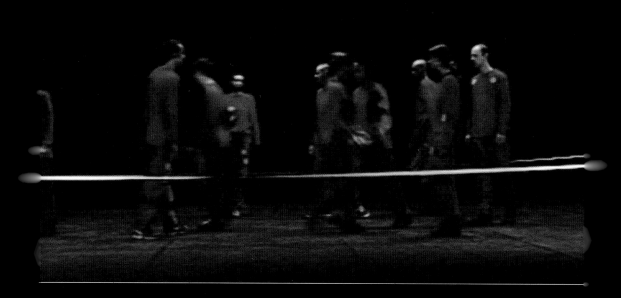

Uri Tzaig | **Infinity** – ∞ | 1998 | Video

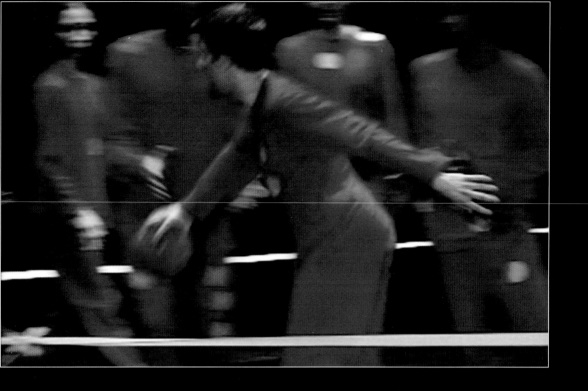

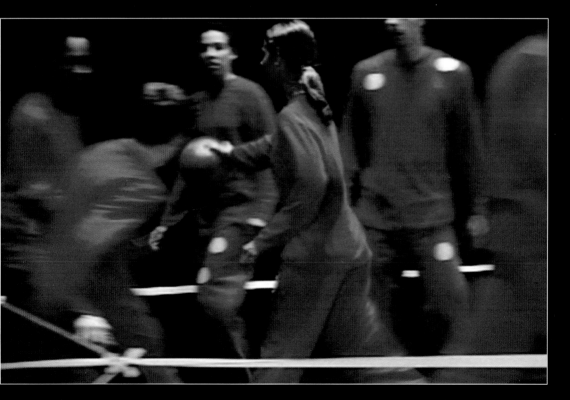

ALAN UGLOW

Coach's Bench, 1997 / 98

Owen Drolet*

Alan Uglow ist ein passionierter Sportfan und seine Leidenschaft für Fußball hat Eingang in seine Kunst gefunden. Seit 1992 fotografiert Uglow Fußballstadien in aller Welt und stellt die Aufnahmen zusammen mit seinen Gemälden aus. Außerdem läßt sich Uglows Kunst als Regelwerk begreifen. Damit meine ich, dass sich Uglow in den von ihm konstruierten Objekten und geschaffenen Bildern auf die Parameter einer gegebenen Erfahrung konzentriert. Diese Parameter sind die Rahmen und Strukturen, die ein Ereignis gleichermaßen produzieren und enthalten, und die Regeln, die die Leidenschaften in einem bestimmten Szenario steuern. Das Ergebnis ist ein überzeugender Ausdruck der Alltagsrealität.

Uglow hebt in seinen Gemälden auf die Materialität des Mediums und die technische Faktur der gemalten Oberfläche ab. Das geht schon aus der Vielfalt der verwendeten Bildträger hervor, zu denen außer der Leinwand auch Aluminium, Fiberglas und Holz gehören. Jeder Träger reagiert in spezifischer Weise auf den von ihm angestrebten haptisch-optischen Kontrast.

Uglow stellt mit seinen Bilder immer aufs Neue die Frage: Welche Wirkung haben die Rahmen, die unsere Thematik eingrenzen? Ob sie lediglich ein neutrales Feld abstecken oder einen bestimmenden Einfluss ausüben, hängt von der jeweiligen Situation ab. Und mit diesen Situationen arbeitet Uglow.

Mit seinen fotografischen Arbeiten treibt er innerhalb seines künstlerischen Schaffens die Untersuchung der Wechselwirkung zwischen Autonomie und äußerem Einfluss sogar noch weiter. Anders als im traditionellen Fotojournalismus will Uglow mit seinen Fotos nicht so sehr den Fußballsport dokumentieren, als vielmehr die strukturellen und soziologischen Determinanten dieses Phänomens aufzeigen. Dies geschieht in erster Linie anhand des Spielfelds, dass durch die verschiedenen Markierungslinien die für das Fußballspiel charakteristischen Aktionen und Ereignisse bestimmt. Die nächstwichtige strukturelle Ebene ist die Architektur des Stadions mit seinen Sitzreihen, den Managerlogen, den Vorrichtungen zur Lenkung der Zuschauerströme und selbstverständlich auch die Zuschauer selbst. Das Spielfeld stellt die ins Auge springende Analogie zu Uglows Gemälden dar, der Brennpunkt aller möglichen Aktionen, das spezifische Feld, auf dem und durch das das Geschehen überhaupt möglich wird. Entsprechend könnte man vom Stadion sagen, dass es die gleiche Funktion hat wie der Ausstellungsraum: Wie dieser

bewirkt es, dass aus dem Geschehen ein öffentliches Ereignis und keine esoterische Übung wird. Der Zuschauer hat die wichtige Rolle des Vermittlers zwischen »Feld« und »Arena«. Die Geometrie, die die Fotos und die Gemälde gemein haben, ist nicht die Folge einer Fetischisierung des Geometrischen oder eines Bedürfnisses, hinter allem das Muster – sei es die klassische Form oder die alles bestimmende Macht – zu sehen. Die Affinität von Geometrie und Architektur wird als gegeben hingenommen und zur näheren Untersuchung innerhalb spezifischer Situationen vorgeführt.

Dass Uglows Bilder und Fotografien zum simplen Vergleich herausfordern, nur um diesen Vergleich zugunsten eines komplizierteren Entsprechungsverhältnisses zu unterlaufen, darin liegt das Wesen seiner ganzen Arbeit: verbunden, aber verschieden. Uglows Gemälde offenbaren in Echtzeit die Spannung zwischen den bildimmanenten Rahmen und den umfassenderen Rahmen des Raums, in dem sie situiert sind. Die Fotografien sind Abbilder desselben Prozesses, der der Außenwelt entnommen ist. Beide künstlerischen Projekte zielen auf eine Bereicherung unseres Verständnisses des anderen. Um dieses Erkenntnisziel zu erreichen, verfolgt der Künstler die jedem Projekt innewohnenden Möglichkeiten, ohne das eine zum Füllen der Lücken des anderen zu gebrauchen. Die Verbindung zwischen Kunst und Sport, die Uglow in die Debatte einbringt, kann zum Verständnis seines Gesamtwerks hilfreich sein. Zeitgenössische Museums- und Galeriebesucher sowie Sportfans haben eine bestimmte Form des Zuschauens gemein, die für jeden Außenstehenden etwas Unverständliches hat. Doch solange man keine Mühe in den Sport oder in die Kunst investiert, wird man davon nichts verstehen. Beide haben ihre eigene Sprache, die man erst erlernen muss, und beide erscheinen in ihrer scheinbaren Schlichtheit völlig irrelevant für alle, die diese spezifische Sprache nicht beherrschen. Beide sind fähig, große Emotionen und echte Empfindungen auszulösen, wenn ihre Strukturen entziffert sind. Freilich sind Kunst und Sport nicht dasselbe. Sie sind verbunden, aber verschieden. Ihre Gemeinsamkeiten, das zeigt Uglows Kunst, können als Anlass zum Nachdenken über das Engagement dienen, das der Sportler beziehungsweise Kunstschaffende und sein Publikum jeder auf seine Weise zeigt, und über den Beitrag zu dem Wechselspiel, das zwischen ihnen entsteht.

* Text aus: Owen Drolet, *A Set of Rules. Alan Uglow's Catography of the Here and Now*, unveröffentlicht.

Coach's Bench, 1997/98

Owen Drolet[*]

Alan Uglow is an obsessive sports fan and his leisure time obsession with soccer has made its way into his art. Since 1992, Uglow has been photographing soccer stadiums around the world and exhibiting them along with his paintings. It can also be said of Uglow's art, that it is 'just a set of rules'. What I mean by this is that Uglow, in the objects that he makes and the images that he produces, tends to concentrate on the parameters of a given experience, the frames and structures that simultaneously contain and create an event, the rules that govern the passions that unfold within a particular scenario. The result is an extraordinary expression or 'act' of the everyday.

Uglow's paintings concentrate specifically on the materiality of he medium and the mechanical production of their painted surfaces. This is made manifest by his wide variety of support materials which includes canvas, aluminium, fibre glass and wood, all of which react differently to the typical haptic-optical contrasts he creates.

What Uglow's paintings ask over and over again is this: what is the effect of the frames that fence in our subjects? Whether neutral housing or determining force depends on the given situation, and it is in these situations that Uglow traffics.

Uglow's photographs, within the artist's own body of work, take this examination of autonomy and influence even farther. The photographs themselves, unlike traditional photojournalism, do not document the sport of soccer so much as the structural and sociological armature that allow it to exist as a phenomenon. This includes, first and foremost, the playing field, which, with its various markings, determines the specific actions possible within a game. The architecture of the stadium, its rows of seats, manager's boxes, and crowd-control people-movers, along with the spectators themselves, becomes the next level of structure within the 'game'. The playing field itself, of course, is analogous to Uglow's paintings, a primary focalpoint for all of the action, a specific field or ground on which and through which the event takes place. The stadium, it could be said, then functions the way the exhibition space does, as the receptor that makes this given event a public act, and not merely a hermetic exercise. The spectator too, assumes an important role as the negotiator between 'field' and 'arena'. The geometry that both the photographs and paintings share is not then the result of any fetishizing of the geometric, a desire to see the grid in everything as a symbol of either classical rightness or pervasive power. Rather, geometry's architectural efficiency is taken as a given and presented for examination within specific situations.

That Uglow's paintings and photographs invite simple visual comparison, only to refute that comparison at the service of a more complicated correspondence is the essence of the artist's entire project: connected but different. Uglow's paintings lay out in real time a negotiation between their built-in containers and those of the greater space in which they are situated. The photographs are representations of this same process taken from real-world events. Each of the two projects serve to enrich one's understanding of the other, but this is done by virtue of their autonomous efficacy at achieving the same goal, not by filling in any blanks. The connection between art and sport that Uglow also brings into the fold can be useful to ground the larger meanings of his work. Contemporary art watchers and sport fans both take an interest in a form of spectatorship that, for those who do not participate, is completely baffling. Until one makes an investment in either one will never really know. Both have their own language that you must learn to read and both appear utterly uneffecting, in their outward simplicity, to those who have yet to comprehend the language. Both are receptors for great intensity of emotion and acute feeling once their structures are deciphered. Art and Sport are not the same thing however. They are connected but different. Their similarities, as highlighted by Uglow, serve as a meditation on the investments made by the practitioner and audience, and their respective contributions to the mechanics that rest between them.

* Text from: Owen Drolet, *A Set of Rules. Alan Uglow's Catography of the Here and Now*, unpublished.

Alan Uglow | **Coach's Bench** | 1997/98 | Verschiedene Materialien/mixed media | 183 x 221 x 94 cm | Sammlung Mondstudio.de |
Installationsansicht/installation view, Württembergischer Kunstverein Stuttgart

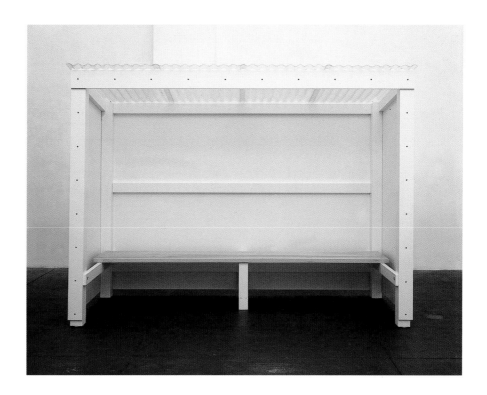

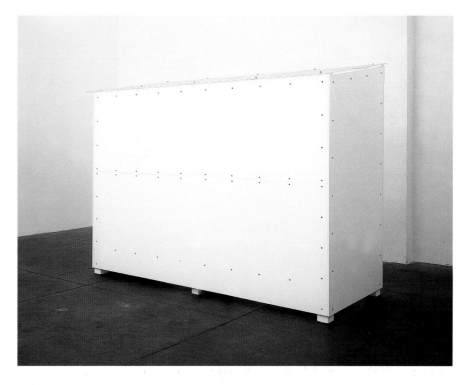

Alan Uglow | **Coach's Bench** | 1997/98 | Verschiedene Materialien/mixed media | 183 x 221 x 94 cm | Sammlung Mondstudio.de

Alan Uglow | **1. FC Union Berlin, Stadion an der Alten Försterei** | 2002 | Fotografien/photographs | je/each 20.3 x 30.5 cm | Courtesy Alan Uglow

WEBER & SCHNEIDER

(Sonya Horn / Tina Schneider)

Wimbledom, 2002

Tobias Wall

Die Installation *Wimbledom* entstand als eines der ersten Projekte des Künstlerinnenduos Weber & Schneider im Jahre 2000 als unmittelbare Reaktion auf die englischen Tennismeisterschaften. Auf einer hellgrünen Steppdecke sind mit weißen Satinbändern die Linien eines Tennisrasens aufgezeichnet, an dessen Schmalseiten sich zwei Monitore befinden. Auf den Bildschirmen sind Videoaufnahmen von den Köpfen der beiden Künstlerinnen in Tennismontur zu sehen, die in rhythmischen Abständen abwechselnd gepresste Schreie ausstoßen, die an diejenigen Laute erinnern, die aus dem Profitennis der Frauen bekannt sind und der Tennisspielerin Monika Seles den Beinamen »Stöhn-Monika« einbrachten.

Doch trotz des angestrengten Stöhnens scheint auf dem Feld keinerlei sportliches Ereignis stattzufinden. Die Frauen auf den Monitoren spielen offenbar gar nicht, und selbst die Pendelbewegungen, mit denen sie ihre Schreie begleiten, sind sonderbar spannungslos und ohne spürbaren sportlichen Elan.

Es entsteht der Eindruck, bei Weber & Schneiders Tennisinstallation sei alles, was ein reales Match ausmacht – Bewegung, Begeisterung, Kampf – eliminiert. So gibt es weder Ball noch Schläger. Die »Spielerinnen« bewegen sich nicht real auf dem Feld, sondern sind, reduziert auf ihre Gesichter, in den engen Kasten des Monitors gesperrt. Die Dynamik und Energie des Spiels äußern sich allein im immer wiederkehrenden Aufstöhnen: Die sportliche Aktion erstarrt im Schrei.

Losgelöst von einem konkreten Spielverlauf beziehungsweise Schlagabtausch, entwickeln die rhythmischen Schreie der beiden Frauen auf den Monitoren ein Eigenleben, das vom konkreten sportlichen Kontext weg in die Nähe anzüglicher Assoziationen führt, was von den Künstlerinnen durch Laszivität in Mimik und Tonfall bewusst forciert wird. (So überrascht es nicht, wenn das Werk bei einer früheren Ausstellung von einem Kritiker als sexistisches Machwerk tituliert wurde, da er aufgrund mangelnder Recherche davon ausgegangen war, ein Künstler namens Schneider habe hier zwei junge Frauen dazu gebracht, sich anstößig zu gebärden.)

Das Werk von Weber & Schneider ist jedoch keineswegs ein moralinsaurer Beitrag zur Debatte um Sexismus und Medien im Sport, sondern eine ironische Anmerkung zur aktuellen Sportkultur, bei der unter der globalen Aufmerksamkeit der Medien die Faszination des körperlichen Wettstreits mitunter als exhibitionistische Selbstinszenierung vermarktet wird.

Entsprechend reduzieren die Künstlerinnen in ihrer Installation den sportlichen Kampf zu einer schwächlichen Karikatur seiner selbst: Der harte Rasen von Wimbledon wird zu einer weichen grünen Steppdecke, an die Stelle des spannenden Wettstreits tritt eine ereignisarme Endlosschleife ohne Ball und Schläger. Das eigentliche sportliche Ereignis schrumpft auf immer wiederkehrende Urlaute, die allerdings nicht Ausdruck von totalem Körpereinsatz sind, sondern sich als eine sinnlose und obszöne Inszenierung erweisen. Die Rituale der Eitelkeiten und Selbstdarstellung treten so weit in den Vordergrund, dass das sportliche Ereignis als solches zur Farce gerät.

Wimbledom, 2000

Tobias Wall

The installation *Wimbledom* was one of the first projects undertaken by the artist duo Weber & Schneider, in direct response to the English Lawn Tennis Championships held annually at Wimbledon, London.

The lines of a tennis court are drawn with white satin ribbons on a bright green quilt, and at each of the shorter ends stands a television monitor. On their screens we can see video footage of the heads of the two artists in tennis outfits; they take it in turns to let out a forced cry, recalling the sounds associated with a number of professional women tennis players – above all Monika Seles, whose cries came to be known as 'Monika's moans'.

Yet, in spite of the strenuous activity suggested by the moaning, no tennis match appears to be taking place on the court. The women we see on the TV screens are evidently not playing, and even the oscillating movements that accompany their cries are curiously relaxed and without any of the vigour that we would associate with sport.

We gradually get the impression that, in the case of this installation by Weber & Schneider, everything that distinguishes a real tennis match – movement, excitement, the sense of a real contest – has been eliminated. There is neither ball nor racket. The 'players' are not engaged in real movement on the court but are, rather, present only as faces, compressed into the narrow boxes of the TV monitors. The dynamism and the energy of the game are expressed only in the two women's endlessly repeated groans. The incessant activity of sport is here petrified into a cry. Removed from the course of a specific match or an exchange of shots, the rhythmic groaning of the women on the TV screens assumes a life of its own, leading us ever further from the concrete context of sport and towards more risqué associations, a tendency consciously encouraged by the artists through the lasciviousness of their facial expressions and the inflexion of their voices. (It is hardly surprising that, on one of its earlier exhibitions, *Wimbledom* was dismissed by one critic as a wretched piece of work about sex: omitting to do sufficient background research, he assumed that a male artist called Schneider had here constrained two young women into a display of indecent behaviour.)

In fact, the work of Weber & Schneider is by no means a drearily moralistic contribution to the debate on the media and sexism in sport; rather, it offers a roguish commentary on the contemporary culture of sport, in which, observed by the all-seeing media, a fascination with physical competition is sometimes marketed as exhibitionist self-representation.

In their installation, the artists therefore abbreviate a sporting contest into a frail caricature of itself: the resilient lawn of Wimbledon becomes a soft green quilt, and in place of thrilling competition we find an uneventful endless loop of film without ball or racket. The real sporting event has shrunk to the repetition of primitive sounds; far from being an expression of the total engagement of the body in a game, they convey little more than a vague and meaningless obscenity. The rituals of vanity and self-representation are here so much in evidence that the sporting event itself is reduced to farce.

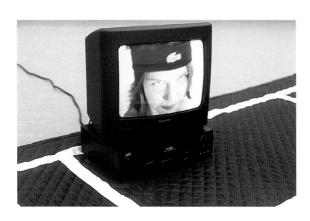 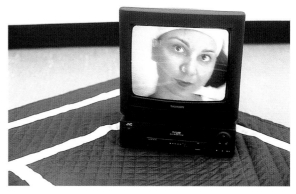

Weber & Schneider (Sonya Horn/Tina Schneider) | **Wimbledom** | 2000 | Videoinstallation/video installation | 190 x 300 cm |
Installationsansichten/installation views, Württembergischer Kunstverein Stuttgart

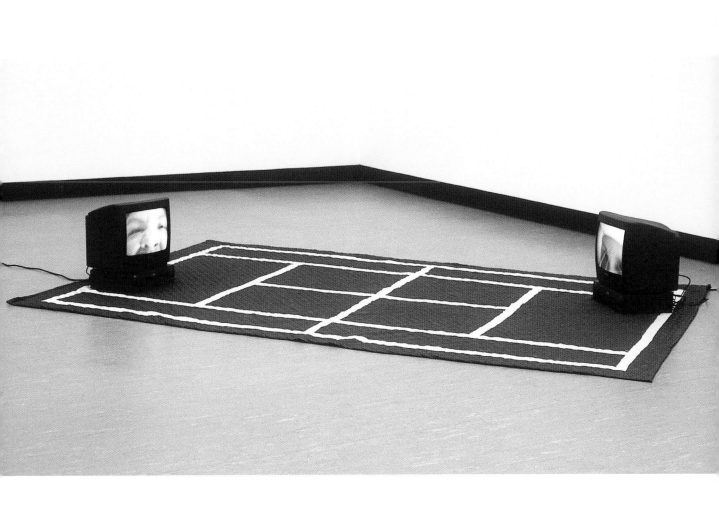

DIE SPRACHE DES SPORTS:

SPIELREGELN, MACHTSPIELE UND DIE KRAFT

Ihor Holubizky

DER REGION

Sport ist keine Metapher. Er ist ein Spiel und ein Bestandteil des Lebens, eine Kulturleistung als antrainiertes Verhalten. Die sozialen Aktivitäten und das Gemeinschaftserlebnis sind wichtiger als Gewinnen oder Verlieren. Dieses Gemeinschaftserlebnis hat seine Wurzeln in einer bestimmten Region und ist abhängig davon, wo man lebt und wie man lebt. Wird das Spiel aus seinem ursprünglichen Lebenszusammenhang in die internationale Arena versetzt – mit einem festen Reglement versehen und auf Sieg ausgerichtet – bekommt es einen anderen, verzerrten Charakter. Im Mittelpunkt der folgenden Untersuchung stehen die Beziehungen zwischen Sport, regionaler Verbundenheit und kulturellen Mythen sowie Beispiele von Künstlern, die auf dieses Phänomen reagiert haben.

Der amerikanische Komiker George Carlin hatte eine Nummer über Sprache und hintergründige Bedeutungen in seinem Repertoire, die auf einem Vergleich mit zwei typisch amerikanischen Sportarten beruht. Er kam zu folgender Schlussfolgerung: »Baseball ist ein ländliches Spiel aus dem 19. Jahrhundert. American Football ist ein Technologie-Wettstreit im Bewusstsein des 20. Jahrhunderts.« Die Sprache des Baseball schlägt regionale Töne an, das »Heimlaufen« (Homerun) bedeutet einen Punkt machen, und es ist vom »Opferspiel« die Rede; im American Football geht es um territoriale Kontrolle, seine Fachtermini entstammen in vielen Fällen dem militärischen Sprachgebrauch. Die Sprache verfügt nach Renato Poggioli historisch gesehen über die größte Macht, Strukturen zu bilden und aufzudecken. Mittlerweile ist ein ganzes Gewerbe entstanden, das darauf ausgerichtet ist, die spezifischen Sprachen in Politik, Sport, Kunst, Film, Werbung und Unterhaltungsmusik zu entschlüsseln.[1] Ferner gibt es eine Sprache des Körpers, die aber nicht universell gültig ist. Im Gegensatz zu Sportarten, bei denen die körperliche Bewegung aggressiv und zielgerichtet ist (zum Beispiel im Augenblick des Torschießens), legt beim Baseball der Schlagmann bei einem Homerun immer wieder Pausen ein und

beobachtet die Flugbahn des Balls, wenn er weiß, dass dieser über das Spielfeld hinausgeht. Er läuft um die so genannten »bases«, winkt den Zuschauern zu und gibt unterwegs seinen Mannschaftskameraden einen Klaps auf die Schulter. Das Ganze wirkt nicht wie ein Siegeslauf, sondern eher wie ein Lauf durch die Landschaft.

Baseball ist der offizielle Nationalsport in Amerika, und auch der Weltmeisterschaftstitel kann nicht darüber hinwegtäuschen, dass es sich dabei im Vergleich zu Fußball etwa keineswegs um eine internationale Sportart handelt. Das Wesen des Baseball entspricht vollkommen der amerikanischen Mentalität: Das Spiel ist regional verankert und reflektiert den amerikanischen Isolationismus.[2] Vor 40 Jahren, auf dem Höhepunkt des Kalten Krieges, befasste sich der amerikanische Publizist William K. Zinsser mit den Veränderungen im Baseball. Einerseits zogen professionelle Baseball-Mannschaften aus ihren Heimatstädten fort, andererseits kamen durch die Erweiterung beider Ligen zusätzliche Mannschaften ins Spiel. Zinsser erhob mahnend den Zeigefinger gegenüber diesen Tendenzen, die aus seiner Sicht ein heiliges Territorium antasteten und das Baseballspiel aus seiner genau austarierten Harmonie rissen.[3] Zinssers Kritik ist ein Echo auf die Sehnsucht nach ländlicher Verbundenheit, die auch Carlin formuliert hatte, und sie unterstreicht das Zugehörigkeitsgefühl zu Familie und Region. Als echter Baseballfan folgt man seiner Mannschaft durch Sieg und Niederlage und hält dem ewigen Verlierer die Treue. Auch das gehört zum Spiel.[4] Ein Spiel auf regionaler Ebene ist ein Gemeinschaftserlebnis: Die Mannschaft steht für die Stadt und die Stadt für die Mannschaft. Daraus erklärt sich auch, warum sich die Vereinigten Staaten nur unter äußerem Druck zur Einheit bekennen.

Jedes Land ist stolz auf einen Nationalsport, selbst wenn ihm der offizielle Segen fehlt oder wenn er seinen Ursprung nicht in der Nationalkultur hat. Nicht Eishockey ist der offizielle Nationalsport in Kanada, sondern Lacrosse, ein Spiel, das auf die indianische Urbevölkerung zurückgeht. Doch was die Kanadier als Nation wirklich fasziniert, ist Eishockey. Eine nahe liegende Antwort mag das Klima sein, die Mystik des Nordens. Der Winter ist dort länger als der Sommer, und der Winter kann künstlich durch Halleneishockey verlängert werden. Kinder spielen im Sommer eine Straßenversion des Hockey und erhalten das Spiel so das ganze Jahr hindurch am Leben. Ebenso spielen australische Kinder eine Straßenvariante von Kricket. Auf internationaler Ebene ist Kricket ein Spiel, an dem der australische Nationalstolz hängt. Auf diesem Feld kann Australien sogar England, die einstige Kolonialmacht, ausstechen. Das Gleiche gilt auch für Indien.[5] Dennoch ist der australische Nationalsport nicht Kricket, sondern Australian Rules

Football. Die Regeln dieses Spiels erklären zu wollen dürfte ebenso schwierig sein, wie einem toten Hasen Bilder zu erklären, wie es 1965 Joseph Beuys in einer Performance versucht hat. Regionale Sportarten sind voller Geheimnisse, die sich nur den Eingeweihten erschließen. Ihre Fans bilden eine verschworene Gemeinde.

Die Masse und die Arena

Obwohl Elias Canetti in seinem Werk *Masse und Macht* nicht ausdrücklich auf den Sport eingeht, sind viele von ihm untersuchte Verhaltensweisen auch bei Sportveranstaltungen nachweisbar. Canetti schreibt: »Eine zwiefach geschlossene Masse hat man in der Arena vor sich.«[6] Die Mauern der Arena und die Rücken der Zuschauer sind der Stadt abgekehrt. (Unter diesem Gesichtspunkt könnte man auch die Bedeutung der fünf ineinander hängenden olympischen Ringe ganz neu sehen.) Ein Verhältnis ließe sich auch zwischen der Stadiongröße und der Menschenmenge einerseits und der Region andererseits herstellen. Die größten Baseballstadien haben 50 000 Sitzplätze, was Puristen bereits als zu groß erscheint.[7] Fußballstadien (solche für American Football eingeschlossen) fassen 100 000 bis 200 000 Zuschauer, das ist die Größe einer mittleren Stadt. Daraus ergibt sich eine unterschiedliche Dynamik für die Zuschauer. Im kleinen Stadion lassen sich die Gesichter der Spieler erkennen und ihre Rufe hören. In Riesenstadien ist die Sicht dagegen »global«: Die Zuschauer sind Pünktchen, und die Spieler gleichen ameisenartigen Figuren. Das Ganze ähnelt einem Kriegsspiel unter strategischen Gesichtspunkten. Die Verbundenheit mit einer Mannschaft entsteht im überschaubaren Rah-

men eines kleinen Stadions und einer Region. Werden Spiele auf der ganzen Welt übertragen, wie zum Beispiel bei Weltmeisterschaften, verallgemeinern sich auch die Zugehörigkeiten der Fans, da die Zuschauermenge durch das Fernsehen um ein Vielfaches vergrößert wird. Kommentatoren sind in der Lage, durch ihre Sprache die Begeisterungsstürme und die Spannung noch zusätzlich zu dramatisieren, wie durch den häufig verwendeten Satz: »Eine ganze Nation bangt um den Ausgang des Spiels.«[8] In Spielberichten zu den ersten Qualifikationsrunden bei der Fußballweltmeisterschaft 2002 war vom Kampf der Kolonialmächte gegen die Kolonisierten die Rede. Ein Beispiel hierfür ist der Bericht der Nachrichtenagentur Associated Press vom 31. Mai 2002 zum Sieg Senegals über Frankreich: »Senegal hat einen historischen Sieg errungen!«, frohlockte Atiouma Diouf am Ende eines der packendsten Partien in der Geschichte der Fußballweltmeisterschaft. »Chirac tröstet die französische Equipe am Telefon. Einwanderer feiern in den Straßen von Paris«; *Il Giornale* bezeichnete den Sieg als »afrikanische Hexerei«.

Den Sieg der Republik Südkorea über Italien im Achtelfinale kommentierte Mark Palmer vom *Toronto Globe and Mail* (18. Juni 2002) folgendermaßen: »Ahn Jung Hwan, der Schütze des entscheidenden Tors für die Koreaner, versetzte das ganze Land in Ekstase. Das Stadion bebte, und die Luft war vom Pulvergeruch der Feuerwerkskörper erfüllt. Das war mehr als ein Fußballsieg. Südkoreanische Medien verglichen es mit dem Ereignis vor 52 Jahren, als General Douglas MacArthur das Land von den Kommunisten befreite.« Die Weltmeisterschaftsspiele wurden auch als Propagandainstrument eingesetzt. Am 22. Juni 2002 zitierte die Nachrichtenagentur Associated Press einen Sprecher des südkoreanischen Generalstabs, Major Yoon Wonshik, mit den Worten: »Wir übertragen die Weltmeisterschaftsspiele als Teil unserer psychologischen Kriegführung gegen den Norden.« Entlang der 240 Kilometer langen Grenze habe man Lautsprecher aufgestellt, »ohne allerdings eine erkennbare Reaktion bei der nördlichen Seite auszulösen«. In der weltweiten Arena ist Sport sowohl ein Teil der ideologischen Projektionen als auch des technologischen Wettbewerbs (Technologien sind immer auch Träger von Ideologien). Je mehr wir jedoch global agieren, desto mehr wird der Sport wieder eine Sache regionalen Interesses. Die internationalen Fußballvereine leihen ihre Spieler für die Weltmeisterschaften an die Nationalmannschaften aus: Die verlorenen Söhne kehren nach Hause zurück, um im

Kampf die Nationalfarben zu tragen; sie spielen die Rolle des David, der Goliath überwindet. Manche Spieler wechseln sogar ihre Staatsangehörigkeit in der Hoffnung, zur siegenden Mannschaft zu gehören.

Mythos und die Kultur des Sports

Die kanadische Künstlergruppe General Idea stellte 1972 die Frage nach der Funktion des Mythos. »Der Mythos verwandelt die Büchse der Pandora in den Bildervorrat der Zwänge. Der Mythos gleitet durch die Mitte und schneidet die Wirklichkeit in dünne transparente Scheiben, mischt Leben wie Blätter und löst duale Spannungen in Geschichten auf. Im Raum zwischen den Mythen liegt der bewusste Ausdruck der künstlerischen Tätigkeit.«[9] Die Beziehung zwischen Kunst und Sport soll nun unter dem Gesichtspunkt der Sportlegenden näher beleuchtet werden. Über den berühmten Baseballspieler Babe Ruth von den New York Yankees wird erzählt, er habe 1926 ein krankes Kind besucht und ihm versprochen, einen Homerun zu schaffen. Versprechen solcher Art machen nur Narren oder Götter. Mag diese Geschichte auch nur zur Hälfte wahr sein, so ist sie doch bedeutsam, weil sie immer wieder erzählt wird. Mythen und Legenden erzeugen Sinn. In dem amerikanischen Film *Field of Dreams* aus dem Jahr 1989 sieht ein Farmer aus Iowa die Geister verstorbener Baseballstars in seinem Maisfeld spielen. Einer der Geister fragt ihn, ob das hier der Himmel sei, worauf der Farmer antwortet: »Nein, das hier ist Iowa.« Der Satz, richtig analysiert, ergibt die Gleichung Iowa = ländliche Idylle = Himmel, und in diesem Himmel gibt es Baseballspieler. Der Farmer hört auch den geflüsterten Rat: »Wenn du das Spielfeld hier anlegst, dann kommen sie auch.« Was hier wiederkommt, ist die Vergangenheit, und es sind die Städter, die ins Herz ihres Landes zurückfinden.

In der Sportwelt gibt es ein Beispiel für einen bis heute lebendigen Mythos: der Haka, ein Kriegsgesang der Maori, der in Neuseeland vor dem internationalen Rugbyturnier aufgeführt wird. Neuseeland ist offiziell eine zweisprachige Nation, die aus den weißen Siedlern und der Urbevölkerung besteht. Das Absingen des Haka geht auf das Jahr 1904 zurück, eine Zeit, zu der Rugby in Neuseeland bereits gemischtrassig gespielt wurde. Der bekannteste Haka stammt von Te Rauparaha (1768–1849), dem Häuptling des Stamms der Ngati Toa. In der Maori-Tradition geht der Haka einem Kampf voran. Der Gegner wird unter wildem Ge-

schrei mit schüttelnden Armbewegungen und erhobener Faust begrüßt, dazu stampft man auf den Boden zum Zeichen, dass (vom Gegner) nur noch Staub übrig bleiben soll. Die ersten beiden Verse des Haka Te Rauparaha lauten: »Es ist Tod, es ist Tod, es ist Leben, es ist Leben.« Der Rugby-Haka wird vom Kapitän der Mannschaft oder dem ältesten Maori-Spieler vorgesungen, und alle Spieler, gleichgültig ob Weiße oder Maori, stimmen ein. Aus dem ursprünglichen Kriegsgesang ist damit etwas Neues entstanden, ein sportliches Ritual wie das Köpfe-Zusammenstecken vor Spielbeginn. Die koreanische Mannschaft zeigte bei der Fußballweltmeisterschaft 2002 ein weiteres Beispiel: Die Spieler verschränkten Hände und Arme und schauten sich gegenseitig an, während sie der gegnerischen Mannschaft und den Zuschauern den Rücken kehrten. So imitierten sie den geschlossenen Ring der Arena. Internationale Sportwettkämpfe dienen jedoch nicht immer der Völkerverständigung. Sie bieten auch ein Forum dafür, kulturelle Differenzen sichtbar zu machen und die Aufmerksamkeit der Weltöffentlichkeit auf soziale Konflikte in einer Region zu lenken. Die herrschende weiße Mehrheit in Amerika reagierte verstört, als bei den Olympischen Spielen 1968 in Mexiko die afroamerikanischen Sprinter Tommie Smith und John Carlos auf dem Siegerpodest eine schwarzbehandschuhte Faust als Zeichen der Black-Panther-Bewegung erhoben. Die Spiele wurden damit zur Bühne für zivilen Ungehorsam. Auch als Muhammad Ali (damals noch Cassius Clay) im Jahr 1964 Sonny Liston im Boxkampf um den Weltmeistertitel im Schwergewicht besiegte, trat ein neues schwarzes Selbstbewusstsein gegen die alte Sklavenmentalität auf. Nach seinem Sieg sprach Ali direkt in die Fernsehkameras und warnte die herrschenden Weißen Amerikas, er sei schwarz, gefährlich und ihr schlimmster Albtraum.[10] Durch seine sportliche Leistung und seine unverblümt geäußerten Ansichten riss Ali die Wunden der Rassentrennung auf. Mehr noch dadurch, dass er eine selbst erworbene persönliche Ethik und Wahrheit beanspruchte, wirkte er über den Sport hinaus und trat in Geschichte und Mythos ein. Auch Metaphern sind konstruiert.

Kunst spielt Sport

Das Publikum in Museen und Galerien lässt seinem Vergnügen oder Missvergnügen nicht einfach freien Lauf. Wie provokant ein Kunstwerk auch sein mag, es ist als Gegenstand intellektueller Auseinandersetzung konzipiert. Nach einem häufig gebrauchten Diktum gilt das Museum als säkularer Tempel. Wir dürfen dort unsere Stimme zum Disput erheben, aber nicht unsere Faust. In seinem Buch *Voltaire's Bastards* geht John Ralston Saul auf die erhobenen Fäuste von Tommie Smith und John Carlos in Mexiko ein, heute ein Siegeszeichen in fast allen Sportarten. Saul vermutet die Herkunft dieser Geste in einem

Fresko Michelangelos aus der Sixtinischen Kapelle. Dort »erhebt Gottvater den Arm und reckt den Zeigefinger mit Furcht einflößender Macht«.[11] Saul geht in der Kunstgeschichte weiter zu Jacques Louis Davids Gemälde *Der Schwur der Horatier*, über Eugène Delacroix' *Die Freiheit führt das Volk an* bis zu Picassos *Guernica*. Seine These mag überzogen sein, doch die Körpersprache ist unübersehbar, und Sport wird zu einem Teil der Kunst, weil die Kunst an den Mythologien der Geschichte teilhat und sie für die Zukunft bewahrt. Saul weist auch darauf hin, dass Sportübertragungen im Fernsehen ein wesentlicher Faktor für den Erfolg des elektronischen Mediums sind. Eine amerikanische Sportsendung aus den frühen sechziger Jahren suggerierte den Zuschauern, dass sie den »Kitzel des Sieges und die Qual der Niederlage« miterleben würden. Das Fernsehen hat sich für seine Berichterstattung die Sprache des Films zu Eigen gemacht, die Zeitlupe, die Wiederholung, die Nahaufnahme, die Froschperspektive, die Totale, die belauschende Tonaufnahme und die Unterlegung mit Musik von Klassik bis Rap. Die Football-Sequenzen in Oliver Stones Film *Any Given Sunday* von 1999 sind wie ein Musikclip geschnitten. In einer Szene benutzt Stone den Song *My Niggas* der Rap-Gruppe DMX, um mit der aggressiven Musik und den provokanten Texten einen Aspekt des Films, die Konfrontation schwarzer und weißer Spieler, zu verdeutlichen. Populäre Kultur geniert sich nicht, mit der eigenen Tendenz zu Hybridisierung und Selbstbezogenheit auch Originalität einzufordern, und konstruiert Sportmetaphern.

Der brasilianische Ausstellungsmacher Paulo Herkenhoff schrieb: »Lateinamerika produziert keine guten Kunstwerke im Zusammenhang mit Fußball, obwohl diese Länder siebenmal die Weltmeisterschaft gewonnen haben.«[12] Das gilt für den Großteil der Kunst, die Sport zum Sujet hat. Die Schwierigkeit für Künstler besteht darin, das Gewicht der Metapher zu stemmen (wie in der Ingenieurkunst gibt es Grenzen der Belastbarkeit). Wie gelingt es Künstlern dennoch, Sportmetaphern zu ersinnen und im Feld der sozialen (und populären) Kultur zu operieren? Die folgenden Beispiele zeigen, wie sie diese Probleme gelöst haben. Im Jahr 1977 erhielt der amerikanische Popkünstler Robert Indiana den Auftrag, ein Basketballspielfeld in Milwaukee im Bundesstaat Wisconsin zu gestalten. Er setzte die charakteristischen Bestandteile seiner Kunst – Primärfarben, geometrische Formen und Text – ein, indem er sie auf die vorgegebenen Spielfeldmarkierungen übertrug. Mit dem Ergebnis, dass das Spiel nun buchstäblich auf einem Kunstwerk ausgetragen wird, ob das den Zuschauern nun bewusst ist oder nicht. Im Jahr 1989 beauftragte man den kanadischen Künstler und Filmemacher Michael Snow mit der Außengestaltung des SkyDome in Toronto, dem ersten Hallenstadion mit Schiebedach. Sein Skulpturenschmuck mit dem Titel *The Audience* besteht aus 14 sechs Meter hohen Fiberglasfiguren, die auf balkonartigen Konsolen an der Stadionaußenwand stehen. Die Figuren haben karikatureske Züge und illustrieren die Mienen und die Körpersprache von Zuschauern bei Sportveranstaltungen: Winken, Jubeln und Auspfeifen. Snow durchbricht den von Canetti beschriebenen geschlossenen Ring – sein Publikum schaut hinaus in die Stadt – und verwendet eine historische Kunstform (die Verbindung von Figur und Baukörper wie im Sakralbau) für die Verknüpfung von zeitgenössischer Architektur und Kunst. Snows Arbeit ist zum Erkennungszeichen des Gebäudes geworden, unabhängig davon, ob die Leute den Namen des Künstlers kennen (so wie sie die Namen der Sportstars kennen) oder ob sie die Figuren überhaupt als Kunst wahrnehmen. Im Bereich der Massenkultur ist der Wiedererkennungswert höher als der Kunstwert. Der australische Aborigine-Künstler Ron Hurley setzte sich in seinem Gemälde *Bradman Bowled Gilbert* (1989) mit dem Verhältnis von Lebensverhältnissen und Sport auseinander. Wir wissen, dass es sich hier um eine künstlerische Arbeit handelt, aber welche Bedeutung hat es für einen Betrachter, der den lokalen Hintergrund nicht kennt? Das Gemälde, ein Diptychon, zeigt auf der linken Tafel einen weißen Kricketspieler, der gerade sein Schlagholz schwingt, und auf der rechten Tafel eine gekreuzte Gestalt in christlicher Tradition. Diese Gestalt hat das nach einem Foto gemalte Gesicht eines australischen Eingeborenen. Der Schlagmann ist Sir Donald Bradman, der größte landesweit bekannte australische Kricketspieler. Er wurde sogar in den Adelsstand erhoben. Der Gekreuzigte ist Eddie Gilbert, ein Werfer, der in den dreißiger Jahren spielte. Gilbert ist der einzige Werfer, dem es jemals gelang, mit einem Wurf Bradman das Schlagholz aus den Händen zu schlagen. Bradman lobte Gilberts Wurftechnik und Schnelligkeit, doch Gilbert durfte wegen seiner rassischen Zugehörigkeit nie in der Nationalmannschaft spielen. Der Sport, der den Nationalstolz verkörpert, verhüllt die nationale Schande, das ist das Gegenteil der Praxis des Haka. Hurley hat eine soziale Metapher wirkungsvoll in ein Sportbild umgesetzt.[13] Um den Schnittpunkt von Sport, Geschichte und Gesellschaftspolitik geht es auch Godfried Donkor. Er projiziert Porträts

von Boxern aus dem 18. Jahrhundert auf die Seiten einer aktuellen Ausgabe der Londoner *Financial Times* und macht daraus eine Tapete zum Bekleben von Galeriewänden. Uri Tzaig gibt dem Spiel einen provokanten Dreh. In seiner Inszenierung eines Ballspiels setzt er ganz so, als ob es die Regel wäre, einen zweiten Ball und einen zweiten Schiedsrichter ein. (In Anbetracht mancher langweiliger Weltmeisterschaftsspiele scheint dieser Gedanke gar nicht so abwegig.) Gabriel Orozco hat Sportarten unter veränderten Bedingungen aufgeführt, beispielsweise ein Wasserbecken in die Mitte eines Tischtennistisches eingelassen, um den Aufprall des Balls zu dämpfen. Das Spiel hat damit seinen Sinn verloren, aber es ist kein sinnloses Spiel für den Künstler. Die Regeln zu ändern ist ein modernes Spiel in der Kunst und im Sport.[14] Sport bleibt kein einfaches, schönes Spiel (wie vom Fußball oft behauptet), wenn es vor der Weltöffentlichkeit ausgetragen wird. Viele Kräfte sind am Werk, und niemand kann die Wogen der nationalen Emotionen leugnen, die bei solchen Sportereignissen im »globalen Dorf« aufgepeitscht werden.[15] Dennoch möchte ich weiterhin behaupten, dass sich das Spiel und der ihm innewohnende Geist in heimischen Gefilden entfaltet. Das Spiel hat einen regionalen Charakter und vermittelt wie der Regionalismus in der Kunst eine regenerative und moralische Kraft.

Zum Schluss noch ein letztes Wort über Muhammad Ali, dessen metaphernreiche Sprache integraler Bestandteil seines Sports war. Ali gilt in dieser Hinsicht als der erste moderne Boxer: »Float like a butterfly, sting like a bee.« Keiner vor ihm hat je auf diese Weise über Boxen gesprochen. Auch wenn er nicht der Urheber dieses Ausdrucks gewesen sein sollte (wahrscheinlich hat sich Drew »Bundini« Brown, ein Mitglied aus Alis Gefolge, den Spruch ausgedacht), so war er doch der Prophet, der ihn der Welt verkündete und der damit die Spielregeln änderte. Ali ist nicht nur deshalb eine Boxlegende, weil er im Ring unbesiegt blieb, sondern weil er ein neues Bewusstsein geschaffen hat. Dieses Bewusstsein hat eine regionale Herkunft – die eines schwarzen Amerikaners aus Louisville – und diente zugleich dazu, die Wünsche und Hoffnungen vieler Menschen an vielen Orten und in ganz unterschiedlichen kulturellen und sozialen Verhältnissen zu beflügeln.

1 Renato Poggioli, *The Theory of Avant-Garde*, New York 1971, S. 17.
2 Zwar spielen auch nichtamerikanische Athleten in den Baseball-Profi-Ligen, aber es gibt keine Bestrebungen, eine Weltmeisterschaft im Baseball zu initiieren. Dabei wird auch in Japan und Lateinamerika hervorragend Baseball gespielt.
3 William K. Zinsser: »Say It Ain't So«, in: ders., *Pop Goes America*, New York 1966, S. 156.
4 Das gilt nicht für American Football. Vince Lombardi, der Coach der Green Bay Packers, stellte Ende der fünfziger Jahre die Devise auf: »Gewinnen ist alles«.
5 Der für den Oscar 2002 nominierte indische Spielfilm *Lagaan* erzählt, wie sich im 19. Jahrhundert die Bewohner eines indischen Dorfes gegen eine Steuererhöhung zur Wehr setzen, indem sie die englischen Soldaten zu einem Kricketspiel herausfordern.
6 Elias Canetti, *Masse und Macht*, Frankfurt a. M. 1980, S. 25. Baseballstadien heißen »Parks«. Sie unterscheiden sich darin von Arenen, dass die Zuschauerplätze hufeisenförmig ausgerichtet sind.
7 Beim Baseball ist der Zuschauer dem Spielgeschehen so nahe, dass er den Ball eines Teams unbeabsichtigt fangen und damit der gegnerischen Mannschaft helfen kann, ohne wegen Störung des Spiels hinausgeworfen zu werden.
8 In einer Fernsehreportage, die vom australischen Sender SBS während der Fußballweltmeisterschaft 2002 ausgestrahlt wurde, wendet sich ein hoher kamerunischer Staatsvertreter mit den Worten an die Spieler, sie seien Symbole für die Nation, und wenn sie dieses Vertrauen enttäuschten, würden sie »von ihren Landsleuten umgebracht«.
9 Auszug aus »Editorial«, in: *File Magazine*, Vol. 1, Nr. 1, April 1972.
10 Jackie Robinson war 1947 der erste schwarze Spieler in den amerikanischen Baseball-Profi-Ligen. Anders als Ali blieb er in der Öffentlichkeit still und zurückhaltend, obwohl er Zielscheibe rassistischer Kommentare und Drohungen wurde. Robinson kritisierte allerdings 1967 Ali öffentlich für dessen Entschluss, nicht für die USA in den Vietnamkrieg zu ziehen.
11 John Ralston Saul, *Voltaire's Bastards. The Dictatorship of Reason in the West*, Toronto u. a. 1993, S. 508.
12 Paulo Herkenhoff, »Incomplete Glossary of Sources of Latin American Art«, in: *Cartographies*, AK Winnipeg Art Gallery und The Bronx Museum of the Arts, New York 1993, S. 177. Im gleichen Zusammenhang gab mir Ivo Mesquita, einer der Kuratoren der »Bienal de São Paulo« 1998, auf meine Frage, warum es so wenige einheimische schwarze Künstler in Brasilien gebe, die Antwort: »Schwarze sehen die Kunst nicht als Mittel an, ihren sozialen Status zu verändern.«
13 Ron Hurley, geb. 1946. *Bradman Bowled Gilbert* befindet sich in der Sammlung der Queensland Art Gallery, Brisbane.
14 Kirk Varnedoe zitiert in der Einführung zu seinem Buch *A Fine Disregard. What Makes Modern Art Modern*, New York 1990, folgendes Sportereignis: 1823 beteiligte sich William Webb Ellis an einem Fußballspiel in Warwickshire, England. Er nahm den Ball in beide Hände und rannte damit los – eine »feine Missachtung« der Fußballregeln, aber die Initialzündung für ein neues Spiel namens Rugby. Varnedoe verwendet dieses Beispiel als Analogie für die plötzlichen und unerwarteten Wendungen im »Spiel« der modernen Kunst.
15 Associated Press meldete am 22. Juni 2002, die Fifa habe 400 000 E-Mails aufgebrachter italienischer Fans erhalten, die ihrem Zorn über die Schiedsrichterentscheidungen im Spiel Italien – Südkorea Luft machten.

THE LANGUAGE OF SPORTS: THE RULES OF THE GAME, AND THE PLAY OF POWER AND REGION

Ihor Holubizky

Sport is not a metaphor. It is a game and a part of life, culture as learned behaviour. The social activity and communion is more important than winning or losing, and the wellspring of that communion is regional, determined by where you live, and how you live. When the game is taken from the 'ritual of life' to an international arena – guided by a rule book, with an emphasis on winning – the characteristic of the game changes and is distorted. This essay examines some of the relationships between sport, regionalism and cultural myths, and how some artists have responded.

The American comedian George Carlin had a stage routine about language and subtexts, comparing two typically American sports. He offered the following conclusion: 'Baseball is a 19th-century pastoral game. [American] Football is a twentieth-century technological struggle.' Baseball language emphasizes 'running home' (to score) and the 'sacrifice play'; American football is based on territorial control, and borrows heavily from military terminology. Language, as Renato Poggioli commented, is our greatest historical revealer, and an industry has developed for the interpretation of specific languages in politics, sports, art, film, advertising and popular songs.[1] There is also a distinctive body language, but it is not universal. Unlike sports in which the physical action is aggressive and decisive (the moment of scoring, for example), the batter who hits the home run in baseball will often pause and watch the trajectory of the ball, knowing that it will go beyond the limits of the playing field. He will jog around the bases, waving to the crowd and slapping his team-mates en route. It is like a scenic drive in the country, not a victory lap.

Baseball is the official national sport of the United States, and in spite of its World Series championship title, it is not a global sport such as football (soccer in North America). The essence of baseball has been equated to that of the American psyche: it is regional, and reflects the historic American isolationism.[2] At the height of Cold War, forty years ago, the American essayist William K. Zinsser turned his attention to the changes taking place in the game: professional baseball teams were being moved from their cities of origin, and teams were added as the two leagues expanded. Zinsser pointed an accusatory finger at the entrepreneurs who disturbed 'a sacred universe ... and tore the game apart from its perfect harmony ... as delicately tuned as the movement of the planets.'[3] Zinsser's commentary echoes a yearning for the pastoralism that Carlin notes, but also underscores the sense of familial allegiance and region. The true baseball fan follows a team in victory and defeat, and even embraces the perennial losing team. That, too, is part of the game.[4] The game played on a regional level is a communion – the team is the city and the city is the team – and the United States is only united under foreign pressure.

Every country prides itself on a national game – even if not an officially sanctioned one, or one that does not have its origins within the national culture. Ice hockey is not the official national sport of Canada; instead it is lacrosse, a sport derived from an indigenous First Nations game. But it is hockey that galvanizes the Canadian spirit. A simple reason for this may be the climate, the mystic northern pastoralism. There is more winter than summer, and winter can be artificially extended by indoor ice-hockey arenas. But the game is kept alive by children who play all year round – playing 'road hockey' in summer. Likewise, Australian children play a 'road' version of cricket. But on the international field, it is a sport of national pride, a means by which Australia can overcome England, its former British Empire master, at its own game. The same is true of India.[5] However, the de facto national sport is a curious hybrid, Australian Rules Football. It is played nowhere else in the world, and to explain the rules is as daunting as explaining paintings to a dead hare, as Joseph Beuys proposed in his 1965 performance. In regional sports, there are secrets known only to the initiated, and the dedicated sport fans form 'the ring'.

The Crowd and the Ring

Although Elias Canetti does not name sport in his expansive study *Crowds and Power*, many of the behavioural attributes he analysed are applicable to and characteristic of sporting events. Canetti wrote that 'an arena contains a crowd which is doubly closed' – the architecture of the stadium and the position of the spectators are both turned inwards, away from the city.[6] (In this light, we may wish to reconsider the meaning of the Olympic logo of five interlocking rings.) A relationship may also be established between arena and crowd size, and region. The largest baseball stadium seats 50,000, and for the purists, that is too large.[7] Football (including American football) arenas can seat 100,000 to 200,000 spectators, the size of a small

city. Hence, the dynamics for the spectator are different. In the small arena, they are able to see the faces of the players and hear them. In the large arena, the view is 'global': the spectators are dots and the players appear ant-like, resembling a war game with a tactical view. The local attachment to a team – what Zinsser speaks of – takes place within the intimate scale of arena and region. On the world stage, as in the football World Cup, allegiances are generalized as the crowd is expanded by television. Passions can be inflated by the language of the commentators, such as the commonly used phrase 'the hopes of a nation' (resting with the outcome).[8] In the opening rounds of the 2002 World Cup, some commentator reports described matches in terms of a struggle between the colonizers and the colonized. An example is the 31 May Associated Press report of Senegal's win over France: ' "Senegal has made history!" celebrant Atiouma Diouf screamed at the conclusion of one of the most stunning upsets in World Cup history ... "Chirac consoles the [French] team by phone. Immigrants celebrate in the streets of Paris"; *Il Giornale* ... called the victory, "African Witchcraft".'

Of the Republic of Korea's victory over Italy in an elimination round, Mark Palmer of the (Toronto) Globe and Mail (18 June 2002) wrote that Ahn Jung Hwan, who scored the winning Korean goal, 'sent the entire country into ecstasy. The stadium throbbed and gunpowder filled the air as fireworks were launched. It wasn't just a soccer moment. It was something similar, according to the South Korean media, to when General Douglas MacArthur liberated the country from the communists fifty-two years ago.' Accordingly, the games were also used as a propaganda tool. Associated Press, on 22 June 2002, reported Major Yoon Won-shik, a spokesman at the office of South Korea's Joint Chiefs of Staff, as saying, 'We are broadcasting the World Cup matches as part of our psychological warfare against the North.' The major went on to explain that they were using a battery of loudspeakers along the 240-kilometre border, but admitted that 'There has been no detectable reaction from the Northern side.' In the global arena, sports are subsumed within the projections of ideology, as well as being part of a technological struggle (technologies have their inherent ideologies). Yet, the more we play on the global field, the more the game becomes tribal. Football clubs are dismantled for the World Cup: the prodigal sons go home to wear the national flag and carry it into battle, to play out the destiny, or become the Davids conquering the Goliaths. Some players may even change their national allegiance in the hope of being on a winning team.

Myth and the Culture of Sports

In 1972, the Canadian artists' collective General Idea asked, What is the function of myth? 'Myth transforms Pandora's box into the image bank of compulsions. The myth slides down the center, slicing realities into thin transparencies, shuffling lives like leaves and dissolving dualities into fabled tales [and] in the space between myths lies the lucid expression of artists' activity.'[9] I will address the relationship of art to sport further on, but will here expand further on sport mythologies. There is a famous story of New York Yankee baseball player Babe Ruth visiting a sick child in 1926, and promising to hit a home run: predictions are only made by fools and the divine. Even if a half truth, the Ruth story is important because it is repeated, and mythologies are powerful generators of meaning. In the 1989 American film *Field of Dreams*, an Iowa farmer sees the ghosts of past baseball stars playing in his cornfield. A ghost-player asks if this is heaven: the farmer replies, 'No, this is Iowa.' The phrase, if deconstructed, tells us that Iowa=pastoralism=heaven, and that heaven has baseball players. The farmer also hears the whisper 'If you build it [the baseball field], they will come.' The second coming is that of the past, and bringing the people from the city to the heartland.

There is an example of sustained mythology in real-life sport: it is the Haka, a Maori war chant performed before the start of New Zealand international rugby matches. New Zealand is officially bicultural and bilingual, White settler and Aboriginal. The performance ritual dates from 1904 – New Zealand rugby was already racially integrated – and the most commonly used Haka is that of Te Rauparaha (1768–1849), chief of the Ngati Toa tribe. In traditional Maori culture, the Haka precedes a battle, and is performed while facing the opponent with fierce shouting, flexing arm movements and fists, and stamping the ground to symbolize grinding whatever is left (of the opponent) into the dust (a portent, or prediction). The first two lines of the Te Rauparaha Haka are, 'It is death, it is death, It is life, it is

Art Plays Sport

The gallery and museum crowd does not express its pleasure or displeasure in a demonstrative way. No matter how explicit the work of art, it is meant to be cerebral. The museum, as we are often told, is the secular temple. We can raise our voices in quiet harmony, but not our fists. In his book *Voltaire's Bastards*, John Ralston Saul takes note of the fists raised by Smith and Carlos in Mexico City, now a sign of victory in almost every sport. Saul proposed a prescient origin in Michelangelo's Sistine Chapel fresco, God's 'arm raised and an index finger pointed aggressively with terrifying power'.[11] Saul moves on to the raised arms in Jacques-Louis David's painting *Oath of the Horatii*, Eugène Delacroix's *Liberty Leading the People*, and then Picasso's *Guernica*. His point may be stretched but the body language is there, and sport enters art because art participates in, and records, the mythologies of history and life. Saul also notes that the television broadcasting of sport is one of the successes of the medium, defining the 'thrill of victory and the agony of defeat', a phase used by an American weekly television sports programme in the early 1960s. Television has also co-opted the vocabulary of art and film (and art film) in its coverage: the slow motion, the replay, the intimate close-up, low ground perspectives, overview shots, conspiratorial eavesdropping sound, and overlaying music from classical to rap. The American football sequences in director Oliver Stone's 1999 film *Any Given Sunday* are cut like music videos. In one scene, Stone uses the provocative and confrontational music and lyrics of *My Niggas*, by the rap group DMX, to underscore one of the film's narrative threads, that of Black and White players. Popular culture has no shame. It can be hybridized and self-referential, while claiming 'originality', and constructs sports metaphors.

Brazilian curator Paulo Herkenhoff wrote, 'Latin America produces no good art connected to soccer in spite of winning the world championship seven times.'[12] The same is true for most art depicting sport. The dilemma for artists is that of compounding the metaphor (as in engineering, there are load-bearing limits). How, then, can artists dodge sports metaphors and also operate within the mythic realms of social (and popular) culture? I will cite a few examples, some of the ways that artists have overcome the problems. In 1977, American Pop artist Robert Indiana was commissioned to design a basketball court in Milwaukee, Wisconsin. He applied his characteristic use of primary colours, geometric forms and text, while conforming to the needs of the court markings. The game, therefore, was literally played on a work of art, whether or not the spectators were aware of it. In 1989, the Canadian artist and filmmaker Michael Snow received the major commission for the SkyDome in Toronto, the first-ever retractable domed stadium. His sculptural work there, entitled *The Audience*,

life.' The rugby Haka is led by the team captain, or the most senior Maori player, and performed both by the White and Maori players. Not only is this an adaptation of the original form but it also gives new meaning to it, and is distinct from other pre-game team 'rituals' such as the huddle. The Korean World Cup football team is an example of the latter: the players look at each other, arms or hands linked, their backs to the other team and to the spectators, and mimic the closed ring of the arena.

The global sports arena does not always unite, however; it can provide a forum to assert other cultural differences and draw attention to social conflict within a region. One of the most profoundly disturbing moments for the American psyche came during the 1968 Olympic Games in Mexico City. Afro-American sprinters Tommie Smith and John Carlos raised black-gloved fists in a Black Panther salute on the medal podium. The game became a stage for civil disobedience, as seen by the ruling White majority. Likewise, when Muhammad Ali first defeated Sonny Liston for the heavyweight boxing championship in 1964 (Ali was still Cassius Clay), it was the new Black consciousness defeating the old Negro consciousness. After his victory, Ali addressed the television cameras directly, telling White America that he was Black and dangerous, and their worst nightmare.[10] Through sports and his outspoken views, Ali forced open the wounds of regional, racial division, but in his conviction to ethics and truths at a personal cost, he transcended the sport and entered into mythology and history for all. In this manner, metaphors are also constructed.

is comprised of fourteen six metre high fibreglass figures, mounted on ersatz balconies on the exterior face of the stadium. The figures are cartoon-like and illustrate the expressions and body language of sports spectators: waving, cheering and jeering. Snow breached the closed ring that Canetti describes – 'his audience' faces out to the city – and has reapplied a historical form of art (figuration and architecture, as in church and temples) to contemporary architecture and art. Snow's work becomes the sign of the building, whether or not people know the artist's name (as they would know the names of sport stars) or even recognize it as a work of art. The sign value is higher than its art value in the public domain. Australian Aboriginal artist Ron Hurley addressed a different set of life and sports issues in his 1989 painting *Bradman Bowled Gilbert*. We know it is art, but what does it mean to someone outside of the region? The painting, a compositional diptych, depicts a White cricket batsman in full swing on the left, and a Christian-motif crucified figure on the right. That figure is given the face of an Aboriginal, a painted photograph. The batsman is (Sir) Donald Bradman, the greatest of Australian cricket players, and known to everyone in the country: he has been knighted and sainted. The crucified figure is Eddie Gilbert, an Aboriginal cricket bowler who played in the 1930s. Gilbert was the only bowler ever to knock the bat from Bradman's hands. Bradman praised Gilbert's skill and speed, but Gilbert was never allowed to play for the national team because of his race. The sport of national pride cloaks the national 'shame', a counterpoint to the performance of the Haka. Hurley has effectively constructed a social metaphor through sport.[13] The junction of sport, history and social politics is also played out by Godfried Donkor. He superimposed images of 18th-century boxers onto the pages of the current London *Financial Times* and presented this as wallpaper or covering on gallery walls.

Uri Tzaig's strategy is to orchestrate the game with a provocative twist. In his staging of a football match as if it were the real thing (it is the real thing), Tzaig adds a second ball to the play, and a second referee. (Considering some of the boring World Cup games, perhaps this is not so far-fetched.) Gabriel Orozco has staged sporting competitions with altered playing fields, such as putting a pond in the middle of a ping-pong table to absorb the bounce of the ball. The game is made useless, but it is not a useless game for the artist, and changing the rules has been the modern game in art, and in sports.[14] No sport remains a simple or beautiful game (as football is often called) on the world stage. There are many forces at play, and there is no dis-

puting the charged emotions that such sporting events can engender en masse in the 'global village'.[15] However, I would propose that the real game and its fundamental spirit is played at home, is regional in nature and, like regionalism in art – Hurley's work is one example – provides a crucial, regenerative spirit and cautionary tale.

A last word must be given to Muhammad Ali, because language was part of his game. Ali is the first and the archetypal modern boxer because he spoke in metaphor – 'Float like a butterfly, sting like a bee.' No one had ever described boxing in those terms before, and even if he was not the originator of the phrase (it was probably coined by Drew 'Bundini' Brown, a member of Ali's entourage), it is the prophet who speaks and is known, and changes the rules of the game. Ali acquired mythic status not only because of his invincibility in the ring but also because of his raising of consciousness. It is a regionality – that of a Louiseville-born Afro-American – but it touches the aspirations and hopes of people in many places, and of their cultural and social regions.

1 Renato Poggioli, *The Theory of the Avant-Garde*, New York 1971,
 p. 17.
2 Although non-American born athletes play in the American
 professional leagues, there is no support for a world professional
 baseball championship, even though Japanese and Latin American
 players excel at the game.
3 William K. Zinsser, 'Say It Ain't So', in *Pop Goes America*, New York
 1966, p. 156.
4 This is not so for American football – Vince Lombardi, the coach of
 the Green Bay Packers, established a 'winning is everything' credo
 in the late 1950s.
5 The Indian feature film *Lagaan*, nominated for an Oscar Award in
 2002, tells the story of 19th-century Indian villagers defying a tax
 levy by challenging British soldiers to a cricket match.
6 Elias Canetti, *Crowds and Power*, Harmondsworth 1973, p. 30.
 Baseball arenas are called parks, and are distinct in the horseshoe
 configuration of the spectator seats.
7 The spectator in baseball is close enough to the action to catch a
 ball in play, and can inadvertently help the opposing team without
 being ejected from the game for interference.
8 In a television documentary shown on the Australian SBS channel
 during the 2002 World Cup, a Cameroon government official was
 shown addressing the players, telling them that they were
 symbols for the nation and if they broke that bond and trust, they
 would 'kill the people'.
9 Extract from Editorial, *File Magazine*, vol. 1, no. 1, April 1972.
10 Jackie Robinson was the first Black player in the American
 professional baseball leagues, in 1947. In contrast to Ali, he was
 quiet and reserved in public, even though he was abused by racist
 comments and threats. Ironically, Robinson publicly criticized
 Ali for avoiding the military draft in 1967.
11 John Ralston Saul, *Voltaire's Bastards: The Dictatorship of Reason
 in the West*, Toronto et al. 1993, p. 508.
12 Paulo Herkenhoff, 'Incomplete Glossary of Sources of Latin
 American Art', in *Cartographies*, Winnipeg 1993, p. 177. In a related
 commentary, Ivo Mesquita, a curator for the 1998 Bienal de São
 Paulo, gave the following response to my question as to why there
 were so few Black (native) Brazilian artists: 'Blacks do not see art
 as a means to change their social status.'
13 Ron Hurley, b. 1946. *Bradman Bowled Gilbert* is in the collection of
 the Queensland Art Gallery, Brisbane.
14 Kirk Vandoe cities a sport incident in the introduction to his book,
 A Fine Disregard. What Makes Modern Art Modern, New York 1994.
 In 1823 William Webb Ellis was playing in a football match in
 Warwickshire, England. He picked up the ball and ran with it – a
 "fine disregard" for the rules of football, but setting into motion
 the new game of rugby. Varnedoe uses this as an analogy for the
 sudden and unexpected shifts in the 'game' of modern art.
15 Associated Press, 22 June 2002, reported that FIFA had received
 400,000 abusive emails from Italian fans irate because of the
 referee decisions in the Italy – Republic of Korea match.

BIOGRAFIEN BIOGRAPHIES

GUSTAVO ARTIGAS

Geboren/born in Mexico City 1970
Lebt und arbeitet/Lives and works in Mexico City

Einzelausstellungen (Auswahl) /
Solo Exhibitions (Selection)

2001 »Locals Hate Us. Gustavo Artigas in South Africa«,
Iturralde Gallery, Los Angeles
2000 »Locals Hate Us«, Bag Factory, Johannesburg
»Porquè no me has llamado?«, Arte in Situ – La torre de
los vientos, Mexico City
1998 »A Clock. The Shape of Time«, Ausstellung während der
Basler Uhrenmesse/exhibition during the Clock Fair,
Basel
1997 »Ritual and Rhythm Installations«, The Other Gallery,
Banff Centre for the Arts, Alberta
»Lectura y Ritual Installation and Video«, Galería
unodosiete, Mexico City

Gruppenausstellungen (Auswahl) /
Group Exhibitions (Selection)

2002 »Sportcult«, Apex Art, New York
2001 »49. Biennale di Venezia«, Venedig/Venice
Centrum Beeldende Kunst, Rotterdam
2000 »7th Art Biennial of Havana Cuba«, Havanna/Havana
»Action videos«, Artists Space, New York
»La Amistad«, Galeria DUPP, Holquin, Kuba/Cuba
1999 »Ruido, Primer Festival de Arte Sonoro«, ExTeresa Arte
Actual, Mexico City
1998 »Non-Lieux. Poesie des Nicht-Ortes«, Kaskaden-
kondensator, Basel
»In the Nineties. Mexican Contemporary Art«,
Mexican Institute of Culture, Washington

Bibliographie (Auswahl)/Bibliography (Selection)

Harald Szeemann, *The Timeless, Grand Narration of
Human Existence in its Time*, AK/exh. cat. 49. Biennale
di Venezia, Venedig/Venice 2001
Luis-Martin Lozano, *In the Nineties. Contemporary
Mexican Art*, AK/exh. cat. Mexican Cultural Institute,
Washington/Buffalo 1999
Noise. First Sound Art Festival, AK/exh. cat. Ex-Teresa
Arte Actual, Mexico City 1999

STEFAN BANZ

Geboren/born in Sursee 1961
Lebt und arbeitet/lives and works in Luzern

Einzelausstellungen (Auswahl)/
Solo Exhibitions (Selection)

2002 »Liquid Sky« (mit/with Christoph Büchel, Bob
Gramsma, Abigail Lane), Frac Bourgogne, Dijon
»Before Live«, Museum Bickel, Walenstadt
»Wild Roses«, Kabinett, Bern
2001 »Salle de Bains«, Museum Bellerive, Zürich
»The Muhammad Ali's«, Kunstmuseum Luzern
2000 »Gulliver«, Migros Museum für Gegenwartskunst,
Zürich
1999 »A Shot Away Some Flowers«, Musée d'Art moderne
et contemporain, Genf/Geneva
1995 »Give me a Leonard Cohen Afterworld«,
Kunstmuseum Luzern
1992 »Anbau des Museums«, Kunsthalle Luzern

Gruppenausstellungen (Auswahl)/
Group Exhibitions (Selection)

2002 »Je t'aime moi non plus«, Kunstmuseum Thun et al.
»Wallflowers«, Kunsthaus Zürich
2001 »Eros«, Plattform für zeitgenössische Kunst, Luzern
»Boxers«, Kunsthalle Tirol, Hall (Tirol)
2000 »Nachbilder. Neue Fotografien in der Sammlung,
1997 – 1999«, Kunsthaus Zürich
»Attraction«, Galeria Metronom, Barcelona
1999 »Images«, Independent Video Festival, Toronto
1998 »CH – Schweizer Kunst«, Ludwig Múzeum Budapest
»Freie Sicht aufs Mittelmeer«, Schirn Kunsthalle,
Frankfurt am Main

Publikationen (Auswahl)/Publications (Selection)

Hilde Teerlink, »Überlebensgröße. Stefan Banz im Migros
Museum Zürich«, in: *Kunstforum International*, Bd./Vol. 155,
2001, S./p. 99 ff.
Stefan Banz, »Dieses Echt, es ist ein ganz seltsames Wort.
Interview Thomas Wulffen/Stefan Banz«, in:
Kunstforum International, Bd./Vol. 145, 1999, S./p. 266 – 277
Arthur C. Danto, »An Unrestricted View of the Mediterranean«,
in: *Artforum*, 10/1998, S./p. 118 ff.
Stefan Banz, *Give Me a Leonard Cohen Afterworld*,
Ostfildern 1995

ANA BUSTO

Geboren/born in Biskaya/Biscay
Lebt und arbeitet/lives and works in New York

Einzelausstellungen (Auswahl)/
Solo Exhibitions (Selection)

2002 »Cuban Boxers«, Tribes Gallery, New York
2001 »La Escuela Cubana de Boxeo«, Galería Oliva Arauna,
 Madrid
2000 »Night Fights«, Sala Rekalde, Bilbao
1999 »Working Shoes«, Sala de exposiciones, El Roser, Lleida
1997 »Transportar«, Museo de Arte Carrillo Gil, Mexico City
1996 »Working Shoes«, El Museo del Barrio, Sala
 Contemporánea, New York
1995 »Juntar – unir – amontonar«, Galería Antonio de
 Barnola, Barcelona
 »Ana Busto«, Galería Visor, Valencia

Gruppenausstellungen (Auswahl)/
Group Exhibitions (Selection)

2001 »SportCult«, Apex Art, New York
 »Bida 2001. Bienal Internacional del Deporte en
 el Arte«, Valencia
 »Women at Work«, Southwestern College, Chula Vista
2000 »The Eyes Have it«, Porter Troupe Gallery, San Diego
1999 »El otro el mismo«, Centro Cultural de España, Lima
1998 »Cómo nos vemos. Imágenes y arquetipos femeninos«,
 Tecla Sala, Barcelona
 »Cast in Iron«, Grounds for Sculpture, Hamilton
 »Pierogi Files«, Brooklyn Museum of Art, New York
1997 »Arco 97«, Galería Visor, Valencia/Galería Antonio de
 Barnola, Barcelona
1996 »Fragments«, Museo de Arte Contemporáneo
 de Barcelona
1995 »Territorios indefinidos«, Galería Luis Adelantado,
 Valencia

GODFRIED DONKOR

Geboren/born in Ghana 1964
Lebt und arbeitet/lives and works in London

Einzelausstellungen (Auswahl)/
Solo Exhibitions (Selection)

2002 »Godfried Donkor«, Albrecht Dürer Gesellschaft/
 Kunstverein Nürnberg, Nürnberg/Nuremberg
2001 »Händel and Hogarth at Vauxhall Pleasure Gardens«,
 St. Peter's Church, Vauxhall, London
 Artists in Residence exhibition, International Artists
 Studio Program, Stockholm
2000 »Whose Africa«, Horniman Museum, London
 »Wrestling and Mysticism«, Dak'Art 2000, Dakar
1999 »Slave to Champ«, EMACA, Nottingham

Gruppenausstellungen (Auswahl)/
Group Exhibitions (Selection)

2002 »Origin of End«, Leicester City Gallery, Leicester
 »Visitors«, Kunsthallen Bohusläns Museum, Uddevalla
2001 »Boxers«, Kunsthalle Tirol, Hall (Tirol)
 »Anstoβ, Kunst, Sport und Politik«, Albrecht Dürer Ge-
 sellschaft/Kunstverein Nürnberg, Nürnberg/
 Nuremberg
 »SportCult«, Apex Art, New York
 »Authentic/Excentric«, 49. Biennale di Venezia,
 Venedig/Venice
 »Africa Today. The Artist and the City«, Centre de
 Cultura contemporànea de Barcelona
2000 »The 7th Havana Biennale«, Havanna/Havana
 »World Trade«, Roebling Hall Gallery, New York
1999 »Picture This. New Representational Painting«, AAA
 Gallery, New York
1998 »Cinco continentes y uno ciudad salon exhibition«,
 Mexico City
 »Dak'Art 98«, Dakar Biennale, Dakar

Publikationen (Auswahl)/Publications (Selection)

Salah Hassan/Olu Oguibe (Hrsg./Ed.), *Authentic/Excentric:
Conceptualism in Contemporary African Art*, New York 2001
Africa Today. The Artist and the City, AK/exh. cat. Centre de
Cultura Contemporània de Barcelona, 2000
M. Franklin Sirmans/Mora J. Beauchamp-Byrd (Hrsg./Ed.),
*Transforming the Crown: African, Asian, and Caribbean Artists
in Britain, 1966–1996*, Chicago 1997

TAMARA **GRCIC**

Geboren in München/born in Munich 1964
Lebt und arbeitet/lives and works in Frankfurt am Main

Einzelausstellungen (Auswahl)/
Solo Exhibitions (Selection)

2002 Galerie Monika Reitz, Frankfurt am Main
2001 Museum der Bildenden Künste, Leipzig
 Mannheimer Kunstverein, Mannheim
2000 Museum Fridericianum, Kassel
1999 Westfälischer Kunstverein, Münster
1998 Kunsthalle Sankt Gallen
1997 »Duchamps Urenkel«, Bonner Kunstverein, Bonn

Gruppenausstellungen (Auswahl)/
Group Exhibitions (Selection)

2001 »Sport in der Zeitgenössischen Kunst«, Kunsthalle
 Nürnberg, Nürnberg/Nuremberg
 »Monets Vermächtnis. Serie – Ordnung und Obsession«,
 Hamburger Kunsthalle, Hamburg
1999/
2000 »Das Versprechen der Fotografie. Aus der
 Sammlung der DG Bank«, P.S.1 Contemporary Art Center,
 New York, et al.
1996 »Manifesta 1«, Rotterdam

Publikationen (Auswahl)/Publications (Selection)

Tamara Grcic, AK/exh. cat. Museum der Bildenden Künste,
Leipzig 2001
Tamara Grcic, AK/exh. cat. Museum Fridericianum, Kassel 2000
Dorothea von Stetten-Kunstpreis 1998, Kat./cat. Kunstmuseum
Bonn 1999

SONYA **HORN (GEB. / NÉE WEBER)**

Geboren/born in Metzingen 1974
Lebt und arbeitet/lives and works in Stuttgart
Seit/since 2000 Zusammenarbeit mit Tina Schneider als
»Weber & Schneider«/working with Tina Schneider as
'Weber & Schneider'

Ausstellungen (Auswahl)/Exhibitions (Selection)

2002 »Iconoclash«, ZKM Karlsruhe
 »Der Kunstgarten« mit dem Projekt
 »Himmelstreppe«, Stuttgart

2001 »Aggregate« (mit/with Tina Schneider), Kunsthalle
 Kornwestheim
2001 »2. Triennale zeitgenössischer Kunst Oberschwaben«,
 Braith-Mali-Museum, Biberach
 »Tage im Gefängnis«, Baden-Baden
 »Moving Pictures«, Villa Merkel, Esslingen
 »Wimbledom« und »Reziprok« (mit/with Tina
 Schneider), Karlskaserne, Ludwigsburg
2000 Künstlerwerkstatt Metzingen/Neuhausen
1999 Einzelausstellung/Solo exhibition, Galerie Art Und
 Deco, Metzingen
 »Die Lagerfeuer unserer Zeit I und II«, Galerie der Stadt
 Backnang

SATCH **HOYT**

Geboren/born in London 1957
Lebt und arbeitet/lives and works in New York

Einzelausstellungen (Auswahl)/
Solo Exhibitions (Selection)

2002 »Within Layers We Reside«, Emma Molina Gallery,
 Monterrey
1997 »Star Worshippers«, Ileana Bouboulis Gallery, Paris
 »Satch Hoyt«, Galerie de l'autre Côté de la Rue,
 Brüssel/Brussels

Gruppenausstellungen (Auswahl)/
Group Exhibitions (Selection)

2001 »Boxers«, Kunsthalle Tirol, Hall (Tirol)
 »All Access«, crosspathculture, New York
 »SportCult«, Apex Art, New York
1999 »Art of Latin America and the Caribbean«,
 UNESCO, Paris
1998 »San Francisco Art Fair«, Contempora Gallery,
 San Francisco
 »Artistes Jamaicans«, DDB, Paris
1996 Opera Gallery, Singapur/Singapore
 »Off Biennial«, Venedig/Venice

Publikationen (Auswahl)/Publications (Selection)

Helen Allen, »SportCult, Apex Art, New York«, in: *Flash Art
International*, 11 – 12/2001
Ovazione, AK/exh. cat. Collezione Aprile di Cima,
Mailand/Milan 1999
Satch Hoyt. August Jams, AK/exh. cat. Disegno Diverso,
Galleria Antonia Jannone, Turin 1993

MICHAEL JOSEPH

Geboren/born in Cleveland 1967
Lebt und arbeitet/lives and works in New York

**Einzelausstellungen (Auswahl)/
Solo Exhibitions (Selection)**

1997 »I Am You Am I«, Postmasters Gallery, New York
1996 »Average Joe«, Silverstein Gallery, New York
»Proxy«, 407, New York

**Gruppenausstellungen (Auswahl)/
Group Exhibitions (Selection)**

2002 »Inner Space«, Art In General, New York
»Parts«, Artspace/Untitled (space), New Haven
2001 »Interval«, Sculpture Center, New York
»Random Access Memory«, Dumbo Arts Center,
New York
2000 »Endurance«, Downtown Arts Festival, New York
»Reactor«, KulturBahnhof, Kassel
»Achieving Failure«, Threadwaxing Space, New York
1999 »The Choice 99«, Exit Art, New York
»Smorgasbord 99«, International Artists Studio
Program, Stockholm
»Formulas for Revelation«, The Rotunda Gallery,
New York
1998 »Time to Kill«, Pineapple, Malmö
»The Bird More Curious than I«, Exit Festival Creteil,
Paris
1997 »Artists' Performances«, New Museum of Contemporary
Art, New York
»The Art Exchange Show«, 407, New York
»Para-Site«, Galleries de la Toison d'Or,
Brüssel/Brussels

Publikationen (Auswahl)/Publications (Selection)

Bill Arning, »The Choice«, in: *Time Out Magazine (New York)*,
Nr./Vol. 221–222, 12/1999
Jessica Chalmers, »L' attualità della performance«, in: *Italia
Flash Art*, 6–7/1998
Lisa Jaye Young, »The Artist's Equation«, in: *Zing Magazine*,
Herbst/Fall 1996

ANTAL LAKNER

Geboren/born in Budapest 1966
Lebt und arbeitet/lives and works in Budapest

**Einzelausstellungen (Auswahl)/
Solo Exhibitions (Selection)**

2001 »Art Mobile«, Künstlerhaus Bethanien, Berlin
»INERS – Passive Working Devices«, »Art Mobile–
Human Powered Biennale Vehicles«, Ungarischer
Pavillon/Hungarian Pavilion, 49. Biennale di Venezia,
Venedig/Venice
2000 »Eurofarm«, Hal Antwerpen, Antwerpen/Antwerp
1999 »Her – The Icelandic Army«, Zenit Gallery, Budapest
»Altered States«, (mit/with Attila Csörgô), SKUC Gallery,
Ljubljana
1998 »INERS – The Power«, Studio Gallery, Budapest
1997 »UGAR« (mit/with Georg Winter), Neuer Berliner
Kunstverein, Berlin
1994 »Bartók Travel«, Bartók 32 Gallery, Budapest
1993 »Pope Collection«, Gallery '56, Budapest
»Emmental Expedition« (mit/with Georg Winter),
Studio Gallery, Budapest

**Gruppenausstellungen (Auswahl)/
Group Exhibitions (Selection)**

2002 »Manifesta 4«, Frankfurt am Main
2001 »Parti pris«, Fonds régional d'art contemporain
(Frac) Languedoc-Roussillon, Montpellier
»Digitized Bodies«, Ludwig Múzeum Budapest
2000 »After the Wall«, Hamburger Bahnhof, Berlin
»Cooperativ«, Stadthaus Ulm
1999 »Budapest – Berlin '99«, Akademie der Künste, Berlin
»After the Wall«, Museum of Modern Art, Stockholm
1998 »Observatory«, Centre for Contemporary Art,
Ujazdowski Castle, Warschau/Warsaw
1997 »5. International Istanbul Biennial«, Istanbul
1996 »Junge Szene Budapest«, Galerie 5020, Salzburg

Publikationen (Auswahl)/Publications (Selection)

Antal Lakner. Popecollection, AK/exh. cat. Galeria 56,
Budapest 2001
Social Intercourse, AK Ungarischer Pavillon/exh. cat.
Hungarian Pavilion, 49. Biennale di Venezia, Budapest 2001
András Zwickl, »Virtuelle Lückenfüller«, in: *Kunst der
neunziger Jahre in Ungarn*, Berlin 1999
Antal Lakner/Georg Winter, *UGAR*, AK/exh. cat. Neuer Berliner
Kunstverein, Berlin 1997

JULIA **LOKTEV**

Geboren/born in St. Petersburg 1969
Lebt und arbeitet/lives and works in New York

Einzelausstellungen (Auswahl)/
Solo Exhibitions (Selection)

2002 »Rough House«, Art Basel/Art Unlimited, Basel
2001 »Said in Passing«, Galerie griedervonputtkamer, Berlin
1993 »The Snooping Room«, The Edge, Denver

Gruppenausstellungen (Auswahl)/
Group Exhibitions (Selection)

2002 »Stories«, Haus der Kunst, München/Munich
»Beautiful Life?«, Contemporary Art Center, Art Tower
Mito, Ibaraki-ken, Japan
2001 »The Body of Art«, Bienal de Valencia
»Going Places«, SMART Project Space, Amsterdam
2000 »Some New Minds«, P.S.1 Contemporary Art Center,
New York
1997 »Just What Do You Think You're Doing, Dave?«,
Williamsburg Art and Historical Society, New York
1993 »The Snooping Room«, The Edge, Denver

Filmfestivals (Auswahl)/Film Festivals (Selection)

Sundance Film Festival (Best Director Award)
Karlovy Vary International Film Festival, Karlsbad/Karlovy
Vary (Best Documentary)
Cinéma du Réel, Paris (Grand Prize)
Internationales Dokumentarfilm-Festival München/Munich
(Grand Prize)
San Francisco International Film Festival (Golden Gate Award)

RUSSELL **MALTZ**

Geboren/born in New York 1952
Lebt und arbeitet/lives and works in New York

Einzelausstellungen (Auswahl)/
Solo Exhibitions (Selection)

2002 Galerie Michael Sturm, Stuttgart
2001 Galerie Schlégl, Zürich
1999 »Accu-Flo«, Dortmunder Kunstverein, Dortmund
Sarita Dubin Fine Art, Tokio/Tokyo
1998 E. S. Van Dam Gallery, New York
»Werk '97«, Symposium, Heidenheim (1. Preis/1st prize)
1997 Werner Kramarsky Gallery, New York

1996 Studio A – Sammlung Konkreter Kunst, Otterndorf
1995 Wilhelm-Hack-Museum, Ludwigshafen (Rhein)
Ars Nova Galleri, Göteborg

Gruppenausstellungen (Auswahl)/
Group Exhibitions (Selection)

2002 »Prescient Then and Now: The Resonance of Supports/
Surfaces«, Dorsky Gallery, L.I.C., New York
2001 »Fifteen Years of Painting«, Stark Gallery, New York
»Öl auf Leinwand – Öl auf Leinwand«, Galerie Michael
Sturm, Stuttgart
2000 »Maximal-Minimal«, Feigen Contemporary Art, New York
»Farbzeit«, Museum Bochum, Bochum
1999 »Surface/Facade«, The Otis Art Institute, Los Angeles
1998 »Vibration«, Margaret Thatcher Projects, New York
1997 »Collected in Saarlouis«, Stadtmuseum, Saarlouis
»Divergent Models«, Nassauischer Kunstverein,
Wiesbaden
1996 »Konkret – Konstruktiv – Arbeiten auf Papier«, Museum
Sankt Ingbert, Sankt Ingberg

Publikationen (Auswahl)/Publications (Selection)

Russell Maltz – Accu Flo, AK/exh. cat. Galerie der Stadt
Backnang/Dortmunder Kunstverein, Dortmund 1998
Russell Maltz. Drawings, hrsg. von/ed. by Werner Kramarsky/
Fifth Floor Foundation, York 1997
Russell Maltz. Gemalt – Gestapelt/Painted – Stacked, AK/exh.
cat. Wilhelm-Hack-Museum, Ludwigshafen 1995

MATTHEW **McCASLIN**

Geboren/born in Bayshore 1957
Lebt und arbeitet/lives and works in New York

Einzelausstellungen (Auswahl)/
Solo Exhibitions (Selection)

1999 Kunstverein Freiburg, Freiburg
1998 Sandra Gering Gallery, New York
1998 Kunstverein St. Gallen, Kunstmuseum
Leipziger Galerie für zeitgenössische Kunst, Leipzig
1997 Baumgartner Galleries, Washington
Real Art Ways, Hartford
»Currents 65«, St. Louis Art Museum, St. Louis
1996 »Harnessing Nature«, Whitney Museum of American
Art at Phillip Morris, New York
»Time Machine«, Gallery Anselm Dreher, Berlin
1995 »Bloomer«, Michael Klein Gallery, New York
Galerie Rolf Ricke, Köln/Cologne

Gruppenausstellungen (Auswahl)/
Group Exhibitions (Selection)

1998 P.S.1 Contemporary Art Center, New York
1996 »Constructions«, Michael Klein Gallery, New York
»Kingdom of Flora«, Shoshana Wayne Gallery,
Santa Monica
»Bonne Année«, Galerie Rodolphe Janssen,
Brüssel/Brussels
»Berechenbarkeit der Welt«, Bonner Kunstverein, Bonn
»Sculpture of the Twenty-First Century«, John Gibson
Gallery, New York
1995 »Drawn on the Museum«, The Aldrich Museum
of Contemporary Art, Ridgefield
»Inaugural Exhibition«, Thomas Nordenstad Gallery,
New York
»Low Tech«, Galerie Christine Koenig, Wien/Vienna
»Passions Envers«, Musee d'Art Moderne de la Ville
de Paris, Paris

Publikationen (Auswahl)/Publications (Selection)

Matthew Yokobowsky, *Harnessing Nature*, Ausst.-Broschüre/
Exh. brochure Whitney Museum of American Art at Phillip
Morris, New York 1996
Thomas Kliemann, »Und alles könnte auch anders sein«,
in: *Frankfurter Allgemeine Zeitung*, 25/3/1995
F. Daftan, Projects 33: Matthew McCaslin, Ausst.-Broschüre/
Exh. brochure The Museum of Modern Art, New York 1992

FLORIAN **MERKEL**

Geboren/born in Chemnitz 1961
Lebt und arbeitet in Hannover und Berlin/lives and works
in Hanover and Berlin

Einzelausstellungen (Auswahl)/
Solo Exhibitions (Selection)

2002 »Aktuelle Zustände«, Wohnmaschine, Berlin
2000 »100 Meisterwerke«, Mitaka Arts Center, Tokio/Tokyo
»100 Meisterwerke« Kunstverein Freiburg, Freiburg
1998 Galleria d'Arte Moderna, Sassuolo
1998 »Penthesilea«, Kleistmuseum, Frankfurt (Oder)
»Leben & Arbeit«, Wohnmaschine, Berlin
1997 Nuovi Eventi, Imola
»Jugend & Technik«, Galleria La Nuova Pesa, Rom/Rome
1996 Nassauischer Kunstverein, Wiesbaden
Kunstverein Göttingen, Göttingen

Gruppenausstellungen (Auswahl)/
Group Exhibitions (Selection)

2002 »Dreiineins«, Essor Gallery, London
»Heimat.de – Fotographische Sichten auf ein besetztes
Thema«, Kunst Haus Dresden, Dresden
»Stories«, Haus der Kunst, München/Munich
2001 »Less Evil«, Galleria La Nuova Pesa, Rom/Rome
»Collector's Joice«, Exit Art, New York
»Ich bin, weil mein kleiner Hund mich kennt«,
Schloss Kromsdorf, Kromsdorf
2000 »Der molekulare Blick«, Kunsthalle Lingen
»Here and Now«, Fotobiennale Rotterdam
»Das Versprechen der Fotografie«, Akademie der
Künste, Berlin/Schirn Kunsthalle, Frankfurt am Main
1999 »Kunst statt Werbung 1999« (mit/with Boris Michailov),
Neue Gesellschaft für bildende Kunst, Berlin
»Mach's gut Mensch«, Kunstverein Schwerte e. V.,
Schwerte
1998 »Das Versprechen der Fotografie«, Hara Museum
of Contemporary Art, Tokio/Tokyo
»Standort Deutschland«, Städtisches Museum
Leverkusen, Schloss Morsbroich

Publikationen (Auswahl)/Publications (Selection)

Florian Merkel. 100 Meisterwerke, AK/exh. cat. Galerie
Wohnmaschine, Berlin 2000
Ute Linder/Patrick Huber, *Copyright Nr. 3*, Berlin 2000
*Global Fun. Kunst und Design von Mondrian, Gehry, Versace
and Friends*, AK/exh. cat. Städtisches Museum Leverkusen,
Schloss Morsbroich, Ostfildern 1999

CAITLIN **PARKER**

Geboren/born in Gainesville 1975
Lebt und arbeitet/lives and works in New York

Exhibitions (Selection)

2002 »Bologna Art Fair«, Bologna
2001 »Liste 01, The Young Art Fair in Basel«, Basel
»Pause and Play«, VTO Gallery, London
»New Paintings«, Rhodes + Mann Gallery, London
»Hidden Identity«, Elizabeth Harris Gallery, New York

JOÃO **PENALVA**

Geboren in Lissabon/born in Lisbon 1949
Lebt und arbeitet/lives and works in London

Einzelausstellungen (Auswahl)/
Solo Exhibitions (Selection)

2002 The John Curtin Gallery, Curtin University, Perth
 Rooseum Centre for Contemporary Art (mit/with
 Matts Liederstam), Malmö
 Max Protetch Gallery, New York
2001 Portugiesischer Pavillon/Portuguese Pavilion,
 49. Biennale di Venezia, Venedig/Venice
 13 quai Voltaire, Caisse des Dépots et Consignations,
 Paris
 »This Side and Beyond the Dream«, Sigmund Freud
 Museum, Wien/Vienna
2000 Camden Arts Centre, London
 Contemporary Art Center, Vilnius
 Galerie im Taxispalais, Galerie des Landes Tirol,
 Innsbruck
1999 Centro Cultural de Belém, Lissabon/Lisbon
 Fonds régional d'art contemporain (Frac) Languedoc-
 Roussillon, Montpellier
1996 »23, Bienal Internacional de São Paulo«, São Paulo

Gruppenausstellungen (Auswahl)/
Group Exhibitions (Selection)

2002 »The Long Long Story Night« Haus der Kunst,
 München/Munich
 »Sydney Biennale«, Sydney
 »Video avond«, Centrum Beeldende Kunst, Rotterdam
2001 »Itazu Litho-Graphik«, Museum Haus Kasuya,
 Tokio/Tokyo
 »Berlin Biennale 2«, Berlin
 »Cine y Casi Cine«, Museu Nacional Centro de Arte
 Reina Sofía, Madrid
2000 »Fossick«, Sali Gia, London
2000 »Art & Industry«, 2000 Biennial, Christchurch
 »More Works about Buildings and Food«, Fundição de
 Oeiras, Oeiras
1999 »Signs of Life«, 1. Melbourne International Biennial,
 Melbourne
 »From Where to Here«, Konsthallen, Göteborg
1998 »Enough«, The Tannery, London
 »La Sphère de l'intime«, Le Printemps de Cahors, Cahors
 »Neither/Nor«, Living Arts Museum, Reykjavik

Publikationen (Auswahl)/Publications (Selection)

Brigitte Huck, »João Penalva«, in: *Diesseits und jenseits des
Traums*, AK/exh. cat. Sigmund Freud Museum, Wien/Vienna
2001
João Penalva – R., AK/exh. cat. 49. Biennale di Venezia –
Instituto de arte contemporânea/Ministery of Culture of
Portugal, Lissabon/Lisbon 2001
Juliana Engberg, »João Penalva«, in: *Signs of Life*, AK/exh. cat.
Melbourne International Biennial, Melbourne 1999

TINA **SCHNEIDER**

Geboren/born in Bad Cannstatt 1974
Lebt und arbeitet/lives and works in Stuttgart
Seit/since 2000 Zusammenarbeit mit Sonya Horn als »Weber &
Schneider«/working with Sonya Horn as 'Weber & Schneider'

Ausstellungen (Auswahl)/Exhibitions (Selection)

2001 »Aggregate« (mit/with Sonya Horn),
 Kunsthalle Kornwestheim
2000 »Wimbledom« und »Reziprok II« (mit/with Sonya Horn),
 Karlskaserne, Ludwigsburg
1999 –
2002 Projekt »Kunstgarten« (mit/with Volkhardt Müller),
 Kunsthalle Kornwestheim
1999 Projekt »Milleniumeiche« (mit/with Volkhardt Müller),
 Expressguthalle Stuttgart
 Videoinstallation/video installation,
 Galerie der Stadt Backnang
1997 »Das neue schöne Bild«, Alpirsbacher Galerie,
 Alpirsbach

DOROTHEA **SCHULZ**

Geboren/born in Karlsruhe 1962
Lebt und arbeitet/lives and works in Stuttgart

Einzelausstellungen (Auswahl)/
Solo Exhibitions (Selection)

2002 »Sprecher I«, SWR Galerie im Funkhaus Stuttgart,
 Stuttgart
 »Sprecher II«, Kunstverein Neuhausen
2001 »La Chambre dans laquelle j'ai appris la langue
 française«, Musée de Valence

1999 »La Couleur de la bière«, Centre européen d'actions artistiques contemporaines (CEAAC), Straßburg/ Strasbourg
1998 »Es macht Dir doch nichts aus, wenn ich für eine Weile zu dir ziehe«, Galerie Patricia Schwarz, Stuttgart
»1.1.1990 – 20.9.1998«, Galerie im Kornhaus, Kirchheim/Teck
1996 Galerie Hannappel, Essen

Gruppenausstellungen (Auswahl)/
Group Exhibitions (Selection)

1999 »Die Kinder der Männer und Frauen von PSR 16 20 20« (mit Olaf Probst), Galerie der Stadt Backnang, Backnang
1998 »Downtown und andere unbekannte Orte«, Württembergischer Kunstverein Stuttgart
1995 »Nord-Süd-Fahrt 1«, Halle K3, Kampnagelfabrik, Hamburg

Publikationen (Auswahl)/Publications (Selection)

Dorothea Schulz, *Apprendre le Français/Französisch Lernen*, Valence 2001
Dorothea Schulz. *Bier 1 – 4/Bière 1 – 4*, AK/exh. cat. Centre européen d'actions artistiques contemporaines (CEAAC), Straßburg/Strasbourg 1999

KAREN **SHAW**

Geboren/born in New York 1942
Lebt und arbeitet/lives and works in New York

Einzelausstellungen (Auswahl)/
Solo Exhibitions (Selection)

1999 Art Resources Transfer, Project Room, New York
1998 Art Resources Transfer, 25 Year Mini Survey, New York
1991 Anthony Giordano Gallery, Dowling College, Oakdale, New York
1990 Het Apollohuis, Eindhoven
1988 »Nature Morte: The Late Great Lakes Installation«, Southhampton
1986 »Some States, Some States of Mind«, City Graduate Center, New York

Gruppenausstellungen (Auswahl)/
Group Exhibitions (Selection)

2002 »Body Language«, Islip Art Museum, East Islip, New York

2001 »The Body Show«, The Workspace, New York
Wake Forest University, Winston-Salem
2000 Art Space, Los Angeles
2000 »Conversation Two Person Exhibition«, Art Resources Transfer, New York
1999 »Millennium Messages. Travelling«, Heckscher Museum, Huntington, New York
»Phenotypology«, HallWalls Contemporary Arts Center, Buffalo
1998 »Art + Suitcase Will Travel«, Conductors Hallway, London
1997 »Antartica«, Eindhoven
1996 »Plastica Contemporanea«, Guatemala City

Publikationen (Auswahl)/Publications (Selection)

Jean Sellem, Interview mit Karin Shaw, in: *Heterogenesis*, Nr. 33, 10/2000
From Hard Hats to Top Hats, AK/exh. cat. The Jewish Museum, New York 1993
Stella Pandell Russell, *Art in the World*, Winston 1983
Karen Shaw, AK/exh. cat. Corinne Hummel Galerie, Basel 1983

GRAZIA **TODERI**

Geboren/born in Padua 1963
Lebt und arbeitet in Mailand/lives and works in Milan

Einzelausstellungen (Auswahl)/
Solo Exhibitions (Selection)

2002 »Homo ludens«, Fondation Miró, Barcelona
2001 Galleria Giò Marconi, Mailand/Milan
»Random«, FA Projects, London
Istituto Italiano di Cultura, Los Angeles
The Project, New York
2000 Galerie Meert-Rihoux, Brüssel/Brussels
Palazzo Lanfranchi, Pisa
Western Front, Vancouver
1999 Projektraum, Museum Ludwig, Köln/Cologne
1998 Castello di Rivoli, Museo d'arte Contemporanea, Turin
Fonds régional d'art contemporain (Frac) Bourgogne, Dijon
Casinò Luxembourg, Luxemburg
1997 Galleria Scognamiglio & Teano, Neapel/Naples
1996 Galleria Artra (mit/with Massimo Bartolini), Mailand/Milan
1995 Studio Casoli, Mailand/Milan
»Bye, Bye, Baby«, Jago Gallery (mit/with Liliana Moro), Paris

**Gruppenausstellungen (Auswahl)/
Group Exhibitions (Selection)**

2002 »Slow Motion«, Ludwig Forum für Internationale
 Kunst, Aachen
2002 »Supermover«, FotoFest, Houston
2001 »Futureland«, Städtisches Museum Abteiberg,
 Mönchengladbach
 »1900 – 1999«, Museum of Contemporary Art,
 Tokio/Tokyo
 SESC Pompeia, São Paulo; Queens Museum, New York
2000 »Novecento. Arte e storia in Italia«, Scuderie Papali del
 Quirinale, Rom/Rome
 »Himmelfahrt«, Karmeliterkirche München/Munich;
 Diözesanmuseum Freising
1999 »DAPERTutto«, 48. Biennale di Venezia, Venedig/Venice
1998 »Public-Private«, Netherlands Media Art Institute,
 MonteVideo/TBA, Amsterdam
 »Every Day«, 11th Sydney Biennale, Sydney
1997 »5th International Istanbul Biennial«, Istanbul

Publikationen (Auswahl)/Publications (Selection)

Rudolf Scheutle, »Grazia Toderi«, in: Renate Wiehager (Hrsg./
Ed.), *Moving Pictures. Fotografie und Film in der zeitge-
nössischen Kunst. 5. Internationale Foto-Triennale Esslingen*,
Ostfildern 2001
Bice Curiger, »Grazia Toderi«, in: *Fresh Cream*, London 2000
Petra Giloy-Hirtz, »Grazia Toderi«, in: ibid. (Hrsg./Ed.),
Himmelfahrt, Ostfildern 2000
R. Ross, »Grazia Toderi«, in: *Kunstforum International*,
Nr./Vol. 145, 5 – 6/1999, S./p. 364

URI TZAIG

Geboren/born in Kiryat Gat 1965
Lebt und arbeitet/lives and works in Tel Aviv

**Einzelausstellungen (Auswahl)/
Solo Exhibitions (Selection)**

2002 Art: Concept Gallery, Paris
 Unlimited Contemporary Art, Athens
 Moderna Museet, Stockholm
2001 »The Other Hotel«, Kojimachi Gallery, Tokio/Tokyo
 »Trance«, VW Video for Windows, New York
2000 »Moonstruck«, Fonds régional d'art contemporain (Frac)
 Champagne-Ardennes, Reims
 »Duel«, Artists Space, New York
1999 Institute of Visual Arts, Milwaukee
 L'Aquarium, School of Fine Arts, Valenciennes

1999 »B/W«, Migros Museum für Gegenwartskunst, Zürich
1998 »Tempo«, De Vleeshal, Middelburg
 »Infinity«, Ateliers du Fonds régional d'art contempo-
 rain (Frac) Languedoc-Roussillon, Montpellier
1997 Mot & Van den Boogaard Gallery, Brüssel/Brussels
1997 Refusalon Gallery, San Francisco
 »Play«, Museum of Modern Art, Ljubljana

**Gruppenausstellungen (Auswahl)/
Group Exhibitions (Selection)**

2001 »International Triennale of Contemporary Art«,
 Yokohama
 »Connivences. 6th Lyon Biennale«, Lyon
 »Trouble Shooting«, Arnolfini, Bristol
2000 »Sporting Life«, Museum of Contemporary Art, Sydney
 »Let's Entertain«, Centre Georges Pompidou, Paris
 Raum Aktueller Kunst, Wien/Vienna
1999 Wiener Kunstverein, Wien/Vienna
 »Young Artists from Israel«, The Jewish Museum,
 New York
1998 »The Earth is Round – New Narration«, Musée
 Départemental, Château de Rochechouard
 »Between«, Museum of Modern Art, Jacksonville
1997 »Unmapping the Earth«, Kwangiu Biennale, Korea
 Documenta X, Kassel
 Biennale di Venezia (mit Fabrice Hybert im
 Französischen Pavillon/guest of Fabrice Hybert
 at the French Pavilion), Venedig/Venice

Publikationen (Auswahl)/Publications (Selection)

Uri Tzaig. Duel, AK/exh. cat. Artists Space, New York 2000
Uri Tzaig. User Guide – Text, Quotes, References & Images, AK/
exh. cat. Migros Museum für Gegenwartskunst, Zürich 1999
Pesach Slabosky, *Never Did Anything Hard. Epilog to the
Conversation*, AK/exh. cat. Tel Aviv Museum, Tel Aviv 1997
The Story Teller, AK/exh. cat. Künstlerhaus Bethanien,
Berlin 1995

ALAN UGLOW

Geboren/born in Luton 1941
Lebt und arbeitet/lives and works in New York

**Einzelausstellungen (Auswahl)/
Solo Exhibitions (Selection)**

2002 Stark Gallery, New York
2001 Galerie griedervonputtkamer, Berlin
2000 Gallerie Onrust, Amsterdam

1996 Galerie Bobvan Orsouw, Zürich
1996 »Drawings & Photos«, Petra Bungert Gallery, New York
1995 »Nye Malerier«, Galleri Tommy Lund Gallery,
Kopenhagen/Copenhagen
Gallery Gimpel Fils, London

Gruppenausstellungen (Auswahl)/
Group Exhibitions (Selection)

2002 »Exhibition der Fussballseele«, Helmhaus Zürich
»Acht Malerische Positionen«, Galerie S 65,
Köln/Cologne
2001 Galerie Tommy Lund, Kopenhagen/Copenhagen
»Fifteen Years of Painting«, Stark Gallery, New York
2000 »Hex Enduction Hour by the Fall«, Team Gallery,
New York
»Contemporary American Drawings from the Sarah-Ann
and Werner H. Kramarsky Collection«, Pollock Gallery,
Dallas
1999 »Protoplasm: Paul Morrison, Carl Ostendorp,
Alan Uglow«, Galerie Bob Van Orsouw, Zürich
1998 »Dijon/le Consortium. Collection tout contre l'art
contemporain«, Galerie Sud du Centre Georges
Pompidou, Paris
»Hey, You Never Know«, 534 La Guardia Place, New York
1997 »High Precision«, Halles Gallery and 172 Deptford High
Street, London
1996 »Learn to Paint and Build, Parts 1 and 2«, Floating
Gallery, London
»Monochromie Geometrie. Helmut Federle, Imi Knoebel,
Alan Uglow et al.«, Sammlung Goetz, München/Munich

Publikationen (Auswahl)/Publications (Selection)

Tom McDonough, »Alan Uglow«, in: *Art in America*, 4/1999
Thomas Wulffen, »Alan Uglow«, in: *Flash Art*, 10/1995
David Carrier, »Attitude Is Everything and Everything Hurts.
Interview David Carrier/Alan Uglow«, in: *Artforum*, 12/1993

2002 *Immer einen hund gehabt/Plane Crazy* (1928)
Uraufführung/First performance: 14/4/1994,
Landesbühne Esslingen
2000 *Triumph der Provinz*
Uraufführung/First performance: 11/4/2002,
Theaterhaus Jena
2001 *Club der Enttäuschten*
Uraufführung/First performance: 23/11/2001,
Stadttheater Konstanz
2000 *Tot im SuperRiesenaquarium*
Uraufführung/First performance: 28/7/2001,
Theater rampe, Stuttgart
Bier für Frauen
Uraufführung/First performance: 23/9/2001,
Staatstheater Mainz
1999 *Im Café Tassl – eine Sprech- und Sprachoperette*
Uraufführung/First performance: 1/11/2000, IN-TEATA,
Köln/Cologne
Vom Heinrich Hödel und seiner nassen Hand
Uraufführung/First performance: 1/2/2002,
Schauspiel Essen

Projekte und Beteiligungen (Auswahl)/
Projects (Selection)

2001 »5. Internationale Foto-Triennale«, Esslingen
»Microwave Festival«, Hongkong
2000 »Ars electronica«, Linz
»Neue Medienkunst aus Deutschland«,
Wanderausstellung des Goethe Instituts, ausgewählt
durch das ZKM, Karlsruhe/touring exhibition organized
by the Goethe Institut in cooperation with ZKM,
Karlsruhe
1998 »The Miracle of Hull«, ROOTfestival, Videoinstallation
im Auftrag von/Video installation commissioned by
Hull Time Based Arts Ltd.
»Videonale«, Bonn

FELICIA ZELLER

Geboren/born in Stuttgart 1970
Lebt und arbeitet/lives and works in Stuttgart

Theaterstücke (Auswahl)/Theatre (Selection)

2002 *Meine Mutter war einundsiebzig und die Spätzle waren
im Feuer in Haft*
Uraufführung/First performance: 28/7/2001,
Theater rampe, Stuttgart

Diese Publikation erscheint anlässlich der Ausstellung
»Body Power / Power Play – Ansichten zum Sport in
der zeitgenössischen Kunst«
6. September – 13. Oktober 2002
Württembergischer Kunstverein Stuttgart

This catalogue is published on the occasion of the exhibition
'Body Power / Power Play – Views on Sports in
Contemporary Art'
6 September – 13 October 2002
Württembergischer Kunstverein Stuttgart

Herausgeber / Editor
Württembergischer Kunstverein Stuttgart, Andrea Jahn

Redaktion / Editing
Württembergischer Kunstverein Stuttgart
Andrea Jahn, Tobias Wall

Verlagslektorat (deutsch) / Copy editing (German)
Judith Vajda

Verlagslektorat (englisch) / Copy editing (English)
Christine Davis

Übersetzung ins Deutsche / Translation into German
Reinhard Tiffert (S./pp. 126, 136 – 141)

**Übersetzungen ins Englische /
Translations into English**
Elizabeth Clegg (S./pp. 5, 23, 31, 36, 41, 53, 63, 92, 98, 102, 113, 118, 123, 127, 133)
Steven Lindberg (S./pp. 7, 16 – 21, 78 – 85)
Justin Morris (S./pp. 27, 47, 57, 67, 87, 108)

**Grafische Gestaltung und Satz /
Graphic Design and typesetting**
Katrin Schlüsener

Reproduktion / Reproduction
Schwaben Repro, Stuttgart

Gesamtherstellung / Printed by
Dr. Cantz'sche Druckerei, Ostfildern-Ruit

Erschienen bei / Published by
Hatje Cantz Publishers
Senefelderstraße 12
73760 Ostfildern-Ruit
Deutschland / Germany
Tel. 00 49 / (0)7 11 / 4 40 50
Fax 00 49 / (0)7 11 / 4 40 52 20
Internet: www.hatjecantz.de

Distribution in the US
D.A.P., Distributed Art Publishers, Inc.
155 Avenue of the Americas, Second Floor
USA-New York, N.Y. 10013-1507
Tel. 0 01 / 2 12 / 6 27 19 99
Fax 0 01 / 2 12 / 6 27 94 84

ISBN 3-7757-1235-6

Printed in Germany

Umschlagabbildung / Cover illustration
João Penalva, *The Prize Song*, 2001

Die Deutsche Bibliothek – CIP-Einheitsaufnahme

Body Power/Power Play : Ansichten zum Sport in der zeitge-
nössischen Kunst; Ausstellung Württembergischer
Kunstverein Stuttgart, 6.9. – 13.10.2002 / mit Grußworten von
Hans J. Baumgart; Raimund Gründler. Beitr. von Ihor
Holubizky ; Andrea Jahn ; Claudia Lüersen. - Ostfildern-Ruit :
Hatje Cantz, 2002
ISBN 3-7757-1235-6

»Body Power / Power Play – Ansichten zum Sport
in der zeitgenössischen Kunst«
'Body Power / Power Play – Views on Sports
in Contemporary Art'
Württembergischer Kunstverein Stuttgart
Schlossplatz 2, 70173 Stuttgart
Tel. 0049/(0)711/22 33 70
Fax 0049/(0)711/29 36 17
info@wkv-stuttgart.de
www.wkv-stuttgart.de

Direktor/Director
Dr. Andreas Jürgensen

Stellvertretende Direktorin/Vice Director
Dr. Andrea Jahn

Ausstellungskonzeption/Exhibition concept
Dr. Andrea Jahn

Wissenschaftliche Mitarbeit/Assistant
Tobias Wall

Ausstellungsassistenz/Exhibition assistant
Christiane von Seebach

Kooperation / Co-operation Stuttgart 2012 GmbH
Ursula Schleicher-Fahrion, Leiterin Kultur / Head of Culture
Katrin Henke, Mitarbeiterin / Head Assistant

Ausstellungstechnik/Installation
Martin Lenz
Matthias Feil
Ernst Kordeuter
Janos Wildner
Marcel d'Apuzzo
Michael Hofmann

Sekretariat/Secretary
Gisela Krönke

Mit Unterstützung der

Stuttgart 2012 GmbH

Trans Video Deutschland GmbH

Glaserei Lauser & Gmelin

Spedition Roggendorf

Heinrich Schmidt GmbH